BEHIND THE
CRIMSON CURTAIN

The Rise and Fall of Peale's Museum

BEHIND THE CRIMSON CURTAIN

CRIMSON CURTAIN

The Rise and Fall of Peale's Museum

Lee Alan Dugatkin

ISBN: 978-1-941953-72-3

Library of Congress Control Number: 2020909631

Cover photo: *The Artist in His Museum*, Charles Willson Peale, 1822.
Courtesy of the Pennsylvania Academy of the Fine Arts, Philadelphia.
Gift of Mrs. Sarah Harrison (The Joseph Harrison, Jr. Collection).

Printed in the United States of America

Book design by Scott Stortz

Published by:
Butler Books
P.O. Box 7311
Louisville, KY 40257
(502) 897–9393
Fax (502) 897–9797

www.butlerbooks.com

For enlightened readers anywhere and everywhere

Contents

PREFACE

If You Seek His Monument, Look Around

I SUPPOSE YOU HAVE SEEN MY ADVERTISEMENT
RESPECTING MY INTENTION OF APPROPRIATING A PART OF
MY HOUSE FOR A REPOSITORY OF NATURAL CURIOSITIES.
PERHAPS YOU COULD PROCURE THE STUFFED SKIN OF AN
ALLIGATOR . . .

— CHARLES WILLSON PEALE TO DAVID RAMSAY,
OCTOBER 15, 1786

In the six decades following this letter, Charles Willson Peale, widely regarded as one of the premier artists of the American Revolutionary era, would create the most important and most famous museum in America. A fusion of natural history and art, Peale's Philadelphia Museum was meant to be an embodiment of the Enlightenment. Over time it would grow exponentially, bringing into its orbit almost every scientific, political, and celebrity persona of the day. The story of this museum provides a unique window into the ethos of science, art,

and the Enlightenment in the early republic, and how these fed the appetites of a public hungry for rational entertainment. In many ways, Peale and his museum shaped the public's sense of what made for an enlightened citizen.

Peale the artist painted at least 18 self-portraits over the course of his lifetime, but none capture him quite like his signature 1822 painting, *The Artist in His Museum* (see book cover). This was a self-portrait in the truest sense, for by this time, 81-year-old Peale and his 36-year-old museum had fused, both in his mind and in that of the public. The trustees of his museum had commissioned him to do the work. After a seven-week burst of octogenarian energy, he produced a nearly nine-foot-tall by seven-foot-wide oil painting on "fine Russian sheeting" that hung in the museum by the first week of October.

The Artist in His Museum was designed to do more than just embody the man and his museum. It was meant to capture the psyche of the early citizens of the new republic, to convey the gestalt of natural history and its marriage to rational entertainment, and to put it all on canvas. Peale wrote his son, Rembrandt, that he "should not only make it a lasting monument of my art as a painter [but] be expressive [so] that I bring forth into public view, the beauties of nature and art, the rise and progress of the museum." Peale's self-assessment that his "portrait in the museum is much admired" would prove to be a grand understatement. Over time, *The Artist in His Museum* became one of the most recognizable paintings of America's earliest homegrown artists.[1]

The museum would have five homes after its 1786 birth, but Peale

situated *The Artist in His Museum* in the "Long Room" of the museum when it was located in the Pennsylvania State House (1802–1827), in what today houses Independence Hall. It was there, one floor below the Long Room, that the Declaration of Independence had been signed and that the Second Constitutional Conventional had burned hot. And it was in the belfry atop the Long Room that each day, a bell inscribed "Proclaim Liberty Throughout all the Land unto all the Inhabitants Thereof" would ring. Peale understood that if there was one spot that symbolized the history of the nation, brief though that history was, it was this building. In principle, he could have situated *The Artist in His Museum* in any of the former locations of the museum, including his home or the halls of the American Philosophical Society. However, it would be in the Long Room in the State House that he and his museum would go to canvas, burning an indelible association between the two into the minds of future generations.

Employing a device he had built to facilitate one-point perspective, Peale set brush to canvas, writing his son, "I wish it might excite some admiration." He places himself in the front of the room with the light shining behind him for maximal effect, dressed in a black suit and white cravat, and lifting a magisterial crimson damask curtain with a calculated dash of the theatrical. Peale then unveils the Long Room of his museum to the viewer. In front of him, and to the left, lies a turkey—the animal Benjamin Franklin had argued should symbolize the new republic—atop a taxidermist toolkit that a Creator-like Peale will wield to breathe new life into this lifeless specimen for museum visitors. To his immediate right is a table covered by a green velvet throw, atop of which sits a painter's palette, with paints and brushes,

hinting at the other tools of the trade that Peale and his sons used to make the museum an Enlightenment shrine of sorts.[2]

Leaning against the table is the giant femur bone of a mastodon placed near a piece of mastodon jaw. As the eye travels back behind the crimson curtain and along the north wall of the room, we see hints of a fully reconstructed mastodon. This creature was the most famous the museum ever housed. Peale and his sons had excavated it two decades earlier from a marl pit on John Masten's farm near Newburgh, New York, in what was both the first-ever large-scale paleontological expedition and the first museum-sponsored research project in America. The mastodon skeleton really sat in its own area adjacent to, but not part of, the Long Room, but, for effect, Peale placed it behind the curtain, partially revealed, along the north wall. To do so, he needed to omit William Rush and Jean-Antoine Houdon's sculptures that sat atop display cases lined with minerals and insects and dispense with the organ that was used for evening outreach events at the museum—all of which actually sat along that north wall. It was a cost he was willing to pay, for it was unthinkable that the mastodon be absent from *The Artist in His Museum*. It had not only become the symbol of American power and grandeur, but the reconstructed skeleton and the well-known story behind it—which included a doppelgänger mastodon that took a brief tour of Europe—made it clear that this museum was no static repository, but instead a dynamic research enterprise.[3]

As viewers travel down the left (southern) wall in the painting, they are treated to four long rows of display cases set under 19- by 22-inch portraits of eminent men of the era, each mounted in an oval frame. The display cases are a sample, albeit a small sample, of the

animals housed in Peale's museum, each carefully mounted and set with a hand-painted panorama of its native habitat. The cases provide a sense of the ordered, hierarchical way that life was represented at the museum. The one-point perspective used in *The Artist in His Museum* limited the space Peale had to lay out his view of the world, but even within the four rows of birds presented, the viewer sees the rapacious, glorious eagle sitting above songbirds, seabirds, and the like. Man sits atop that world, below him the animals. Peale the deist may not have believed that a supernatural force was actively maintaining order, but there was order nonetheless, an order that he often praised.

To make the Long Room appear more welcoming, Peale was comfortable taking more minor liberties. The rope barrier in front of the bottom cases to keep visitors from touching the displays was removed. In the glimpse we are given into the doorway in the foreground, Peale, in deference to the temple he built nearly 40 years before, has removed the artifacts that sat there, and replaced them with a paddlefish that was the first specimen donated to the museum.

Halfway down the southern wall, the viewer is again reminded of the mastodon across the room, as a Quaker lady, bonnet atop her head and both hands lifted, looks at the great beast in sheer awe. Behind her stand a father and son, as well as a contemplative young gentleman with arms folded, doing a bit of indoor bird watching. In these four, Peale captured the breadth of visitors to his museum, male and female, young and old. Apropos for the Enlightenment ethos of the museum, the boy holds a guide to the museum in his hands, and his attentive father has one arm around him, while the other arm points, in professorial-like fashion, at the display cases. Both gaze at the wonders before them.

If a painting can ever truly capture a man and what he created, then *The Artist in His Museum* does so. It is the artistic rendition of the epithet for Sir Christopher Wren on the walls of the London St. Paul's Cathedral that he designed: "Si monumentum requiris, circumspice"— "If you seek his monument, look around."[4]

CHAPTER 1

THE BIRDS AND BEASTS
WILL TEACH THEE

Peale family legend has it that Charles Willson's father, Charles, attended Cambridge University, though no record of this exists. We do know that Charles Peale the elder was born in England in 1709 and was schooled for a life in the ministry, but rather than taking the path to the pulpit, he became a clerk. He eventually rose to the position of deputy director of London's General Post Office. Things did not go well. In 1735, he was charged with forgery and theft of nearly £2,000 from the postmaster general. He pleaded guilty and was sentenced to death by hanging. That sentence was commuted to exile in the North American colonies, where Charles first landed in Virginia before settling in Maryland and marrying Margaret Triggs. As a schoolmaster at the Kent County School, Charles taught Greek, Latin, mathematics, navigation, and surveying. He tried, unsuccessfully, to publish his book, *An Essay towards Rendering the Rudiments of the Latin Tongue*. Somewhere along the way, he became

acquainted with Benjamin Franklin.[1]

In an autobiography that he penned in the third person, Charles's son and namesake, Charles Willson Peale, writes that he was born in Queen Anne County, Maryland, on April 16, 1741. The house where he spent his early years was modest, furnished with eight chairs, two chests, a couch, a table, and a corner cupboard. Charles Willson remembers his father as a man "greatly respected; but his income was low: as is too generally the case with teachers." In 1750, nine-year-old Charles Willson and his four siblings, James, Margaret Jane, St. George, and Elizabeth, lost their father, and their mother, Margaret, was left a "widow to support five children by her industry alone." Soon Margaret moved the family to Annapolis where she made ends meet as a seamstress specializing in cloaks and gowns.[2]

In 1754, Charles Willson was apprenticed as a saddler to Nathan Waters, a Philadelphian, who had settled in Annapolis. He learned his trade quickly and was fortunate that he had a master who paid him for each of the saddles that he made above and beyond what Waters took to be a fair lot for an apprentice. Peale eventually scraped together enough money to buy a watch and when it broke a second time, he tried, quite unsuccessfully, to fix it himself, but along the way "acquired knowledge of the principles of such machines," which would serve him well in the future.[3]

When he was 17, Peale took a trip across a tributary of the Chesapeake Bay to visit his friend John Brewer. John's 14–year-old sister Rachel greeted him at the door and Charles was instantly smitten. "Hail, rain, or snow," he wrote, "no weather deterred him from crossing South River and a creek every week to visit" this young woman whose

brown hair "hung in curling ringlets upon her long beautiful white neck . . . her face a perfect oval . . . her nose straight with a few angles, such as painters are fond to imitate." He soon asked Rachel's mother, Eleanor, for her daughter's hand, and after some cat-and-mouse games, the coquettish Rachel agreed. On January 12, 1762, with a Reverend Barkley presiding over the ceremony, 21-year-old Charles and 17-year-old Rachel were married: in time, they would have 11 children together, six of whom would survive childhood. Their first, Margaret Jane, was born in 1763, and died before she turned two weeks old.[4]

Peale's apprenticeship had been set at eight years and during the penultimate year, an opportunity arose to cut it short by four months. Waters was ill and told Peale of his plans to sail to Bermuda for convalescence, promising him that if he would take over all the operations during his absence, upon his return, Waters would release him from his apprenticeship four months early. Charles jumped at the opportunity, but Waters reneged on the agreement and tried to hold him to the full term. Peale would have no part of it, and in a brash move, went to Charles Wallace, a man "who had considerable influence with his master" and told him what had occurred.[5]

Wallace made things right and soon the apprenticeship was over. "How great the joy!" Peale wrote, "how supreme the delight of freedom! It is like water to the thirsty, like food to the hungry." With his newfound freedom, he secured a loan of £20 from James Tilghman, a family friend, and in the January 21, 1762, edition of the *Maryland Gazette* announced the opening of his own saddle shop. In a bizarre twist, Peale received a letter soon thereafter from Captain J. Digby, a Brit claiming kinship, informing him he should sail overseas to claim

an inheritance from his father's estate. He had no knowledge of such a cousin, and though he did reply to the letter, he did not have the means to pursue the matter, which turned out for the better as the letter was a forgery. Peale came to think it was sent by local saddlers and "was framed for the design to prevent [him] from settling at Annapolis as an opponent in trade."[6]

Peale had a fondness for drawing and painting that was sparked, in part, by a sketch he had made as a young boy of Adam and Eve and the mythical tree of knowledge. When he was a bit older, an uncle died, and his grandmother, sensing a precocious artist-in-the-making, had Peale draw a sketch of the dead relative. But painting and drawing remained a hobby, and one only dabbled into on rare occasions. That changed when Peale made a sortie to Norfolk, Virginia, to acquire some leather. There, while he was visiting the brother of a friend, Peale came across some paintings the man had drawn. "They were miserably done," he recalled, but "had they been better, perhaps they would not have led [me] to the idea of attempting anything in that way." The seed was planted, and with "the idea of making pictures now having taken possession of his mind," Peale painted a few landscapes that his friends and family liked and followed this by a self-portrait with a disassembled clock before him, a portrait of Rachel, and another of his siblings. Word spread and soon Peale received his first commission: £10 to paint a Captain Beriah Maybury and his wife. He was beginning to think that he "possibly might do better by painting, than with his other trades." He took the first step in that direction by opening a sign-painting business, but from the start, saw himself as a budding portrait and landscape painter, doing signs to make ends meet.[7]

At the time, there were only four portrait painters in Annapolis, including Gustavus Hesselius and his son John Hesselius. Even though competition was scarce, Peale had a rough go of it at the start. He was, by his own admission, a rank amateur. He was even at a loss to know what colors to purchase at paint stores, as he "only knew the names of such colors as are most commonly known," and had never worked with an easel or a palette "and therefore had his own inventions to supply these conveniences." But he tinkered and experimented. An autodidact, he also purchased or borrowed books, including Robert Dossie's 1758 *The Handmaid to the Arts*, which he took home and read straight through in four days "with very little intermission." He also devoured Hogarth's *The Analysis of Beauty*, De Fresnoy's *De Arte Graphica*, and, most likely, Joshua Reynold's *Discourses*. He even went to John Hesselius and traded him his finest saddle for a bit of instruction that included finishing the other half of a portrait that Hesselius had begun. Soon painting became Peale's primary profession.[8]

Charles seemed eternally in debt, a consequence, as he saw it, of his inveterate dabbling, leading him into endless side industries, including clock repair. His debt became more dangerous when, in the Maryland elections of 1764, he took political sides with Samuel Chase, the anti-propriety, trade party candidate running against George Steuart, the landed, aristocratic court candidate. In retribution, Steuart's supporters had four writs served against Peale on account of his debts. Charles and Rachel then slipped out of Annapolis, but soon enough the authorities tracked him down. When the sheriff discovered his whereabouts, "so narrow was [my] escape," Peale wrote, "[I] then found it necessary to tear [my]self from [my] fond wife and friends."[9]

For the next year, with pregnant Rachel staying with her family, Peale was on the run, first in Virginia, where he stayed for a brief stint with in-laws, and then joining one of those in-laws, Robert Polk, on a "lonesome disconsolate journey" aboard a ship to Boston in the summer of 1765. There, he likely joined in protests against the Stamp Act, or, at the very least, witnessed such protests. Polk lent him £16 for room and board, and Peale picked up some extra money painting portraits of local families. In Boston, he met John Singleton Copley, who but three years older than Peale, already had a reputation as a major portrait painter. Charles described Copley's studio as "a great feast" to the eyes, and he dined with Copley on at least one occasion. These interactions appear to have spurred him to paint his first miniature, a self-portrait.[10]

Though he received an occasional commission, work was hard to find in Boston, and after briefly considering a stint in South Carolina, Peale headed back to Virginia. When his ship docked at Metompkin Inlet, a local judge, James Arbuckle, came on board, and in the course of events, spotted one of Peale's paintings hanging in a cabin. Arbuckle was impressed and took an immediate liking to the artist as well as his art. The judge commissioned him to do a series of family portraits, and insisted Peale reside with him during his time in Virginia. In return, during his stay, Peale taught the judge the art of watch mechanics and a bit of silversmithing. Eventually, Arbuckle arranged for Peale to be able to return to Annapolis and join Rachel, who had made her way back there, on the promise of his making good on his debts within four years. When Peale returned, he was introduced to his baby son, James, and immediately took again to painting as his main profession. After

one more brief encounter with the law over debts, in which the family put up Rachel's inheritance as collateral, his financial problems abated. Then, as Peale described, "a new scene is about to take place," a scene for which he could thank his long dead father.[11]

One of Peale's paintings, though we do not know which, made it into the hands of Elizabeth Bordley, whose stepbrother, the Honorable John Beale Bordley, was a powerful member of the Maryland aristocracy. Decades earlier, young John had been a student of Peale's father and had formed a deep friendship with his mentor. Now, he sat transfixed, staring for two straight hours at Peale's painting. He then declared, "something must and shall be done for Charles," and after talking with Peale about his art, asked him, "if he was willing to go England to get improvement, if the means could be provided." Charles was thrilled. Soon John Beale Bordley solicited his well-to-do friends, including Governor Horatio Sharp, as cosponsors and obtained the needed funds for the voyage and for Peale to study in the studio of the legendary painter, Benjamin West. West, though born in Pennsylvania, had migrated to England and taken up classical history painting in grand style as in his *Venus and Adonis*. Bordley and the other sponsors also obtained letters of introduction for Peale to present to West and other luminaries of the British art world.[12]

In December 1766, Peale bid farewell to his family and boarded the *Brandon*, a merchant vessel, and set sail on an eight-week voyage "in rough and disagreeable weather" to London. Seasick most of the journey, he did manage to write some poetry, modeled after Milton, as well as construct a violin from the materials at hand, and passed the time teaching himself how to play. Upon disembarking on February

13, 1767, he purchased a light blue half-dress suit, gloves, and a beaver hat, checked a bit more into the possibility that a paternal inheritance might be awaiting him—it wasn't, in part because his father may have had a mistress—and called on Benjamin West.[13]

Though the king's painter, West was a sympathizer with the colonial cause and welcomed Peale with open arms, promising "all the instruction he is capable of giving," and noting how impressed he was with the letters of introduction. As was Peale's temperament, he began studying with a laser focus. As a general rule, he was not one to think "poets, painters and company are born such." A few may be born with a specific innate talent, but others "show an equal readiness to acquire knowledge in whatever may be difficult: perhaps their minds may be compared to a fine soil in which everything will grow." Though he didn't necessarily think he was such a man, continuing the horticultural analogy, he did believe "cultivation is absolutely necessary." To facilitate such cultivation as a painter, Peale largely ignored the entertainment available in Europe's leading city, in part to maximize his time in the studio, and in part out of guilt that Rachel could not be there to share it all with him. Over the course of two years, he went to only seven plays at Covent Gardens and Drury Lane, popped over to Windsor once, and went to a single dinner party.[14]

One highlight he would not permit himself to miss was meeting Benjamin Franklin, who at the time was acting as a colonial agent, and who, the prior year, had pleaded before the House of Commons to repeal the Stamp Act. Peale showed up, unannounced, at Franklin's residence on Craven Street to see the good doctor. Franklin was then 61 years old, clad in a bright blue-green suit, and had the landlady's

27-year-old daughter, Polly Stevenson, sitting on his lap. (Peale later sketched the scene in his notebook.) After Charles introduced himself, he inquired whether Franklin remembered his father. Franklin did and was delighted to see his old friend's son studying in London. "The Doctor was very friendly to me . . . showed me his experiments . . ." Peale wrote, "and desired me to call on him at any of my leisure moments and he would always be glad to see me."[15]

Making the most of his opportunity to work with West, Peale "was not contented with knowing how to paint in one way, but . . . engaged in the whole circle of arts . . . also at modeling and casting in plaster of Paris." Most of the work was done in West's studio, where he learned about poses, composition, textures, lighting, and canvases, though his sculptures may have been cast in Joseph Wilton's studio and/or the Royal Academy. At West's suggestion, Peale copied his mentor's works. Soon he was painting a series of commissioned miniatures— small watercolors on ivory, starting to come into fashion—but his best, and most well-known works from the time in London were his paintings of William Pitt. In one, an eight-foot by five-foot oil on canvas commissioned by Richard Henry Lee of Virginia, Peale cloaks Pitt in a Roman consular habit, as he stands to defend the claims of the colonies. Pitt is shown with the Magna Carta in his left hand, while his right hand points to a statue representing British Liberty, stepping on a petition from the Congress of New York. In the background, as a not-so-subtle reminder of the fate of tyrants, is the Royal Palace where Charles I was executed. Soon a similar portrait of Pitt by Peale was gracing the walls of the Maryland State House.[16]

About a year into his stay in London, despite keeping meticulous records of every purchase he made (down to paying for a glass of milk in the park), Peale had exhausted his sponsors' funds and was set to return to Annapolis. West advised him to stay longer and offered free board if he did. That, along with some additional funds sent by his sponsors on the condition that he behave with "prudence and frugality," prolonged Peale's visit. As a result, one of his paintings, *Child with a Toy Horse*, was displayed at a special exhibit in honor of a visit by Christian VII, king of Denmark, and four of his other works were shown in the Society of Artists exhibition at Charing Cross, with Peale listed as a "miniature painter" in the catalog.[17]

After two years in England, on March 8, 1769, Peale began a 12-week voyage back to Annapolis, having secured not just the skills of an artist, but a growing reputation as a talented one. The homecoming was warm, and though his young son James had died while he was away, the future looked promising.

In the early 1770s, Charles established himself as the leading portrait painter in the middle Atlantic colonies, largely as a result of a series of paintings commissioned by the Cadwaladers, one of the leading families of Philadelphia. After Peale completed two miniatures for John and Elizabeth Cadwalader, the family, in part to solidify their community standing as patrons of the arts, had Peale paint 16 pieces, including many family portraits. At the time, the large-scale commissions they provided Peale were rare. The Cadwaladers had turned to Peale, rather John Singleton Copley for these works, in part because they appreciated his apprenticeship under West and the Old

World flavor that it produced. It was a good omen. Peale quickly gained a name as a painter who thrived on domestic scenes. He painted more works with children in them than any American painter before him, and many after him. The portrait he painted of his own family shortly after his return from London was his pride and joy. John Adams told Abigail that in it he found "a happy cheerfulness in their countenances and a familiarity in their air toward each other."[18]

Annapolis, a major seaport, and "the genteelest town in America," as it was called by some, was the hub of political and social life in Maryland. Georgian mansions, like those of William Paca, a future signer of the Declaration of the Independence, and politician James Brice, lined its finer streets. In 1772, construction of what would become the Maryland State House had begun, and a year earlier a new redbrick theatre had opened. There were coffee houses, social clubs like the Knights of the Moon, horse races, music, balls, and dances. The arts were thriving, with the *Maryland Gazette*, published out of Annapolis, running a poet's corner that included such pieces as "An Ode to Delia, Playing on the Harpsichord, with Her Gloves On." It was a place, Peale wrote Benjamin Franklin, where "the encouragement and patronage I have met with exceed my most sanguine expectation."

It was a busy, somber time in the Peale home. He and Rachel's third child, Eleanor, was born in 1770—she was to live a short three years—and in January 1772, before Eleanor died, a sibling, Margaret, was born, only to die that same year. By the end of 1773, the Peales had lost all four children Rachel had borne, but their fortunes would change in 1774 with the birth of Raphaelle, and the following year with the birth of Angelica, both of whom would lead long lives. Aside from

paterfamilias duties, Peale remained close to his siblings. He hosted the wedding of his sister Margaret Jane to Princeton graduate Nathaniel Ramsay, who many years later would make a passing remark that would change everything. Professionally, he wrote often to his local sponsors, and to London as well, both to West and Franklin, discretely suggesting to the latter that he had come to see him as something of a father figure. He spent time teaching his brother James to paint. He welcomed friends and would-be patrons of the arts into his home studio, the centerpiece of which was a leather chair that was a farewell gift from West when he left London. Peale expended considerable effort at this time retouching many of his early works, done before he fully understood colors, and he tried his luck with encaustic painting, a difficult method where the medium is comprised of color pigments added to beeswax to create an oil paint-like texture. He also tinkered with a machine that he called a "painter's quadrant" that appears to have been used to help with perspective.[19]

Peale's brush was in high demand. He was painting portraits of astronomer and mathematician David Rittenhouse and John Dickinson, who had penned *Letters from a Pennsylvania Farmer*. John Beale Bordley, who had sponsored the trip to London, continued his patronage, commissioning new paintings. Richard Penn, the lieutenant governor of Pennsylvania, had Peale work on a portrait. In 1771, Peale met Martha Washington in Williamsburg, where he painted miniatures of her two children. A year later, Martha herself sat for a miniature, and not long after that, during a visit to Mount Vernon, Peale convinced her that Colonel Washington should sit for him. It was

a sitting he would long remember, not only because it was the first of 25 portraits, miniatures, mezzotints, or sculptures he would do of the soon-to-be general, but also because Colonel Washington had spotted Charles and others playing "pitch the bar" and promptly far outdid the young whippersnappers, quipping "when you beat my pitch, young gentlemen, I will try again."[20]

In the midst of it all, Peale was also tutoring artists-to-be, cementing connections with the political and social elite as a member of Annapolis's Homony Club, and forging bonds with rebels by painting flags for the Independent Company of Williamsburg and the Independent Company of Baltimore. He adopted a life-long habit of moderation with respect to alcohol, tobacco and meat. He even taught himself and Rachel French in the evenings, such that he was "able to translate French into English . . . and enjoy a French author before the next summer's approach." For reasons that are unclear, though his commissions were many up through the mid-1770s, Peale fell into debt yet again. To remedy this, he often went on painting tours to Philadelphia, Baltimore, Norfolk, and Williamsburg, sometimes alone, and sometimes with Rachel and the children. His different-sized works, including half lengths (50 by 40 inches), "kitkats" (36 by 27 inches), and "head size" (23-by-19-inch busts) were drawing commissions from five to twenty pounds each, and his financial problems seemed once and for all settled by mid-1775. Peale wrote to a friend that he had "just now worked myself out of debt. Except my debts of gratitude . . ." opening the door for a move that he had been planning for years.[21]

In the six years following his 1769 return from London, Peale had made many trips to Philadelphia. As early as 1770, he wrote of "a great

desire to settle there." Two years later, he was distributing 500 calling cards he had printed, this time held back only by his wish to make a name for himself before moving there. At long last, on December 18, 1775, just four days before Rachel gave birth to Angelica, Charles, with his debt now behind him, and a market for his art in place, moved to Philadelphia despite the obvious and dangerous role that the city would play in the already ongoing hostilities against England. His family would join him there soon, in a house he rented on Arch Street.[22]

Three days after arriving in Philadelphia, Peale was already at work studying, this time for the revolutionary cause, learning David Rittenhouse's gunpowder formula. A week later, he was at Rittenhouse's home again, discussing the notion of "a rifle with a telescope," and not long after that he was experimenting with making "springs to prevent the eye from being hurt by the kicking of the gun." Though there was the occasional day where his entire journal entry was comprised of "cleaned my gun, am very idle," or "reading," for the most part, Peale kept himself busy. He made the rounds, dining with Franklin and partaking in a fast ordered by Congress "so that every American would drop a tear in memory of George II under whom we had lived so happy." Professionally, he spent time grinding colors for his many commissions, including a full-length work of Julia Rush, the wife of physician and savant Benjamin Rush; she was clad in an exquisite blue silk dress and strumming a lute-like instrument. He even set aside some time to do watch repair work and carve a set of false teeth.[23]

Peale's star was on the rise. After a visit to Charles's studio, John Adams wrote Abigail that he was "tender, soft, affectionate . . . he is ingenious." In May 1776, John Hancock, president of the Continental

Congress, in an attempt to ingratiate himself to the new commander-in-chief, commissioned Peale to do a full-length portrait of Washington. It became one of his most famous early works. He had the general, who sat twice for him in late May, draped in a stunning blue jacket with epaulettes on the shoulders, with his right hand resting on a walking stick and his left hand perched in his vest and scabbard hanging down below that. That could only have made even more satisfying his diary entry of July 2—"This day the Continental Congress declared the United Colonies Free and Independent States."[24]

In August 1776 Peale enlisted as a private in the Philadelphia militia. He described himself as a "thin, spare, pale-faced man . . . totally unfit to endure the fatigue of long marches." Within three months, he was elected first lieutenant; in less than a year, he was captain of his company, and not long after that, he was appointed captain of the Fourth Battalion of the Philadelphia Militia. In December, as the revolution ramped up and it was clear that the British had set their sights on occupying Philadelphia, Peale arranged for his family to leave the city and stay in a house about 12 miles away in Abington. On December 5, Charles, clad in a plain brown uniform, topped with a black hat with a gold button and gold braid, boarded a shallop and set sail to New Jersey. He was under the command of one of his patrons, John Cadwalader. In New Jersey, Peale and his comrades were to join up with Washington's troops at Trenton, where the army had retreated after losses at Long Island and White Plains in the summer and fall of 1776.[25]

While they saw "a few cannon shot . . . flying over their heads," Peale's unit's mission centered on diversionary tactics. They were not

involved in the heavy fighting at Trenton or Princeton, nor were they on board for the famous crossing of the Delaware. Charles did witness the Christmas night landing, which he said struck him as "rather the appearance of hell" as a result of "the hollowing of hundreds of men in their difficulty of getting horses and artillery out of the boats." Years later, he returned to both Trenton and Princeton to refresh his memory of the landscape for his paintings *George Washington at the Battle of Princeton* and *George Washington after the Battle of Princeton*, the latter commissioned by the Supreme Executive Council of Pennsylvania to hang in their chamber in what would come to be called Independence Hall.[26]

Peale's company marched back to Philadelphia on January 19, 1777, and the family soon joined him there. But not for long. On September 19, shortly after the loss at the Battle of Brandywine, General Howe's troops began an occupation of Philadelphia. The Continental Congress moved to Lancaster and then York. Peale evacuated his family again shortly before the occupation, and he himself was back with the militia. In addition to his military engagements, and at times in conjunction with such engagements, Charles was busy with miniatures and portraits in 1777. These included works on Washington, Hamilton, and the Marquis de Lafayette, as well as a self-portrait in militia garb.

Peale's enlistment ended in late November 1777. "Having no employment at home," he wrote in his autobiography, "[I] frequently returned to the army," primarily to capture key military personnel and events on canvas. This connection between the military and his art reached its pinnacle during the 1777–1778 winter encampment at

Valley Forge. Peale had the freedom to return home at will, which he did numerous times, including a five-week stint in January and early February for the birth of his son Rembrandt. However, he was in camp much of the winter, on occasion dining with the commander-in-chief, and painting more than 30 miniatures, including ones of Washington, Nathanael Greene, Henry Knox, and Lord Stirling.[27]

After the British occupation of Philadelphia, Peale returned to the city to find "houses in general . . . pulled to pieces." An active member of the Whig Society, he more than sympathized with patriots who had remained in the city. He wrote of "the doleful tale of their sufferings, how the Tories had abused them . . . [how] they dare not say a word, but that they be called rebels and threatened with . . . prison and the halter." Still, he didn't relish the position he had been assigned on a committee charged with dealing with such Tories, where one of his main duties was to commandeer property, including homes of suspected British sympathizers, seeing it more as a necessary evil, a "most disagreeable business."[28]

Pennsylvania was going through serious economic woes, including severe inflation. Although Peale reminded friends he had "more attended to make my country than myself independent," the late 1770s and early 1780s saw a relatively steady flow of commissions, including miniatures of Franklin, Lafayette, the Comte de Rochambeau, and Baron von Steuben, as well as multiple Washington pieces and various sketches of the State House.[29]

Peale's work at the easel didn't quash his interest in forwarding the principles of his new republic, and in October 1779, he was selected one of five assemblymen representing the City of Philadelphia in

Pennsylvania's Fourth General Assembly. The assembly had a busy legislative agenda, which included amending the charter of the College of Philadelphia to eliminate its link to the Anglican Church. In the end, Charles served only a single term, being "firmly determined no longer to take any active part in politics." At least not as an elected representative. But when news of Benedict Arnold's treason broke, it was Peale who constructed an effigy of a double-faced model of Arnold in a carriage, dressed in a red coat, and holding a letter to Beelzebub while the devil stood behind him shaking a purse full of money. It was paraded through the streets of Philadelphia to the tune of "The Rogue's March." In the front of the carriage, affixed to a lantern, was a sign reading "Major Benedict Arnold, late commander of the Fort West Point. The crime of this man is high treason."[30]

In August 1780, Peale moved his family from the Market Street house they had been renting since the British had left Philadelphia to a home he had purchased at 62 Lombard Street, on the southwest corner of Third Street. They were a large clan by this point, with new son Titian recently joining the clutch. The new home was a two-and-a-half story construction, with Lombardy poplar trees aplenty in the front yard, nestled among homes of a coach maker, a baker, a grocer, and a mast maker. When news came of the surrender at Yorktown, Peale covered the front of this new home with transparencies painted on window shade cloth, including one of "our illustrious CHIEF (Washington) and the Comte de Rochambeau, with rays of glory from them . . . with this motto—SHINE VALIANT CHIEFS." A month later, Charles again draped his home with these transparencies as Washington made his triumphant return to Philadelphia.[31]

To cover the cost of the down payment on 62 Lombard Street, Peale wrote colleagues, including Washington, diplomatically requesting payments owed on miniatures and portraits he had painted, and he also cut in half the price for miniatures to boost current sales. Two years later, his commissions had secured him sufficient funds to start construction of a dedicated portrait gallery, loosely based on Benjamin West's London studio. It was a 66-foot extension to the house, which had a series of skylights with screens that could be adjusted to manipulate mood and setting. Peale woefully underestimated the cost of the gallery—"My building has made me miserably poor," he wrote Benjamin West—no doubt contributing to "a kind of lethargy" he complained to friends about.[32]

On November 14, 1782, the *Pennsylvania Packet* announced the opening of Peale's portrait gallery to the public. His new "Exhibition Room," they noted "is open for the reception and entertainment of all lovers of the fine arts, being ornamented with the portraits of a great number of worthy personages," including Washington, Franklin, Paine, Rittenhouse, John Paul Jones, Lafayette, Rochambeau, and some 30 others. The gallery would not only serve as a tribute to the early republic Peale cherished so deeply, but also as a life-size business card for his work as an artist. Charles wrote to a friend, "This collection has cost me much time and labor and I mean to keep adding as many of those who are distinguished . . . as opportunity will serve in full expectation that my children will reap the fruit of my labors."[33]

With the signing of a peace treaty with Great Britain, the *Pennsylvania Gazette* saw reason to welcome 1784 with open arms.

The January 1, 1784, edition had its New Year's verses opening with:

How things have changed since last New Year

What dismal prospects then arose!

Scarce at your doors I dared appear

So multifarious were our woes

But time at length has changed the scene

Our prospects now are more serene.

The Pennsylvania Assembly, seeking a "public demonstration of joy" to celebrate the end of the war, funded the construction of a triumphal arch at Market Street between Sixth and Seventh Streets. Situated just three blocks west and five blocks north of Peale's home and gallery, the arch stood more than 35 feet tall and 50 feet wide with paintings on canvas stretched across it, all backlit by more than 1,000 lamps. Its three arches and four Ionic columns had native flowers running their length, with scenes of Washington as Cincinnatus, a library with engravings of "the arts and sciences," and spandrels engraved with S.P.Q.P (Senate and People of Pennsylvania). On the balustrade were four statues representing Justice, Temperance, Fortitude, and Prudence.[34]

While both his active participation in politics and his service in the army had come to an end, Peale's patriotism had not, and he was happy to be placed in charge of creating the myriad transparencies for the panels, frieze pedestal, and the balustrade. His pièce de résistance was the construction of a large statue of Peace and her servants surrounded by clouds that were to sit atop the entire arch.

The day of the unveiling saw Philadelphians giddy with excitement, as crowds gathered beside the arch. Just as Peale was putting the

finishing touches on Peace, the preliminary fireworks began, and though it is not exactly clear how, sparks from one of the seven hundred rockets launched landed on the arch. In short time, the entire structure was ablaze. One, or perhaps two, spectators were killed, and Peale found himself with his clothes on fire, burns on his hands and head, one or two broken ribs, and a severe contusion that kept him in bed for three weeks. But neither he nor the city were to be robbed of their public demonstration of joy, and on May 10, six days after Charles and Rachel's newest boy, Rubens, was born, a new triumphal arch was complete, emblazoned by the art that Peale had meticulously recreated upon his recovery.

Sometime in May 1784, Peale's brother-in-law, Colonel Nathaniel Ramsay, visited the Peale home and planted a seed that would soon blossom into an enterprise that would forever change Charles and his family. It all started with a box of very large bones sitting on a table at the Peale home/gallery.[35]

These bones, from Big Bone Lick in what would later become the Commonwealth of Kentucky, were with Peale as the result of an unusual series of events. With the war over, a German officer, who had served with the British army, wished to keep a promise he made to his family to bring home what he called the bones of a mammoth. We don't know the identity of this officer, but he clearly had some clout, for when he applied to Washington for assistance in obtaining such bones, the general supplied him with men and wagons for a dig, but "a tremendous storm came and blasted all their hopes." With little

time before his departure home, there was no time for more digging. The officer next went to Philadelphia to see if he could buy some mammoth bones that were the property of John Morgan, a prominent Philadelphia physician. Morgan was not interested in selling them but agreed to allow drawings of them to be made, so that the officer would not go home completely empty-handed. Arrangements were then set in place for Peale to sketch these bones.

Farmers had been digging up mammoth bones in upstate New York for nearly 80 years before Morgan's bones sat before Charles. In 1705, a Dutch farmer at Claverack Manor near Albany unearthed a tooth weighing close to five pounds. He promptly turned his find into an even more valuable commodity, selling it to Assemblyman Peter van Bruggen for a half-pint of rum. After van Bruggen showed his newest acquisition to his fellow assemblymen, he gifted it to Edward Hyde, the Third Earl of Clarendon and the Royal Governor of New York, who then sent it to the Royal Society in London, in a box marked "tooth of a giant." Before making its way across the Atlantic, the tooth was supplemented by other bones dug up at Claverack. When Edward Taylor, a Congregationalist minister and grandfather of Ezra Stiles, the future president of Yale University, saw the collection, he thought they were the remains of a monster that he judged to be more than 60 feet tall. Others were even more astounded, and imagined:

His arms like limbs of trees twenty foot long,

Fingers with bones like horse shanks and as strong

His thighs do stand like two vast millposts stout.[36]

The bones were stirring debate: were they the remains of a biblical race of giant humans, or some behemoth, a terrestrial leviathan of sorts? Either notion seemed both extraordinary and plausible. Cotton Mather thought they might be the giants of the Old Testament that legend had perishing in Noah's flood, but most everyone else believed the bones were those of a creature like the one Taylor had eulogized. A pair of Royal Society papers in 1728 put the matter to rest: comparative analysis had unequivocally labeled them animal remains. News also arrived of prisoners exiled to Siberia by Peter the Great who had uncovered similar bones thousands of miles away, remains of what they dubbed a "mammut" or mammoth, a term likely derived from Mehemot, the behemoth in the story of Job. Soon colonists were using this new mammoth moniker, though many referred to the mysterious creature as the incognitum a term derived from the Latin for "unknown."[37]

We now know that there were in fact two distantly related groups of giant creatures that, until about 10,000 years ago, roamed both America and the rest of the world: mammoths and mastodons, each group having multiple species within it. The bones before Peale in 1784 were in fact those of American mastodons (*Mammut americanum*), but at the time, Peale and others referred to them as mammoth remains. It was not until 1806 that French comparative anatomist and paleontologist Georges Cuvier officially classified mastodons, in part based on the very bones that sparked the birth of Peale's museum in 1784. Cuvier distinguished them from mammoths based largely on a tooth surface that had cusps that reminded him of a female breast ("mastos"). But the fact remains that long after

that, many, Peale included, continued to use "mammoth" as a catch-all term for giant beasts the size of mammoths and mastodons. In an 1809 letter to Jefferson, Peale informed his confidant that Cuvier had "given the name Mastodonte to the animal which we commonly call Mammoth . . . I would willingly change the name of Mammoth if you think the name which Mr. Cuvier has given is appropriate." Jefferson, as ever, was happy to share his opinion on all things natural history. He wrote to Peale that "the protuberances on the grinding surface of the teeth, somewhat in the shape of the mamm, mastos, or breast of a woman, which has induced Cuvier to call it the Mastodonte, or bubby-toothed, which name perhaps may be as good as any other and worthy of adoption, as it is more important that all should agree in giving the same name to the same thing." Despite his friend's advice, as late as 1822, Peale was still referring to his bones as those of a mammoth, and so we will follow his lead and do so as well.[38]

As the number of mammoth fossils uncovered grew, so too did the legend. Today we know this creature was an herbivore. However, its sheer size—weighing in at about 10,000 pounds and standing around 10 feet tall—and the very notion that something that big roamed North America, led many colonists and early Americans to believe that this was a fierce creature. Eventually the mammoth was painted as a killer of enormous proportion, capable of apocalyptic actions. One of the richest sources of bones of these giant creatures was the Big Bone Lick deposit, which had yielded the bones Peale was sketching, as well as Ben Franklin's mammoth tusks, molars, and vertebrae, and the mammoth bones in Jefferson's collection.

It was while Peale was sketching Morgan's mammoth bones for the German officer that Nathaniel Ramsay happened to visit. Others had commented in passing on how wondrous the bones appeared, but Ramsay seemed utterly transfixed by the specimens. As Peale recalled, Nathaniel told him that he "thought them so interesting . . . he would have gone 20 miles to behold such a collection." Flattering, but what really caught Peale's attention was when Ramsay added that he should add these bones to his gallery for "doubtless there are many men like myself who would prefer seeing such articles of curiosity than any paintings whatever, it would be little trouble to keep them, and the public would be gratified in the sight, at such times as they came to see the paintings." The bones were not Charles's to display and, a few years later, they would be sold to Dutch anatomist Peter Camper, but other such bones might be acquired, as could natural history specimens of all sorts. The idea of pairing art, particularly art capturing the early history of the republic, with natural history, such that they might complement each other in the eyes of a visitor to a future museum he might establish, set Peale's mind racing.

The timing was right. It was an age when curiosity about the natural world and how it worked was on the rise, when a new ethos out of Western Europe landed in America and made "the secular world its point of departure," historian Margaret Jacob notes, without necessarily denying "the meaning or emotional hold of religion." Curiosity cabinets, often elaborate hutches that housed everything from fossils and shells to artifacts from distant, still largely mysterious, cultures, were the rage and served as status symbols for the wealthy. Natural history was seen by many, including Peale, not just as a way

to classify and categorize the natural world, not only as a means for learning about medical plants and deadly plants along with the habits and locations of prey one was hunting, but as a manifestation of the Creator's glory. Art that focused on the recent revolution and break from Britain, on a new republic and its heroes, was a manifestation of man's glory. If he could bring all this together, for no one in the United States had as yet, making it of a piece at a grand scale, Peale saw an opportunity to both enlighten the public and generate an income.[39]

Soon Peale was approaching those whose opinions he valued most about the idea. His friend, David Rittenhouse, who in a few years would be president of the American Philosophical Society, was quite fond of the idea. However, he cautioned Peale "that while collecting and preserving subjects, you will neglect your pencil and consequently it will be a great injury to your interest in a pecuniary point of view." Robert Patterson, professor of mathematics at the University of the State of Pennsylvania, had no such fears and "much approved the plan." So enamored was Patterson that he "very obligingly presented [me]," Peale wrote, "a curious fish called the paddle fish caught in the Allegheny River." Just over four feet long, and described by the *Columbian Magazine* as a "a curious nondescript fish," it was the first of what would come to be tens of thousands of natural history specimens to reside in the museum: some like the paddlefish, great curiosities: others more mundane, but just as dear to Peale.[40]

Throughout 1784, Peale continued to paint miniatures and portraits, his primary income to feed the many mouths at home. While he did so, his vision was growing grander. To draw in more perspective patrons

and to make his museum-to-be potentially even greater in scope, he expanded the painting studio in the house so as to entertain visitors with "moving pictures with changeable effects," a sort of dynamic curiosity cabinet. These moving landscapes were produced by a device called an eidophusikon imported from England's Drury Lane, and the brainchild of Philippe de Loutherbourg. The eidophusikon employed still paintings, three-dimensional objects, backlighting, moving transparent colored strips, rotating colored glasses, and soundscapes of rain and thunder, produced by tambourines, copper sheets, and rattled boxes of shells and peas. The effects produced scenes like the sun rising in the early morning dew, a midday bird flight below the clouds, a sunset amid the fog, and the moon rising over an open field.[41]

Peale settled on showing four moving picture shows a day, including two evening performances, and charged an admission of one dollar (later lowered to half a dollar) to this part of his gallery. To maximize visual effects, he used a new kind of lamp that Franklin had brought back from his travels in Europe; and, to keep audiences comfortable, he installed 12 pasteboards fans that were a blessing for performances in the city's sweltering summers. The May 1785 premier performance of six moving pictures was set on a stage ten by eight feet long and six feet high, and included daylight breaking on a lovely field, birds singing, and "clouds . . . seen gathering in the horizon . . . a heavy rain accompanied with thunder and lightning . . . succeeded by a lovely rainbow." Though not a financial success, the effects were as intended. These moving pictures, Peale noted, were "visited by a great deal of company, generally much gratified with the changes produced in each piece."[42]

By July 1786, some two years after Ramsay sparked it all, and just a few months after the birth of his daughter, Sophonisba Angusciola Peale, 45-year-old Peale was ready. And so it was on the seventh of that month that Philadelphians opening the popular *Pennsylvania Packet* newspaper read:

> *Mr. Peale, ever desirous to please and entertain the public, will make part of his house a repository for natural curiosities. The public he hopes will thereby be gratified in the sight of many of the wonderful works of nature which are now closeted and but seldom seen. The several articles will be classed and arranged according to their several species; and for the greater ease to the curious on each piece will be inscribed the place from whence it came, and the name of the donor. . . .*
>
> *Mr. Peale will most thankfully receive the communications of friends who will favor him with their assistance in this undertaking.*
>
> *Corner of Lombard and Third Streets, Philadelphia*[43]

The museum, his "repository for natural curiosities," at various times called Mr. Peale's Museum, the Philadelphia Museum, Mr. Peale's Philadelphia Museum, and even, on occasion, the American Museum (though we will avoid that usage), was open for business. No place was better suited for such an enterprise than Philadelphia. "There were few cities," Peale would later note, "that contribute to enlarge the facilities of enquiring minds as Philadelphia." Still, it

was a risky, audacious unveiling. The portraits and moving pictures, though constantly growing in number, had been in place for years, and the natural history collection would quickly grow, and was one of the first to be organized by scientific principles. However, when the doors opened in the summer of 1786, it was largely Patterson's curious paddlefish, and assorted fairly common specimens that Peale himself had collected or hunted—waterfowl, fish, turtles, lizards, snakes, deer, fox, raccoon, squirrel, shells, and rocks—that made up the bulk of the exhibited items.[44]

From the outset, Peale envisioned this place evolving into an Enlightenment temple, a place to "bring into one view a world in miniature." It was to be a new creation for the public, born both of art and science, a mecca of rational amusement, and an homage to the original Greek meaning of museum (Μουσεῖον), a "seat of the muses." Art was to capture history, particularly of the new country, or to be coupled with natural history. Specimens, be they animal, mineral, or ethnographic, were not to be grouped haphazardly, but rather classified by principle. And it was to be a collaborative effort, with Charles turning to his fellow citizens to contribute what they could, be it specimen or knowledge. These appeals would often be made in newspaper advertisements. Each year, Peale would publish dozens of such ads: ads that would include not just a call for specimens, but lists of new specimens received of late, information about new exhibits, changes to museum hours of operation, and perhaps strangest to our eyes, praise or admonitions of the way the public was responding to activities at the museum.

Peale's natural curiosities call-to-arms yielded immediate results.

Two of the first to contribute were Franklin, who sent his friend the body of an angora cat that he received from Madame Helvétius when he had left Paris, and Washington, who sent the body of a just-deceased golden pheasant from the aviary of Louis XVI that the general had received as a gift from the Marquis de Lafayette. As the museum grew, it would begin to amass not just a vast collection of birds, mammals, fish, insects, amphibians, reptiles, and botanical material, but anthropological material, minerals, manufactures, crafts, inventions, coins, antiquities, and on rare occasion, as "such subjects are not always agreeable to the sight," specimens of *lusus naturae*, that is, sports of nature and freaks. Soon there would be lectures and live experiments in chemistry and electricity, often accompanied by music.[45]

The museum was also a business, soon to be Peale's primary source of income. Admission was set at 25 cents, on par with and often less than admission to the theatre, a concert, or the circus, and about the equivalent of an hour's labor for the average Philadelphian. The first museum ticket had its work cut out for it, to somehow capture the gestalt of it all. Etched by Peale himself, along the periphery are sketches of pelicans, monkeys, alligators, and more, with trees and a shallow body of water in the background. Atop the ticket sat a book emanating rays of light and inscribed "NATURE." Peale the deist and child of the Enlightenment wanted his museum to be both a tribute to rationality and an homage to a long-inactive God of first causes, and so below the Book of Nature sits a banner paraphrasing Job—"The Birds and Beasts will Teach Thee." On the bottom half of the ticket was a call-out to the hybrid nature of what the visitor would encounter:

"Containing the wonderful works of nature," on one line, and "Curious works of art" on the next. For a piece of paper two by three inches it did a respectable job of depicting Peale's grand vision "[to] enlighten the minds of my countrymen and demonstrate the importance of diffusing a knowledge of the wonderful and various beauties of Nature" and to "render the Institution a lasting honor and benefit to America."[46]

CHAPTER 2

To Humanize the Mind

YOU WILL SCARCE GUESS HOW I EMPLOY MY TIME;
CHIEFLY AT PRESENT IN THE GUARDIANSHIP OF EMBRYOS AND
COCKLESHELLS. SIR HANS SLOANE IS DEAD, AND HAS MADE ME
ONE OF THE TRUSTEES OF HIS MUSEUM . . . HE VALUED IT AT
FOURSCORE THOUSAND AND SO WOULD ANYBODY WHO LOVES
HIPPOPOTAMUSES, SHARKS WITH ONE EAR, AND SPIDERS AS BIG
AS GEESE! . . . WE ARE A CHARMING, WISE SET, ALL PHILOSOPHERS,
BOTANISTS, ANTIQUARIANS AND MATHEMATICIANS; AND
ADJOURNED OUR FIRST MEETING BECAUSE LORD MACCLESFIELD,
OUR CHAIRMAN, WAS ENGAGED TO A PARTY FOR FINDING OUT
THE LONGITUDE.

— Horace Walpole to Sir Horace Mann,

February 14, 1753

Peale's museum was the first concerted American effort at what we would today call a museum for the general public, but many Americans, especially those in Peale's social strata, would have heard tale of other museums, both successful ones abroad and not-so-successful attempts at home.

The storied British Museum was born with the death of 93-year-old Sir Hans Sloane. A physician and natural historian, Sloane served as president of the Royal Society, and was friends with the likes of Franklin, Handel, and Voltaire. Sir Hans, a tall, affable fellow, was a collector of the first order. Over nine decades, he had amassed a library of 50,000 manuscripts and books, 23,000 coins and medals, a large collection of paintings from Europe, Japan, and Persia, antiquities, weapons, mathematical instruments, and artifacts from indigenous societies from all around the globe. Sloan also had a natural history cabinet stocked with samples he had collected himself in Jamaica, as well as collections he purchased wholesale from others. Upon visiting the collection at Sloan's mansion in 1748, Frederick, Prince of Wales, exclaimed, "It is a great pleasure to me to see such a collection in England." He added, significantly: "It is an ornament to the nation. Great honor would redound from the establishing of it for public use."[1]

Upon his death in 1753, Sloane's last will and testament directed "that for the promoting of these noble ends, the glory of God and the good of man, my collection in all its branches may be, if possible, kept and preserved together whole and entire . . . that the same may be, from time to time, visited and seen by all persons desirous of seeing and viewing the same . . . that the same may be rendered as useful as possible, as well as towards satisfying the desire of the curious, as for the improvement, knowledge and information of all persons." Soon thereafter, by an act of Parliament, the British Museum, which included Sloane's collections, as well as the libraries of Robert Harley, the First Earl of Oxford, and Sir Robert Cotton, was born.[2]

The museum had departments of Printed Books, Natural and

Artificial Productions, and Manuscripts, and a staff of librarians, curators, porters, messengers, and housemaids. When it opened in 1759, at Montagu House, Great Russell Street, a new type of space was born. There were no British national public museums open and free to the public as this one was. Indeed, the only other museum to speak of in all of England was the Ashmolean Museum at Oxford, which had opened in 1683, seven years after Elias Ashmole donated his collection to the university. The Ashmolean housed natural history exhibits on the first floor, a lecture hall on the ground floor, and an anatomy theatre and chemistry lab in the basement.

The British Museum would have a dual purpose: to enlighten the general public and at the same time, provide a repository "for the use of learned and studious men, both natives and foreigners, in their researches into the several parts of knowledge." Soon such learned and studious men as Sir William Blackstone and David Hume were drawing on the museum's collection for their studies.[3]

Balancing the two aims caused a number of hiccups early on, but soon a system was worked out: the museum would be accessible six hours a day from Monday to Friday. Ten tickets per hour were issued and groups were taken on a guided tour through the collections by an under librarian. After a brief stop in the reception room, visitors were led up the stairs to the east end of the building, which housed five large rooms of books and manuscripts, and then to a corner room which housed the exquisite coins and medals of the museum, of which a portion was reserved to exhibit Sloane's collection of medals. Next came the antiquities, and then a series of antechambers and foyers where the natural history collections lay. Then using a second staircase,

visitors headed back down to the ground floor and the stunning portrait collection there. If nine-year-old Wolfgang Amadeus Mozart's "God is our Refuge," which he wrote as a gift to the museum upon visiting, was any indication, people did not soon forget their visit.

A large-scale public display fusing natural history, the arts, and antiquities was not the European model. Monarchs had long amassed works of art and the like for their courts and to bedazzle visiting dignitaries, but these were rarely accessible to the general public. And European natural history collections, often royal in patronage, typically had a dual mission—to impress foreign and homegrown dignitaries and to sponsor research, as was the case for Parisian Jardin du Roi (Garden of the King) and the associated Cabinet du Roi (Natural History Cabinet of the King), which together morphed into the Muséum National d'Histoire Naturelle in 1793.

Louis XIII created the Jardin du Roi, originally called the Royal Garden of Medicinal Herbs, in 1626. In time, it grew to cover 20 acres with large plots broken up by meandering walkways. Its mission grew along with it. By the middle of the 18th century, the jardin was a living work of art for the king to enjoy and flaunt. It was also a university of sorts, training botanists and physicians with a bevy of demonstrators and professors, and an early research lab tapped for practical application. Samples came from Asia, Africa, and Central America, as well as Europe. Eye-popping flowers laid out for maximum visual effect swamped the senses; melons, beans, and the like added to the panoply of colors at appropriate times of year, all alongside cherry trees, apricot trees, peach trees, fig trees, and much more. Horticulturists at the

jardin studied the medicinal applications of some species and worked with others to domesticate them for life in French soil.[4]

Those fortunate enough to be invited to the Cabinet du Roi, located in a building on the grounds of the jardin, were, as intended, awestruck and dazzled. The thousands of specimens included "the yellow parrot of Cuba, the jabiru, a large fishing bird from China, twice the size of the biggest Stork . . . the promerops of Guinea, coal black, about the size of a magpie, with a tail two-foot long and wings bordered with the brightest green." Peale, though he never visited, was in awe of this museum, calling it "undoubtedly the first," that is, the best "museum in the world." He would soon develop important contacts there, and he was especially impressed by the fact that there were a dozen or so professors employed at the museum.[5]

Georges-Louis Leclerc, the Comte De Buffon, was the most famous curator of both the jardin and the cabinet. Study of the specimens in the Cabinet du Roi would provide him with some of the data he would use to compose his famous *Natural History: General and Particular*, a 36-volume encyclopedia. It included an argument—hundreds of pages long—on why life, both animal and indigenous people, in the New World was degenerate compared to that in the Old World. Peale knew Buffon's work well, citing it often, and aside from Buffon's degeneracy claims and his atheism, Peale had great admiration for the count.[6]

The Royal Swedish Academy, with whom Peale would soon be swapping samples, also housed a large natural history collection. Still, most Philadelphians, even those with means to sail across the Atlantic, had not actually visited the British Museum, the gardens and cabinets in Paris, or the Royal Swedish Academy. At home, the few precursors

to Peale's museum were far more modest than the ornate, grand halls of Montagu House or the lush botanical wonders of the jardin.

One of those precursors was the Charleston Museum, an offshoot of the Charleston Library Company established in January 1773. The initial solicitation from the museum envisioned that one day it would be filled with samples from "every species whether terrestrial or aquatic . . . with the best accounts of their customs and natural habitudes." Though the original accession lists are lost, contemporary accounts suggest the museum did not live up to initial expectations, housing a hodgepodge of natural history specimens, "instruments and apparatus for astronomical and philosophical observations and experiments," "elegant globes," an Egyptian mummy, and other objects that were primarily for use by Library Society members. The library, with its six thousand volumes, and the museum both suffered severe damage in a fire that spread across Charleston on January 17, 1778.[7]

Philadelphians would have been more familiar with another precursor to Peale's museum in their own city: Pierre Eugène du Simitière's short-lived museum on Fourth and Arch Streets. Born in Geneva in 1737, du Simitière was an artist, natural historian, and inveterate collector. At age 20, already conversant in Dutch, French, German, and Latin, and with a passable handle on English, du Simitière embarked on a series of adventures that took him to almost all of the islands of the West Indies, where he collected natural history, anthropological, and archeological specimens and relics. He also churned out hundreds of drawings and descriptions of everything from the birds of Jamaica and San Domingo to the worms, mosses,

fishes, snakes, insects, and monkeys of the islands, with the ultimate goal of producing a guide to the natural history of the region. In the 1760s, he would at times pause from this work in the West Indies to visit New York, Boston, Charleston, Newport, and Philadelphia. In 1770, he settled in Philadelphia for a two-year stretch, supporting himself by painting commissioned portraits and making a name for himself as an artist and natural historian. After one more sortie to the West Indies from 1772 to 1774, he returned to make Philadelphia his permanent residence.[8]

Though he would never achieve the community standing Peale did, du Simitière, largely as a result of his talents as a portrait painter and illustrator, began to make friends and build connections in Philadelphia, even serving as art teacher to Thomas Jefferson's young daughter, Martha (Patsy). His illustrations and general artistic talents drew attention. When the Continental Congress appointed Jefferson, Adams, and Franklin as a committee to design a seal for the United States, this troika turned to du Simitière for his thoughts on such a seal. Writing to Abigail shortly after that, John told her, "This Mr. du Simitière is a very curious man . . . a painter by profession whose designs are very ingenious, and his drawings well executed." Though du Simitière's specific design was ultimately not selected, elements of a later revision he sketched, which included the eye of Providence and the motto "E Pluribus Unum," were eventually incorporated into the Great Seal.[9]

Du Simitière's reputation, primarily as an artist, but also as a collector and natural historian, continued to grow. He was elected a member of the American Philosophical Society and chosen as one

of the curators of their collections. Though Peale painted numerous earlier portraits of Washington, du Simitière was commissioned to paint the general in 1779 and is credited with the first profile of the great man. Washington wholeheartedly approved of the end product, and it served as the template for the 1791 Washington penny.

As he illustrated and painted, du Simitière solicited friends and colleagues to send him whatever articles they could spare for his growing natural history cabinet. He received a "very obliging offer to assist in [his] collections of American curiosities" from General John Sullivan. In reply, du Simitière bombarded the general with a laundry list of requests, including not just "the curious and rare bird the crossbill found in the pine forest of your state" but also "ores, crystals, marbles, talcs, colored earths . . . the petrifications of animal parts . . . antiquities of the Indians . . . such as their cooking vessels of stone and earthenware." As early as 1775, men like Richard Smith, a representative to the Continental Congress, would note of "amus[ing] myself all the morning in M. du Simitière's, perusing his collections and his portraits." In April 1782, at the behest of friends, buoyed by his recent honorary degree bestowed by the College of New Jersey, and in part because he was in severe debt and in need of funds, du Simitière opened the doors to what he dubbed the American Museum, located at his home on Arch Street. He was four years ahead of Peale.[10]

Published in the *Pennsylvania Packet* on April 18, 1782, du Simitière's first advertisement for the American Museum is tepid and nondescript and appears to be aimed more at his friends who had already visited his cabinet than the vast majority of Philadelphians who had not. No details of the museum's contents are provided. Instead, du Simitière

simply notes that lack of space in the advertisement prevents his "giving a syllabus at the present time." Du Simitière spent more space delineating the restricted hours of operation of 11:00 a.m. to noon and 3:00 to 4:00 p.m. on Tuesdays, Thursdays, and Saturdays, and group size, which he hoped would "not exceed six," than to any other matter in the advertisement. Admission was 50 cents.

While no record books from the American Museum exist, it appears the initial advertisement failed to draw in visitors. His second advertisement, which appeared six weeks later, included much-expanded museum hours, and readers saw a new pitch that was as dynamic and salesman-like as the first was static and pedantic. Du Simitière opened with the exotic, informing readers they would be treated to a collection from not just America, but also the West Indies, Africa, the East Indies, and Europe. The advertisement ended with Du Simitière leaving no doubt as to his grand intention: "he intends his cabinet to be hereafter the foundation of the first American museum." Without accession lists, it is difficult to estimate how many natural and artificial curiosities were actually present or how they were organized, but based on descriptions of visitors and the estate sale at du Simitière's death, which lists only five lots of "curiosities" and nine lots of drawings and prints, it's likely that the absolute number of specimens ran low.[11]

Peale knew of du Simitière's American Museum, though it is not certain whether he himself visited or simply read or heard of it. If we are to take him at his word on assessing a venue that some would view as the predecessor to his own, Peale was not especially impressed. Years later, when he retired at his country estate, he wrote his son Rembrandt that he had become: "acquainted with Mr. Semitere [*sic*]

a miniature painter, he was fond of collecting subjects of natural history . . . in his latter time he made a sort of museum displayed in one or two rooms . . . he received a small sum for admission."[12]

Others expressed similar sentiments, suggesting a venue worth a visit, but not exceptional. Baron Ludwig von Closen made note of the many "fine things" there. The Marquis de Chastellux, visiting shortly before the official transition to museum, and no doubt biased by the comparison he would be making to the jardin, described it as "a cabinet of natural history . . . small and scanty," noting "it is greatly celebrated in America, where it has no rival." Still, even the critical de Chastellux noted he "satisf[ied his] eyes." Johann David Schoepf, a visiting German physician, was a bit more generous, describing a "collection, a small one, of natural curiosities and a not inconsiderable number of well-executed drawings of American birds, plants and insects." Though none of these assessments were glowing, the very fact that many foreigners made a point of stopping at the American Museum suggests it was considered a place of note.[13]

Du Simitière's writings suggest the fortunes of the American Museum would vacillate, at times providing him with sufficient income to meet his needs, and at other times not. In the spring of 1783, income from the museum and his work as a painter/art teacher was insufficient to cover his expenses, and his landlord was pressing hard for the quarterly rent. Then on March 16, 1783, the top joint of one of the fingers of du Simitiére's left hand had to be amputated due to an illness, severely curtailing his painting and any income that was providing. Soon after that, du Simitière's letters and diary all but dry up, but what does remain is evidence of a depressed, desperate man: a

man whose mind, as du Simitière writes of himself, is "on the rack." In October 1784, 47-year-old Pierre Eugene du Simitière died, and along with him, his museum. Du Simitière was buried in an unmarked grave in Saint Peter's churchyard, and the contents of his museum, including the aforementioned lots of curiosities and artist works, plus 18 lots of his books, were sold at auction.[14]

The time was ripe for a place like Peale's museum. And Philadelphia, home to the Continental Congresses and the hallowed hall where the Declaration of Independence had been signed, and a city that would host the Constitutional Convention and become the temporary capital of the country in a few short years, was the ideal place for such an enterprise.

Optimistic and bustling with thought and action, Philadelphia was also the unrivaled economic capital of the country. It was soon to be home to the First Bank of the United States, the United States Mint, and the first stock exchange in the country. Science was in the air there. Thomas Paine noted, "almost every Philadelphian, it seemed, had some scientific interest or business." A new sense of freedom, tied to the passion that many Philadelphians, particularly those in power, had for Enlightenment ideology, was creating a city where politics, commerce, education, and entertainment were on the move alongside freedom, equality, and compassion.[15]

An appetite for the written word is often part and parcel of such a society, and Philadelphians had a voracious appetite for books and newspapers. In a city of about 28,000, there were 40 bookshops, printers, and publishers: the equivalent of approximately two and a half

thousand such establishments in modern Philadelphia. During the 1780s and 1790s, bookstores largely carried imported editions, though with time, more and more homegrown titles would stock their shelves. With the vast majority of the population being literate, Philadelphians had their share of genres to choose from. The year before Peale opened his museum, Robert Bell's bookstore, on Third and High Street, seven blocks north of Peale's museum, carried an inventory of well over a thousand titles.[16]

Philadelphians also had dozens of newspapers, gazettes, and chronicles to turn to for information on domestic and international affairs. Peale would make great use of many of these to advertise his museum, with a heavy reliance on the *Pennsylvania Packet*, the *Federal Gazette*, the *Freeman's Journal*, the *Independent Gazetteer*, and the *Aurora General Advertiser*.

Their passion for the written word, and more generally, the quest for knowledge among Philadelphians, manifested itself in both formal and informal settings. Informally, there were coffeeshops, like the London Coffee House on the corner of Front and High Streets, which often stocked the latest newspapers and pamphlets. And there were the 175-plus taverns, ranging from establishments wherein inebriation, brawling, and prostitution ruled the day (and night) to those regarded as public debate spaces. The latter included the Indian Queen, the George, the Black Horse, and most important of all, the City Tavern, "the most genteel one in America," as Adams called it, on Second Street between Walnut and Chestnut Streets, just a minute walk from the museum.[17]

Peale's Philadelphia was also home to more formal venues for

expanding the mind via the written word. The most famous was Benjamin Franklin's Library Company, which had already been operating for more than 50 years when Peale opened his museum. In 1790, the company moved to its new building on Fifth Street facing the State House, just a few blocks from Peale's museum. Peale would make use of the Library Company on many occasions, borrowing such items as Pennant's tome *British Zoology* and Pulteney's *General View of the Writings of Linnaeus*. He and the museum would also be involved in fossil swaps with the company, including one that yielded a mastodon bone from the library's collection.[18]

Franklin's Renaissance-man imprint was stamped on two other institutions that would come to shape intellectual life in early Philadelphia. One was what eventually became the University of Pennsylvania. In time, when Peale presented a month-long series of 40 lectures on natural history, he turned to the University of Pennsylvania for use of one of their lecture halls as a venue. The other institution that would come to be linked with Peale's museum in both direct and indirect ways was the American Philosophical Society. After some difficulties establishing itself in its early years, by the late 1760s, the American Philosophical Society had become a centerpiece of enlightened Philadelphia, and its members shared their results with learned societies the world round (and vice versa). The society's library became one of the most important in the early United States, its displays of new mechanical devices were world class, and its membership rolls boasted not only the leading scientific thinkers of the day (including Peale, starting in 1786), but the likes of Washington, Jefferson, Paine, Madison, and Lafayette. The state of

Pennsylvania granted the society a charter in 1780 and then deeded the society land in what is now modern Independence Square. When Peale was elected a member of the American Philosophical Society just a few weeks after his museum opened, he was granted "all the rights of fellowship with all the libraries and privileges thereunto belonging." He would avail himself many times in what would become an evolving complex relationship between Peale's own "school of wisdom" and the American Philosophical Society.[19]

When Peale opened his museum's doors, the citizens of Philadelphia suffered no lack of alternative leisure activities, from the refined to the spectacular. It was a time and place where, in the words of the Pennsylvania General Assembly, "rational and innocent amusement . . . affords a necessary relaxation from the fatigues of business [and] is calculated to inform the mind and improve the heart." Even outside the typically, though surely not always, convivial atmosphere of the coffeehouses and taverns, there was plenty to do. On the spectacular end, there were automata to be seen, such as those on display at the Young Ladies Academy on Cherry Alley, a small wax museum whose physician proprietor displayed different stages of human development using sliced wax figures, and also firework shows aplenty. And then there was ballooning, which captured the fancy, and sometimes sparked the anxiety, of many a Philadelphian.[20]

Philadelphians did not need to look skyward for spectacle. It was not hard to find small-scale freak shows featuring acts such as "The Invisible Woman," or "The Learned Pig" at Cook's House on High and Third Streets. For a quarter, one could gaze at said pig who "will read

write, spell, tell the hour of the day, distinguish colors, the number of persons present . . . and what is more astonishing, any lady or gentleman may draw a card and keep it concealed, and the pig, without any hesitation, will discover the card from another pack."[21]

The circus, initially linked to equestrian derring-do, was also coming into its own. Americans loved their horses, and circuses were a new addition on that front, adding to the pony races that were common in Philadelphia. The August 25, 1785, issue of the *Pennsylvania Packet* described a certain Mr. Pool as the "first American that ever exhibited the equestrian feats of horsemanship," and provided a description of his upcoming performance near Centre House. It was not long before there were larger touring circuses, like the Lailson Circus and John Bill Ricketts Show, with its 90-foot-tall circus tent, that, in addition to clowns and horses, had a rope dancer by the name of Seignior Spinacuta. No less than George Washington, who attended a performance during Ricketts's premier season in Philadelphia, noted how impressed he was by the spectacle.

If circuses and ballooning were a bit too rambunctious, there were more refined options. Dance lessons were to be had at Duport's on Second Street, and a "French School for Boys" was just over on Walnut Street. Music was everywhere, from the living room to the drawing room to more organized concerts, like the March 18, 1784, event organized at Lodge Alley and advertised in the *Pennsylvania Packet*: 10 shillings provided a lady and her gentleman a double concerto for violin and flute, followed by a ball. Churches often doubled as concert halls. The same year that Peale opened his museum doors, "The Grand Concert" was held at the Old Reformed Church on the corner of Race

and Fourth Streets, a leisurely stroll from the museum. The concert involved about 280 performers playing to an audience of nearly 1000. Tickets were two-thirds of a dollar, and all net proceeds went to the Pennsylvania Hospital, the Philadelphia Dispensary, and the Overseers of the Poor, whose job it was to help the indigent.

There was also the theatre, with the earliest companies of the 1750s performing on Plumstead's ramshackle warehouse stage on Water Street. By the time Peale's museum was operating, plays and other theatrical performances could be seen at any number of theatres, from the Southwark to the more splendid Chestnut Street Theatre on Sixth and Chestnut Streets three blocks east and six blocks north of the museum. The Chestnut Street Theatre had three galleries seating more than 1,100, parquet floors, and a French lighting system with oil lamps that could be adjusted based on the ambiance of the scene at hand. The theatre featured performances of everything from the *Roman Father, or Deliverer of his Country* to the more farcical *Tony Lumpkin in Town*.

Those drawn to art for their leisure time dalliances were more than at home in Philadelphia, which had its share of artists, whose homes would often serve as makeshift studios or galleries. Directories from 1785 list more than two dozen such artists, including Peale. Lessons were also available for the would-be artist.

If all these leisure activities were not sufficient, Philadelphians with deep enough pockets could go elsewhere for entertainment. Just five blocks from the museum, a daily 4:00 a.m. coach left from the Indian Queen Tavern to New York along what had been known as King's Highway and another departed daily to New York City from a Mr. Paul's, as well as a 5:00 a.m. coach to Baltimore, departing the Indian

Queen each Monday, Wednesday, and Friday.[22]

Philadelphia was, in many ways, a grand and relatively enlightened place to live in the late 1700s. Yet the city into which Peale planted his museum was no utopia. There was slavery, which though not as pervasive as in southern cities, was just as real for the 210 men and women treated as human chattel and listed as slaves in the 1790 census. The Philadelphia-based Society for the Relief of Free Negroes Unlawfully Held in Bondage, often called the Abolition Society, had long fought to blot out slavery, but progress was slow. The society first met at the Rising Sun Tavern in 1775, and spurred Pennsylvania's 1780 Act for the Gradual Abolition of Slavery, one of the earliest of its kind. The *gradual* nature of the act was such that though adult slaves were not freed, children born to slaves from that point forward were freed in the sense that they were not to be considered chattel, but instead, until age 28, assumed the role of indentured servant to their mother's owner.[23]

Peale's own relationship to slavery, and in particular to the Act for the Gradual Abolition of Slavery, is complex, and serves as an example that he could be slow to adopt the Enlightenment ideals that he so often professed. He often contributed to the Society for the Relief of Free Negroes and bemoaned that "the very idea of slavery is horrible." When he was a member of the assembly, he had been part of the committee that drafted the Act for the Gradual Abolition of Slavery. Yet, at the very moment that Peale was championing that bill, he owned two slaves, Lucy and Scarborough, who he had acquired when living in Maryland, likely in exchange for his service as a portrait painter. In 1786, the same year that his museum opened, Peale emancipated Lucy

and Scarborough, who took on the surname Williams, but their nine-year-old son, Moses, remained part of the Peale household. Because Moses was born before the enactment of the Act for the Gradual Abolition of Slavery, he was still considered property, but Peale treated Moses as an indentured servant until Moses turned 27. In time, Moses would take on a unique role in the museum, initially as a servant and later as a free man.[24]

It was not just slavery that tarnished Philadelphia. Crime, though often localized, could be rampant. Poverty was real, with almshouses receiving more than a thousand applicants a year and, depending on how statistics are calculated, somewhere between one in twenty to one in three people receiving some sort of public aid. Drunkenness was commonplace, with many living by the words of the old ditty "Here's but one good reason I can think why people never cease to drink, sobriety the cause is not, nor fear of being deem'd a sot, but if liquor can't be got." Philadelphians need not have worried about what could be got, as their city had more taverns per capita than most leading European cities. Then there was the smell. The products from tanneries, distilleries, and other such places mixed with human and animal excrement and created a stench that, during the unbearably hot and humid summers, felt as if it hung in the air, ready to wrap itself around anything that ventured onto the streets.[25]

It was in this city, enlightened, but not without blemishes, that Peale, also enlightened, but not without blemishes, opened the doors to his museum.

The first visitor description of Peale's museum comes from the

Reverend Manasseh Cutler, a respected naturalist of the day, who had gained fame for his bravery as a chaplain during the Revolution. After learning of the museum from New England pastor and intellectual Jeremy Belknap, Cutler's curiosity was piqued, and he visited Philadelphia in July 1787, the summer of the Constitutional Convention. In his July 13 diary entry, Cutler tells of an evening stroll that he and Gerardus Clarkson took to Third and Lombard where they "called on Mr. Peale to see his collection of paintings and natural curiosities." These, along with the material for the moving pictures, which had come to include vocal and instrumental music between acts, were all housed in the sky-lit gallery at the rear of the house, which now ran 77 feet long, as Peale had extended its length in 1784. Though no blueprints survive, hints from visitors suggest that they could enter the galley by a separate door from the entrance to the house, while Peale and his family could also enter from within the house. The galley struck Cutler as a site that produced "a most astonishing effect. It is very long but not very wide, has no windows . . . but is open up to the roof, which is two or three stories, and from above the light is admitted in greater or less quantities at pleasure." The walls were covered with portraits, and because Cutler knew many of the subjects personally, he could vouch for their accuracy. He was especially taken by the full length, "nearly as large as life" portrait of Washington that graced the wall at the upper end of the gallery.

At the opposite end of the gallery from Washington sat the natural curiosities "arranged in a most romantic and amusing manner." At the center were two rudimentary dioramas—a mound with trees and an

artificial pond, each showing the results of Peale having spent many a morning "dressing the museum in moss." The pond was stocked with fish, geese, ducks, cranes, herons, and more, "all having the appearance of life, for their skins were admirably preserved." On the beach around the pond Cutler was dazzled by an assortment of "shells of different kinds, turtles, frogs, toads, lizards, water snakes, etc." On the nearby mound diorama sat a partridge and quail, a bear, deer, wildcat, fox, raccoon, rabbit, squirrel, and more. "In the thickets," Cutler records, were "land-snakes, rattle-snakes of an enormous size." This mound housed a tree whose branches "were loaded with birds, some of almost every species in America, and many exotics."

Peale knew that though "It is not the practice . . . in Europe to paint skies and landscapes in their cases of birds and other animals," it was done on occasion, and he thought it "pleasing to see a sketch of a landscape, in some instances the habits of the animal may be also given." Peale's dioramas were the first expression of his deep-seated belief that simply displaying an animal did not do it justice, that he needed to fully convey "their manners and dispositions," and capture a sense of place, of harmony, of community. The mound display also presented a lesson in geology, a tribute to the ground upon which nature plays itself out, as Peale had dug holes and exposed the strata and minerals therein "to show the different kinds of clay, ochre, coal, marl, etc., which he had collected from different parts; also, various ores and minerals."

Mixed in with all this, Cutler tells of a humorous encounter he and Clarkson had with a wax figure. As Cutler tells it, upon entering the museum and seeing a wax statue of Peale, "standing with a pencil in

one hand and a small sheet of ivory in the other, and his eyes directed to the opposite side of the room, as though he was taking some object on his ivory sheet," they mistook it for the real man. Though the story is likely embellished for effect, it nonetheless introduces one of the many well-executed wax displays that Peale would produce and display in the museum.[26]

As Cutler prepared to leave the museum, Charles, as was his wont, asked that his visitor "favor him with any of the animals and fossils from this part of America, not already in his museum, which it might be in my power to collect." Peale would have been pleased had he the chance to read Cutler's diary entry later that day, which ended "Mr. Peale's animals reminded me of Noah's Ark, into which was received every kind of beast and creeping thing in which there was life. But I can hardly conceive that even Noah could have boasted of a better collection."[27]

The museum was in its infancy, but Peale's vision for it was not. He saw his creation as rational amusement at its best. "Human nature is such that amusements are absolutely necessary to contentment . . ." he wrote, "therefore such exhibitions as blend amusement with instruction are most valuable." From the moment its doors opened, the museum had many interconnected missions. His "world in miniature," was meant as a means of employing rational amusement as a tool to teach his countrymen "the importance of diffusing a knowledge of the wonderful and various beauties of Nature . . . to humanize the mind, promote harmony and aid virtue." He believed such a place would foster a public "learned in the science of nature, without even

the trouble of study," as well as serve as an ever-growing accessible repository for scientists and philosophers. If done properly, Peale wrote in a newspaper article, "To the Citizens of the United States of America," it would be "useful in advancing knowledge and the arts, in a word all that is likely to be beneficial, curious or entertaining to the citizens of the new world."[28]

From a utilitarian prospective, Peale believed the museum would promote an understanding that natural history had lessons to teach above and beyond what plant was poisonous or how to best hunt a rabbit. "The farmer ought to know that snakes feed on field mice and moles," he told visitors, "which would otherwise destroy whole fields of corn." Peale was fond of recounting the true tale of a New England village where, to stop the damage from purple grackles feeding in their fields, villagers were paid three shillings for every dozen grackles they killed. Only after extirpating the local grackle population did they learn that these birds had been keeping "the larvae of noxious insects" under control, in effect providing a benefit that far exceeded any grain they gobbled. If those New Englanders would only have had a sound grounding in natural history, precisely what visitors to his museum would be given, they would not have made the mistake they did. And it wasn't just farmers who had much to learn from natural history as it was conveyed in the museum. "To the merchant," Peale proclaimed, the "study of nature is scarcely less interesting, whose traffic lies altogether in materials either raw from the stores of nature or wrought by the hand of ingenious art. The mechanic ought to possess an accurate knowledge of many of the qualities of those materials with which his art is connected." If all those utilitarian pluses were insufficient, natural

history, he argued, was also "a powerful means of every aid to . . . those studying the medical art," teaching them comparative zoology.[29]

Peale bemoaned European museums that reach "particular classes of society only, or open at such turns or at such portions of time, as effectually to debar the mass of society, from participating in the improvement, and the pleasure resulting from a careful visitation." That would not happen in *his* museum, which would be open to all—"the unwise as well as the learned." And not only unschooled and learned adult males. Both because he held progressive views on women and children, and because he knew that a family-friendly venue would attract more visitors, Peale reached out to bring women and children into his museum.[30]

Women were not only encouraged to visit the museum, Peale wanted them to contribute to the enterprise, sending in samples and sharing ideas. Society, he believed, raised roadblocks to women "which allow no time for them to devote in the arduous pursuits of science," but, he was quick to point out that "when females have devoted themselves to these pursuits they have given every demonstration of the intensity and depth of their intellectual powers." He wanted to tap into those powers to better the museum and the plight of women. For women who were not yet aware of either their potential or the potential of the museum, he was not above using witty satire to awaken them, as in this fanciful, fictional dialogue, almost surely written by Peale, which appeared in the *General Advertiser* newspaper on September 8, 1792:

Charlotte: It is very surprising that we should not before today have enjoyed the rational entertainment of Mr. Peale's Museum, though we

have frequently seen it mentioned in the gazettes: How many innocent and improving pleasures do we lose by mere indolence!

Maria: Say rather, my dear, our frivolity: for we young ladies are more inquisitive after the gay toys of the shops, than the beautiful wonders of nature.

Celia: True enough. I am ashamed of our silly taste: but hereafter I shall prefer the crest of the Cocatos, to the loftiest cap, and respectfully lower my cushion before the Wissent.

Charlotte: And I shall never again sigh for jewels, because the costliest of them would never make me a rival of the Diamond Beetle.

Maria: Nor shall I ever be tempted to set of my cheeks with rouge, after having seen the crimson glow of the hummingbird.

The museum, with exhibits that Peale wrote "speak in a universal language," was a perfect educational tool for teaching the young. He was pleased with "A lover of Nature," who wrote in the *Pennsylvania Packet* that "parents may regard Mr. Peale's Museum as a school of education for their children." To facilitate that, admission for children was sometimes free, and it was always significantly less than for adults. At times he had special children's tickets printed as mementoes for his smallest of visitors, and much later on he declared the museum a safe haven for lost children.[31]

It wasn't just women and children and the normal stock of men.

The museum was open to visitors regardless of religious persuasion. It was to be "a pure source of delight to the votaries of every denomination of religion," Peale declared, "nay it is a powerful aid to the truly religious mind." Politics were to be checked at the door. "I wish to be understood," he wrote, "a museum can have no more to do with the politics of a country, than with particular religious opinions. It has a much broader bottom." Indeed his museum might even be a catalyst to heal political wounds, for there he believed "the opponents in politics, may accidentally meet, and while viewing such interesting objects, naturally hold some converse, and perhaps, by some congenial sentiments, may insensibly forget their personal prejudices."[32]

Peale's museum would soon become his main source of income, and though he understood that all too well, the notion that he should profit from it was a sensitive point, and he would often feel obliged to justify profits as a byproduct of the greater good. "I have always declared [the museum] was designed for benefit of America," Peale wrote. "Have I not been persevering more for the public good than for my own emolument?" Such a public good, he was convinced, "ought to become a national concern, since it is a national good," and hence should grow into federal, or at the very least, state sponsorship, for "the very sinews of government are made strong by a diffused knowledge of this science."[33]

Peale's first mention of state or federal support to people in power is cryptic. Writing George Washington just months after the museum opened, he reminded the general that his museum would help put the United States on the international science stage, allowing the young nation "to retain with us many things really curious which would

otherwise be sent to Europe." Follow-up letters to Washington a few years later were more explicit, with Peale telling Washington, by then president, he hoped that one day the museum would be under congressional "patronage."[34]

For the moment, Peale's quest that the museum become a state or national one was a lofty aspiration. Over time it would become an obsession.

So many of the museum's missions were tied to Peale's deism. That deism, with its long-inactive God of first causes, when applied to natural history, shared much in common with brands of religion that held tight to the notion of divine revelation and an active, intervening God. Both believed, with supreme confidence, that the animals and plants they saw around them were not just designed by God, but a manifestation of God's power and his perfection as designer and architect. For Peale, an understanding of natural history opened a window, at least as far as it could be opened for mortals, to the very essence of the Designer. He had long believed that, but his convictions grew stronger after the museum doors swung open. "With my early labors," Peale noted, "a field of wonders opened to my view to create and vibrate in my mind . . . the most escalated view of the great Creator."[35]

A consequence of Peale's deism was that, as both a pantheon of science and a house where God's works were to be displayed and understood, his museum would foster morality, and "divert [people] from frivolous and pernicious entertainments." How, he thought, could it be otherwise? And natural history's moral lessons would be especially critical for the young

"to whom all things are new . . . if they enter with zeal into this pleasing source of meditation, they will not easily be seduced from the paths of virtue." Waxing poetic on the subjects of youth, natural history, and morality, Peale wrote: "What charming conversations will knowledge of this science [of nature] afford between the father and his sons at the age when they become agreeable and useful companions to each other. How often in their morning or evening walks might the infirmities of age be beguiled, while recounting their observations, and explaining the vivifying scenes of Nature."

These moral lessons took many forms. The most obvious to Peale was that natural history inspired awe and reverence for a Creator, that though no longer active, was regardless the author of the world around us. "Frequent contemplations of the magnificence, beauty, regularity, proportion and utility in the works of creation"—precisely the sort of contemplations he was fostering in his museum—"cannot but impress the minds of men, not only with ideas of wonder, admiration, and gratitude; but induce the most cheerful acquiescence in the dispensations of a wise providence." Peale had seen in the museum, he wrote Jefferson, "folly stopped in its carrier, by the sight of a few articles in this repository."[36]

Awe of the Designer was not the only moral lesson taught at his natural history museum. The creatures of the land, sky, and sea, Peale believed, had lessons of their own to teach us. He saw the loyalty, self-sacrifice, and parental devotion of dogs, cats, fish, polar bears, and birds as moral guideposts. Reptiles "against whom prejudice has produced too much antipathy, unworthy of a philosophic mind," he thought, "loved their offspring as much as any creatures." And then

there were harmonious social insects, whose "Herculean and incessant labors" never ceased to amaze Peale. "Nothing," he noted, "can elevate the mind more forcibly . . . [than] the industry of the ant, and the wisdom of the bee." Reading Peale's thoughts on insects suggests he saw them, alongside humans, as a pinnacle of morality. "Insects are capable of feeling quite as much attachment to their offspring as the largest quadrupeds," he proposed. What's more, "they undergo as severe privations in nourishing them; expose themselves to great risk in defending them."

Peale was convinced that the museum promoted morality through knowledge of natural history. So much so that he "meditated adding on Temple of Wisdom" to the name of the museum. In the end, he decided against this for "fear of intruding on the office of religion." But, should others bandy about the word temple when describing the museum, all the better. It is hardly surprising that Peale was immensely fond of telling the story of how after the Comte de Volney (Constantin-François de Chasseboeuf) had visited, he proclaimed, "This is the temple of God. Nothing but truth and reason."[37]

When the museum opened its doors in 1786, in addition to the natural history exhibits, there was, of course, the art. Hanging on the walls in the sky-lit gallery extension, were luminaries of the American republic. These included portraits of Washington, Franklin, Paine, Jay, Rittenhouse, John Paul Jones, Robert Morris, Robert Livingston, Elias Boudinot, and Henry Laurens, and alongside them power brokers and Enlightenment thinkers from Europe, the likes of Lafayette, the Marquis de Chastellux, Baron Johann de Kalb, and Peter John Van

Berckel, minister plenipotentiary from Holland. Some of these portraits were copies made from prior works Peale had painted, others the result of sittings he had arranged specifically to stock his museum gallery. On occasion, the museum would also house portrait exhibitions on loan, such as a set of Italian pieces on exhibit in August 1787. Though initially the art had stood alone, separate from the other parts of the museum, soon Peale erased the physical boundary between the portraits and the natural history specimens, hanging the portraits over exhibits of the latter to capture the "great chain of being," from the lowly to the grand, with man atop it all.[38]

Peale's portrait painting would play another, more indirect role, in the museum's development. He painted at least 39 pieces in 1786 and 1787 to supplement his income from the museum, which during those two years was nowhere near sufficient yet to handle "pecuniary matters." Paintings during this period included a summer 1787 portrait of Washington, as he headed up the Constitutional Convention at the State House, just four blocks north and three blocks west of the museum. A year later, Peale the artist was again linked to the Constitution. When Philadelphia held "public rejoicings for the completion of . . . the new constitution of the United States," the grandest spectacle in the celebrations was a mock-up 30-foot-long version of the "Federal Ship" *Union* that was paraded through the streets. Peale was involved in every aspect of building the float. He painted the water scene backdrop for *Union*, designed and cut the ship's armor, and paid for the silver leaf that covered it.[39]

In addition to the portraits that, along with the natural history exhibits, dominated the museum, Peale was still showing moving

pictures. But now performances were limited to "private companies, consisting of twenty or more persons, on previous notice being given." In August 1787, in part because the moving pictures were not profitable, but primarily because he needed space, regular performances were dramatically reduced, but not before the Society of the Cincinnati attended a special performance. Where the moving picture exhibit had stood, Peale built a grotto to display his reptile and marine specimens, with mirrors placed to create a water effect, and the walls and ceiling lined with the faux rocks that he and his sons, nine-year-old Rembrandt and thirteen-year-old Raphaelle, had crafted in a makeshift carpenter shop elsewhere in the house.[40]

In the early years of the museum, Peale devoted extraordinary effort to increasing his natural history collection. His voluminous correspondence with friends and colleagues, particularly those who traveled far and wide or knew others who did, is replete with requests for new specimens and reminders that no matter how much they sent, he could always use more. After Washington sent his golden pheasant in 1787, Peale sent a hearty thank-you, telling the general that until that point, he had thought the golden pheasant was but a mythical beast to be found only in Chinese paintings. But once the pleasantries were dispensed, Peale immediately turned to Washington to send more samples, and because one could never be too careful with such treasures, Peale added, "If the weather should be warm, be pleased to order the bowels to be taken out and some pepper put into the body, but no salt which would spoil the feathers." To a relative who did business in Curaçao, he was even more specific, requesting, if at all possible, a sloth, a flamingo, an anteater, and an electric eel.

In Peale's newspaper articles and broadsides soliciting donations, he implored readers, "including the gentle sportsmen of Philadelphia," to assist him, as he was "earnestly bent on enlarging the collection with a great variety of beasts, birds, fishes, insects, reptiles, vegetables, minerals, shells, fossils, medals, old coins . . . utensils, clothing, dyes and colors or materials for coloring." He depicted the museum as a tender plant early in development, a seedling that needed to be nurtured to its full potential. Citizens needed to understand that should the museum stand "only on his solitary efforts, the progress must be slow," but should they join him in this effort, and the museum "receive the smiles of the public, the progress will be proportionally great." Almost all of the many dozen advertisements he placed in newspapers over the first few years of the museum contain something akin to his August 27, 1788, appeal in the *Pennsylvania Packet*: "As this museum is in its infancy, Mr. Peale will thankfully receive the assistance of the curious."

The call for assistance from the curious, both laypeople and professional naturalists, was made not only to citizens of Philadelphia. Peale had agents on the ground elsewhere, assisting him. He ran ads in the *Maryland Gazette* (and similar ads elsewhere), saying that "The gentlemen and ladies of Maryland who are encouraged by Mr. Peale in his undertaking to collect and form a repository of natural curiosities are informed that Mister Richmond of Annapolis will receive for and forward to Mr. Peale anything which may be offered to him for that purpose." Peale was also starting to reach out to naturalists overseas, including private collectors in England and the Netherlands, and museums in Sweden. "Gentlemen, knowing your high reputation in the learned world," he wrote the members of the Royal Swedish

Academy of Science, "I solicit the honor of your acquaintance, and present you with a collection of American birds, which though small, is limited by the present opportunity; and will I hope, meet with your kind acceptance. I should be happy in a regular correspondence with you, and exchange of American production for those of Sweden."[41]

New items pouring into the museum came from many sources, the two most significant being Peale's own hunting expeditions and donations from friends, friends of friends, and strangers who had seen the newspaper advertisements. Early on, virtually all the donations came from Americans. Some no doubt had their own small curiosity cabinets, others simply collected unusual specimens in a less formal way, in part because so little was known of the natural history of North America. On occasion, Peale would inquire about, or be approached to gauge his interest in, a private collection of specimens, such as when he heard of a collection in Annapolis and wrote a friend there asking "whether the birds are of this country, whether they are well preserved . . . if they have artificial eyes, and if worth purchasing at what price?" But prices, such as the five hundred dollars that William Pierpont wanted, were often too prohibitive for such en masse additions to the museum.[42]

On an almost weekly basis, the readers of the *Pennsylvania Packet*, as well as other papers, would learn of new museum acquisitions from China, Africa, India, Pacific Islands, and North and South America. These ranged from the spectacular to the more mundane. There were new birds aplenty: hummingbirds, birds of paradise, parakeets, pelicans, snipes, swans, sparrows, bitterns, owls, bluebirds, and ducks, to name just a few. Mammals of all shapes and sizes now adorned the

museum. New additions included black panthers, oncillas (cats from South America), minks, opossums, and bison, along with tiger skulls, and a four-pound tooth of a mammoth. There were new creatures of the sea, new lizards and new amphibians, added by collection or donation. The museum now housed hammerhead sharks, garfish, porcupine fish, trumpet fish, African salamanders, and siren lizards, alongside a jaw of an unidentified 17-foot shark from the "Western ocean," and a six-foot sword of a swordfish that Peale had helped extract from the hull of a ship. Scattered throughout the museum were also new botanical samples, including silk grass, exotic nuts, and grass from Madagascar, alongside shells from across the globe and minerals aplenty, such as lava samples from Mount Vesuvius.

New anthropological and ethnographic specimens were also arriving. There was a feather cap and cloak from Tahiti that had been donated by Washington, and clothing, fans, and weapons from East India. The museum was home to a bow from Madagascar, a sword from Damascus, chess pieces, shoes and a Mandarin pipe from China, a piece from the Bastille prison, cudgels from the Caribbean, a model of a Native American canoe, South American baskets and more, including the occasionally morbid exhibit, like the skin from the leg and thigh of a Native American who had been killed "in the late war," and the fingers of an executed man.

If all this, the art, the zoology, the botany, the mineralogy, the anthropology, and the ethnography were not sufficient, admission to the museum also entitled visitors to amble through a small menagerie that Peale kept in the yard at Third and Lombard. Some creatures roamed

free there, others were in cages. There were red doves, cockatoos, eagles, owls, baboons, mongooses, hyenas, and some snakes—a gift of 63 young vipers presented to him by the French Consulate—that Peale had raised up to maturity. Though as a general rule, he shied away from freaks of nature, on occasion Peale would have a cow with five legs and six feet on display in the menagerie.

In the midst of all this collecting and museum building, Peale suffered a devastating blow. After complications associated with a cold that quickly developed into "a fixed disorder of the lungs" (consumption), Rachel died on April 12, 1790. Grief stricken at the loss of his wife of 20 years, Charles was left alone to raise Raphaelle, Angelica, Rembrandt, Titian, Rubens, Sophonisba, and baby Rosalba, who had joined the clutch shortly after the museum had opened its doors. Knowing that this was an untenable position, Peale soon went searching for a new mate. After a failed courtship with Molly Tilghman, daughter of Matthew Tilghman, who had served in the Continental Congress, Peale married 26-year-old Elizabeth DePeyster on May 30, 1791. Almost half his age, the daughter of well-to-do-merchants in New York, Elizabeth had first met Charles when she visited his museum just a few months earlier. On that encounter, she had joined Peale and others in a serene singalong of "Hush Every Breeze." Now with a new mother for his children, he could again turn to museum affairs.[43]

The specimens flowing in were a financial boon to the museum. But this new material created its own set of problems. For one thing, the sheer scope of new samples arriving almost daily was, at times, simply overwhelming for any one person, even when helped on occasion by

his sons. That, coupled with all the changes as paterfamilias, might explain his rather bad-tempered *Pennsylvania Packet* advertisement in which he informed museum visitors that "Mr. Peale finding the task of personally waiting on his fellow citizens rather irksome, has now declined any further labor in that way." But above and beyond prompting an occasional public outburst, what all the new material meant was that preservation, presentation, and organization, all of which were simple enough the first couple of years of operation, had to be rethought.[44]

Peale was quite discerning when it came to the quality of the specimens he would display, but that did not alter the fact that each and every animal or plant specimen in the museum, displayed or not, needed to be preserved for the long haul. His inclination, as ever, was to learn what he could from colleagues and from books, and then to modify and improvise. He copied chunks of British botanist and apothecary John Hill's studies on preserving specimens, and likely read treatises on the subject by René-Antoine Ferchault de Réaumur and the Comte de Buffon's collaborator Louis-Jean-Marie Daubenton. Often working on preserving specimens until midnight, Peale employed well-established skinning techniques, stuffing his birds and mammals with cotton, and applying an "antiseptic powder" that was a mixture of a drying agent and spices, including black pepper and cinnamon. When insects began eating the specimens nonetheless, he experimented by immersing specimens in turpentine. Not satisfied with the staying power of that method, the following year he began dipping specimens in boiling water laced with arsenic. That seemed to do the trick. Though the long-term danger of such a concoction was

not known at the time, Peale did understand that dipping his hands in and inhaling the vapors of arsenic was likely the cause of his inflamed fingers, red nails, and severe bouts of night fever. Initially he tried castor oil as a remedy, but as time went on, and physicians began to understand that sulfur ameliorated some of the detrimental effects of arsenic, he turned to that.

With preservation under control, there was the matter of presentation. A few specimens were in the dioramas; a few others, like a buffalo, ostrich, and albatross, were standalone exhibits, but these were the exceptions. The hundreds, soon to be thousands, of other birds, mammals, fish, amphibians, reptiles, and insects, also needed housing. Here, Peale mixed the accepted with the radical. As was common in European museums and private collections, he made, or had made, scores of glass cases, which, except for the case of insects, would house a single specimen. Each display would have a label, in English and sometimes French, "to inform the curious observer . . . with such particulars as are necessary in a concise manner . . . [including] the donor's name."

It was in the backdrops of these glass cases that Peale introduced something completely new: painted landscapes of the natural environment of the species enclosed within. Here Peale the artist, Peale the natural historian, and Peale the purveyor of rational entertainment, became one. Pleased with the chance to create these backdrops, many a morning he could be found tinkering with colors and painting landscapes, then taking a stuffed specimen and using art to infuse it with life.[45]

When it came to organizing the museum's ever-growing

repository of natural history curiosities, Peale turned to the Linnaean classification scheme, developed by Swedish botanist and taxonomist Carolus Linnaeus in his classic *Systema Naturae*. In Linnaeus's system, individuals that share the most characteristics are classified as being part of the same species. Species that are most similar are then grouped together in the same genus. Each distinctive type of life form in this system has a two-part (binomial) name, *Homo sapiens* for modern humans, *Pan troglodytes* for chimpanzees, *Turdus migratorius* for robins, and so on, for all life on the planet. Linnaeus clustered similar genera (the plural of genus) into orders, and similar orders into classes. He distinguished the class Mammalia, for example, as possessing four-chambered hearts, teats used to provide milk to offspring, and hair (except for aquatic mammals). The top rung on the Linnaean classification chart was kingdom, which clustered together similar classes. "Regular and uniform subordination of one tribe to another down to the apparently insignificant animalcules in pepper water," was how John Adams described this chain of being, an idea that played equally well to deists and more traditional believers.[46]

Peale spent endless hours reading Linnaeus's works, filling his own notebooks with data on species names, genera, classes, and orders. When advertising the museum, he rarely failed to inform the reader that it was organized along Linnaean principles, in part because his was the first major natural history museum to adopt this classification system. At times, he waxed poetic in his discussion of the famed Swedish naturalist. "Linnaeus stands before me shrouded in splendor, that great and good man was beloved and honored by all civilized natures; he opened the Book of Nature to a wondering world."

So awestruck was he, that in 1794, Peale would break the tradition of naming his sons after artists, with the birth of Charles Linnaeus Peale (often called Linn).

Peale employed the Linnaean classification system, and aside from dioramas that captured communities, would cluster songbirds with songbirds, seabirds with seabirds, primates with primates, and so on. Linnaeus's system appealed to Peale not only because of its power to organize, but because it was so in line with the Enlightenment ethos that things made sense—that complex totalities, be they political systems, cities (such as gridded Philadelphia), or the world of natural things, were interpretable and amenable to order and systemization.[47]

The quality of the preserved specimens, the clarity of the exhibits, and the organization along the lines of Linnaeus had the desired effect on visitors. "Wonder and admiration, these, believe me, sir, are indescribable, you must see them . . ." wrote one. "I expect, you'll say with me, 'I must see them again,' for it is like Horace's finished piece of poetry, *decies repetita placebit.*" Another visitor was "entertained for two or three hours, in viewing his collection of artificial and natural curiosities," whose combined effect convinced him that the museum "will be very valuable in the eyes of posterity."[48]

Peale was pleased with the reactions of visitors, but equally, if not more so with the number of people the museum was drawing. Most visitors to the museum bought a 25-cent single-day pass, a ticket good for one visit, but in June 1787, Peale also created a subscription to the museum, where for the price of one dollar annually, subscribers were entitled to unlimited access to the museum. In the very early years of the museum, Peale even went door to door soliciting such

subscriptions, but by 1790, he decided that advertisements and word-of-mouth were more effective tools.

Though we have hints and glimpses of the people purchasing tickets for a quarter at the door, much more is known about the subscriber list. Alongside subscribers like President Washington, Vice President Adams, Secretary of the Treasury Hamilton, Secretary of War Knox, 20 United States senators, 68 members of the United States House, diplomats from Spain and France, and leading scientists of the day like Rittenhouse, the subscription list included people from all walks of life, spanning the economic and social gamut. There were merchants and apothecaries, dentists and doctors, ironmongers and woodworkers, scriveners and printers, grocers and shopkeepers, medical students and teachers, as well as sea captains and clergymen, many of whom likely used their engraved museum passes as a badge of status. A list of 397 individuals, and another 60 or so whose identities are not known, suggests that Peale's vision of an Enlightenment temple for all was starting, but only just, to come to fruition. While subscribers spanned the economic ladder, they clustered on the elite and middling rungs of it—they were, for example more likely than most to own a home and drive a carriage. And despite Peale's intentions to make the museum a place of appeal to both men and women, at most 15.7 percent of subscribers listed were women. Records also suggest that unskilled laborers and farmers were vastly underrepresented as subscribers, and there were no Native American or free African American subscribers, though unskilled laborers, farmers, and Native Americans are known to have visited using single passes.

There are no records of the total number of people passing through

the museum each day, but because tickets and subscriptions were the sole source of income generated by the museum, using annual income figures, and what is known from the subscription list during the early years, annual attendance in the early years is estimated to have been between 3,500 to 12,000. Although this figure almost certainly includes some nonsubscribers who visited more than once in a year, in a Philadelphia of 54,000, if one counts for "Philadelphia," "Suburbs," and "remainder of Philadelphia County" in the 1790 census, the museum was starting to make its mark.[49]

Never one to sit on his laurels, in early 1792, in an attempt to broaden the reach and prestige of the museum, to lighten his load, and provide the opportunity for "my children to contribute their future aid to this my favorite undertaking," Peale formed a Board of Inspectors, which he sometimes called a Society of Visitors or Society of Directors. A year earlier, when he and Elizabeth were in New York City for their wedding in 1791, they had visited Gardiner Baker's tiny American Museum. The collection was not much, but they did have a board, which Peale thought a good idea, retrieving it now for his own museum.[50]

Peale's board was comprised of a who's who of Philadelphia. There was Secretary of State Thomas Jefferson, who Peale had met only a year earlier, but who soon would play a pivotal role in the museum's development; Secretary of Treasury Alexander Hamilton; Congressman James Madison; Gouverneur Morris; Thomas Mifflin; mathematician and now president of the American Philosophical Society David Rittenhouse; naturalists Benjamin Smith Barton and William Barton; Robert Patterson, who had contributed the first item

(the paddlefish) to the museum; and John Beale Bordley, Peale's first patron, to name just a few. Peale lacked moneyed ancestors and a formal education and could never be a gentleman in the 18th-century meaning of the word. First his art, and now his museum, had raised him, though, to a position in Philadelphia society where he could gather together such a group.

In a broadside titled *My Design in Forming this Museum,* Peale informed the gentlemen he was courting for the board of the history of the museum, the progress made these first six years, and his hope that "in the end it might become the basis of a great national magazine of those subjects in nature." At the first gathering at the museum on February 5, Peale stood before this august group and explained why he was calling on them to serve on his board, and how their association with the museum would ensure that their "countrymen may be assured . . . the museum shall not be lost to America." Charles then added his own personal guarantee, which over time he would waffle on, that "I will at no future time sell or dispose of the subjects of my museum" without approval of the board, as it was his "earnest desire that the public of the country should possess them, rather than they should be transferred to any foreign nation or people."

All present were suitably impressed and after a flurry of subsequent meetings, including one on February 14 when Thomas Jefferson was elected president of the museum board, Peale and the board took to writing a set of bylaws and regulations. One of the first orders of business was the board approving an appeal on behalf of the museum that Peale had drafted for the House of Representatives in the state legislature. After providing the House committee with an overview

of the museum, Peale informed them that although he had "exercised great patience, economy and diligence" he had not given "sufficient consideration of the difficulties with which it was to be attended." As such, he called upon them to provide support for his "great national repository of the mineral, animal, and vegetable kingdoms." Leaving the exact nature of the support to the House's "wisdom and liberality," he requested they create a special commission for "assistance to raise the superstructure and to render the institution a lasting honor and benefit to America and a successful rival to boasted museums in Europe."[51]

The legislative committee that received the appeal made note of its receipt but failed to act up or down, instead tabling the matter. Though disappointed, Peale was not disheartened, hoping "the delay will afford me time . . . to further increase and arrange my museum . . . [to] more fully illustrate the utility and advantage which must arise to the public" for a future appeal to politicians. Indeed, this was but the first volley he would shoot for support from the state legislature, and eventually, the national government.[52]

CHAPTER 3

The Parade to
Philosophical Hall

In the fall of 1792, a few months after his museum board was established, Peale published what, at first appearance, seemed like an unusual newspaper piece. The article told of John Strangeways Hutton, a 109-year-old former sailor living in Philadelphia, who just a few days prior had sat for Peale, for a portrait "to be preserved in my museum." Peale had interviewed Hutton's children "and others of his acquaintance," and the article was the condensed tale of Hutton's nearly eleven decades. An accompanying table of Hutton's 132 children, grandchildren, and great-grandchildren resembles what a naturalist might publish after studying a dramatic new species. The Peale museum, it was to be understood, would study *Homo sapiens* as natural history.

The article was about more than a portrait and a natural history take on humans; it was meant to convey both lessons to be learned and entertainment to be had at the museum. Peale described the habits of his subject, in both the artistic and scientific sense of the word, as "always plain and temperate in his eating and drinking and particularly

avoided spiritous liquors." This hinted not only at his own growing obsession with longevity and health but was also a stark reminder to readers that there are always moral lessons to be gleaned from natural history, including the natural history of human centenarians. At the same time, Peale understood all too well that rational entertainment was also meant to entertain, and he closed by telling readers and potential visitors to the museum that in the portrait of sailor John Strangeways Hutton, they would be casting their eyes on a man who claimed to have known Blackbeard the pirate.[1]

By the early 1790s, Peale could take pride in the reception his museum was receiving both from locals and visitors from abroad. A major directory to the City of Philadelphia devoted more space— almost a full two pages—to the museum than to any comparable point of interest in the city, including the American Philosophical Society, the public libraries, theatres, Ricketts Circus, and so on. "Of the different institutions in this city calculated to promote science," the guide wrote of the museum, "this may certainly be considered as one of the most important." It was a place arranged with "the greatest order and judgment," with specimens, from birds, mammals, and fish to amphibians, reptiles, and insects "placed in their most natural attitudes." Alongside were "arms, dresses, tools, utensils of the aborigines of different countries," all set below rows of portraits by an artist and natural history curator described as "remarkable for his ingenuity and perseverance, rather than his pecuniary abilities." Peale and his museum, the entry continued, have "paved to the American nation, an easy access to the proper subjects of the natural history of

our country, an object surely of the greatest importance, and without his exertions would be almost inaccessible." With such a fawning description, it is hardly surprising the entry closes with a rousing recommendation to visit. "The small price of twenty-cents is paid for admission . . . who would not cheerfully contribute this trifle for the privilege of examining a collection so truly valuable and interesting?"[2]

That directory, as well as other city guides and directories, helped draw Philadelphians and others to the museum, and once there, many felt compelled to write of their experience. One traveler to Philadelphia, who had clearly heard good things about the museum beforehand, published an account of his visit in the *National Gazette*. Both to "gratify [his] curiosity" and "to steer clear of embarrassment at the time of [his] intended departure" for not visiting such a place, this anonymous tourist, likely from Maryland, paid a visit to "Mr. Peale's Museum," which he described as "a repository of once-living things, preserved so as to resemble life." He was immediately taken with the giant mounted buffalo that greeted him as he entered, "its huge and natural shape" juxtaposed with an exhibit containing buffalo yarn that Peale had spun himself. As he walked through the museum, this visitor was struck by "a vast variety of monsters of the earth . . . fowls of the air . . . in perfect preservation and in their natural shape and order," and was especially taken with the jaw, teeth, and assorted bones of the mammoths before him.

Peale personally chaperoned this museum guest around, bringing him over to an exhibit of live "rattle, black and spotted snakes . . . confined in cases, enclosed with wire and glass." There "Mr. Peale opened a box in which two black runners were confined, each about

four or five feet long; one of these reptiles is very tame, which Mr. Peale took out as unconcerned as if it had been dead." Toward the end of the visit, Charles led his guest to the outdoor menagerie, where he was treated to an owl, baboon, monkey, elk, and an eagle that sat in a cage with a sign that read "Feed me daily [for] one hundred years."[3]

Another visitor, identified only as a "Lover of Nature," took to newspapers to tell readers not just of the hummingbirds, "scarlet sparrows," "Brazilian creepers," and "ruby crested wrens" he encountered in the museum, but that "the moral effect of a museum is very considerable." Yet another visitor, "A. R.," wrote: "The exertions of Mr. Peale in the collection, and his taste in the disposition of natural history objects in his museum, are very honorable to himself, and highly advantageous to the progress of this science." Assuring his readers (and the printer) that "Mr. Peale knows nothing of this note," A. R. wrote of a "live opossum with young in embryo visible . . . to the eye of the observers," and opined that a "European naturalist would not have thought a voyage across the Atlantic too great a price for this sight."[4]

Many overseas travelers, naturalists or not, did indeed visit the museum when they were in the temporary capital of the United States. Englishman Henry Wansey, a member of the British Society of Antiquaries, toured the United States on holiday, and made a point of visiting. In his journal, which he shortly thereafter published as a book, Wansey wrote of the red and blue manakins, birds of paradise, toucans, and spoonbills before him. So enamored was he with the mammoth teeth on exhibit that he took to measuring their size for himself, estimating them at "sixteen and seventeen inches round." Wansey

was just one of many foreigners visiting. In a *General Advertiser* newspaper piece by an anonymous American Francophile, the writer told Philadelphians of the many foreign guests visiting the museum, among which "the French generally appear to be well informed within [the museum] and do not appear to be at a loss to know the objects within." Not so for some of the Englishmen "who view [the exhibits] and pretend to know a great deal, yet with a few exceptions really know but little." The writer's unpretentious fellow Americans, on the other hand, "have some knowledge [of the exhibits], yet without knowing more than they are really acquainted with."[5]

It wasn't only foreign visitors, but also foreign institutions that were taking note. Nicholas Collin told Peale that he had heard from his colleagues at the Swedish Academy that they were quite interested in the exchange program with the museum that Peale had proposed, and they expressed "lively interest in the success of your museum." Soon thereafter Peale proudly announced that he "deems it a duty to inform the kind promoters of the museum that he has received from foreign countries very flattering encouragement for the proposals he had made of reciprocal exchange of natural subjects."[6]

Just as the museum was establishing itself as a must-see for many, attendance suddenly dropped due to forces beyond Peale's control. Unknown to him, in August 1793, just a few days before he went off to Cape Henlope in Delaware on a multi-week collecting mission for the museum with 13-year-old Titian, Peale's friend, physician Benjamin Rush, had diagnosed a few cases of yellow fever in Philadelphia. The victims lived in a lodging house on North Water Street, all too close to

the museum. As the number of victims grew, an odd debate emerged between Federalists, who thought the disease to have come with French immigrants from the West Indies, and the Republicans, who saw the birth of the disease as local, and one of the evils of urban spaces. By September, Philadelphians were terrified, and close to half the city fled to outlying areas to escape. By the time the epidemic ran its course in late November, records from burials in churchyards and mass graves put the number of victims at between 4,000 and 5,000.[7]

When Peale heard of the "dreadful fever," he packed up the bird specimens he had collected, specimens that included mud hens, willets, curlews, snipe, marsh hawks, kingfishers, woodpeckers, plovers, gull and white cranes, along with sections of a whale skeleton, and headed back to Philadelphia, arriving home on September 16. Upon his return, his brother James told him that "most of the shops were shut up, and uptown scarcely a person was seen in the streets," with residents hit by the fever often surviving but five days. "The dead," said James, were "generally buried by night." Peale's first thought was for the safety of his family, but he also feared that with the exodus to surrounding, less urban, settings "if half the bad news which he heard was true . . . the museum could not be productive of sufficient income to support them." To save on costs, he cut back on newspaper advertisements during the peak of the fever, while at the same time doing what he could to make the museum safe for those who did visit. He sprinkled vinegar generously about and employing another oft-used response to yellow fever, "now and then explode[ing] some gun powder" in various rooms.[8]

The Peale household was spared compared to others. His wife,

Elizabeth (Betsy) appears to have been infected, but Charles helped nurse her back to health in a few weeks. Fourteen-year-old Moses Williams contracted a mild case of the fever, but he too recovered. Peale made a point of noting that he did everything for Moses that he had done for his wife, though skepticism is warranted here, as that claim was made decades later in an autobiography written for posterity.

Although nominally open, the museum was effectively shut down during September and October and truly reopened in November as the epidemic wound down. Even with some financial support from Betsy's family, the lack of income during those months was difficult. Peale tried to take it in stride. When not nursing Betsy or perhaps Moses, he organized the many still uncategorized samples that had flowed into the museum and caught up on his Linnaeus readings. Most remarkably, starting before, and continuing through and past the yellow fever epidemic, Peale and the museum, along with Jefferson and the American Philosophical Society, became entangled in a debacle that involved sending an ambitious French botanist on an expedition to the Pacific. Had it been successful, the expedition would have all but made the Lewis and Clark expedition a decade later, unwarranted, or, at best, an historical footnote.

Sometime in 1792, Jefferson recalled approaching the American Philosophical Society to "set on foot a subscription to engage some competent person to explore . . . by ascending the Missouri, crossing the Stony mountains, and descending the nearest river to the Pacific." That recollection came two decades later, and if we trust Jefferson's memory and some ancillary evidence, his timing was fortuitous. For

in late 1792, Frenchman André Michaux, who had already spent many years in America as the royal botanist, found himself "destitute of means." He was unable to get the back pay owed to him as a member of the French court and was wondering whether the political upheavals in France left him with a job or not. It seemed to Michaux, unaware yet of Jefferson's proposal, that the American Philosophical Society might be of some service on such matters, and it indeed turned out to be, as did both Jefferson and Peale.[9]

Michaux had trained at Buffon's Jardin du Roi in Paris. After a stint studying in England, visiting botanical meccas like Kew Gardens, he returned to France for a botanical expedition in the Auvergne Region. He then headed off to study the plants of the Spanish Pyrenees as a "Correspondent of the Royal Garden." Michaux next set his sights on botanical work in Persia. When the French consul to Persia was back in Paris for a visit, Michaux used his connections to successfully plead his case to Marie Antoinette and was soon off to Persia and sent back treasure troves of botanical samples. Louis XVI had long championed importing plants and trees from all around the world that might be useful as food, in construction, or for decorative purposes. Not long after Michaux returned from Persia, the king was looking to the New World for such material, and knowing of Michaux's work, in a brevet dated July 18, 1785, he appointed him royal botanist and sent him to America. The position came with an annual salary set at 2,000 livres. At least in principle it did.[10]

On September 28, 1785, André Michaux, unmistakably patrician in appearance, with his shock of dark brown hair on an already receding hairline, boarded *Le Courrier de New York* docked quayside in Lorient,

and set sail for the fledgling United States. After 46 days at sea, much of it on unbearably choppy waters, he arrived in New York Harbor. Michaux spent 1785 to 1792 botanizing (a favorite term of his) around the United States and Canada. He collected samples of anything and everything, discovered scores of new species, shipped more than 60,000 samples back to France, and eventually published two books, *History of the Oaks of North America* and *The Flora of North America*. During these eight years, he visited Philadelphia on many occasions, but he does not appear to have interacted directly with Jefferson, Peale, or the American Philosophical Society before December 1792.[11]

By the time André Michaux rode into Philadelphia on December 8, 1792, France was a republic, not a monarchy, and his royal sponsor, Louis XVI, was in prison awaiting trial. Michaux no longer knew whether he was acting as a botanical minister for the New Republic, and more pressingly, whether he would ever receive the 17,520 livres in back pay that had accumulated over the years, and if not, how he could possibly cover his mounting debts. The solution he arrived at was meant to mitigate his economic woes, and, at the same time, allow him to do the botanizing he so loved.

On December 10, Michaux approached members of the American Philosophical Society, including Jefferson, with an audacious idea. He proposed "the advantages to the United States of having geographical information about the country west of the Mississippi and asked that they back my explorations," informing his potential sponsors that he was "ready to go to the sources of the Missouri and even explore the rivers that flow into the Pacific Ocean." Jefferson, the vice president

of the society, as well as secretary of state, had envisioned just this sort of thing when he approached the society the year before. In short time, he became the point man handling Michaux's proposal. Shortly after Michaux made the offer (the exact date is not known except that it was sometime in 1793), Peale and his museum enter the story. Michaux further solidified his ties to the American natural history community, and to Peale's vision of it, by becoming an annual subscriber to the museum.[12]

Michaux approached the American Philosophical Society with a list of conditions under which he would undertake the journey, including "letters of recommendation necessary for negotiations with . . . Indian chieftains." In his "Observations on Proposed Western Expedition," presented to the society on January 20, 1793, Michaux spelled out who would get what, should he head off to the Pacific. "All knowledge, observations, and geographical information will be communicated to the Philosophical Society," but "other discoveries in natural history will be for my own immediate profit, and, afterwards, destined for the public good."

The next day, January 21, though Michaux would not have known it, Louis XVI went to the guillotine. One day after that, Jefferson, on behalf of the American Philosophical Society, presented Michaux with the first official subscription for this expedition. The society, "desirous of obtaining for ourselves relative to the land we live on, and of communicating to the world, information so interesting to curiosity, to science, and to the future prospects of mankind," would sponsor the expedition. The subscription was signed by 38 individuals, many of them members of the American Philosophical Society, but others not.

The first two signatures were those of President Washington and Vice President Adams, with commitments of $125, respectively, and later down on the list, Jefferson and Hamilton, pledging $50 each. The total for all signatories amounted to $870: a respectable start to what would be an ongoing funding campaign.[13]

With a deal in principle now in hand, Michaux and the society needed only to work out the details. In particular, the society needed to communicate a more precise set of instructions to Michaux on how he should proceed west, and what he should be doing along the way. While he waited for those instructions, Michaux did some botanizing in New York. In early April, upon his return to Philadelphia, the society appointed a fundraising committee of three to both collect the amounts pledged earlier and to continue to solicit additional subscribers for what would be a costly endeavor. One of the committee members was Peale. Michaux was now benefactor of his fundraising efforts and subscriber to his museum. The committee membership was known to all, including Michaux, and so Peale had good reason to believe that should Michaux one day decide to part with some of the treasures he would collect on his journey, Peale's museum would be their ultimate home. Michaux had, after all, declared such items to be "destined for the public good," and what better home for natural history specimens destined for the public good than his museum? And at the very worst, the information accrued by Michaux would be of use to Peale as the curator of the country's only full-fledged natural history museum.[14]

In a charge to Michaux, the American Philosophical Society noted, "The chief objects of your journey, to find the shortest and most

convenient route of communication between the U.S. and the Pacific Ocean . . . [to] take notice of the country you pass through, its general face, soil, rivers, mountains, its productions animal, vegetable, and mineral so far as they may be new to us and may also be useful or very curious." Ten years later, President Jefferson wrote Meriwether Lewis about his upcoming mission with William Clark that "a considerable portion of [the instructions] being within the field of the Philosophical Society, which once undertook the same mission." Indeed, Lewis and Clark's instructions are essentially a longer, more detailed version of those given to Michaux However, in Michaux's case, Jefferson emphasized that "the mammoth is particularly recommended to your enquiries," whereas no mention is made of the beast in instructions to Lewis and Clark. Because he believed the economy of nature did not allow for extinction, Jefferson still thought mammoths were roaming out West when Lewis and Clark set off, but, by that this time, he had realized that the general consensus was that mammoths were likely gone forever. Gone, but as we will soon learn, becoming something of an obsession with Peale.[15]

With Michaux's instructions now communicated, everything appeared to be in place for him to begin gathering what he would need for an expedition the likes of which had never been attempted. But just then fate, in the person of French Minister Edmond-Charles Genêt, stepped in to make the situation much more complicated.

Genêt, the first official representative of the new French Republic to the United States, arrived in Philadelphia in May 1793. He and his entourage were greeted warmly by the Washington administration and the people of Philadelphia, including Peale, who quickly sent Genêt

an offer for a free annual pass to the museum, with "cordial wishes for the success of the Republic of France." The reception might have been otherwise had Americans been aware of the secret instructions that "Citizen" Genêt had been issued. Genêt had received a generic and admirable enough charge to facilitate an alliance that would "encourage the liberation of mankind." Above and beyond that, however, he had been ordered by the leaders of the New Republic to "pave the way for the liberation of Spanish America . . . [and] deliver our brothers in Louisiana from the tyrannical yoke of Spain. . . . [which] will be easy to carry out if the Americans wish it." Genêt was empowered "to make whatever expenditures he shall judge appropriate to facilitate the execution of the project, leaving this to his prudence and loyalty." These clandestine instructions put him on a collision course with Washington. On April 22, in response to France declaring war with Austria, Prussia, England, Holland, and Spain, and in an attempt to forestall America being drawn into a vortex of seemingly unending war across the European continent, Washington had issued a proclamation of neutrality. He ordered that America "pursue a conduct friendly and impartial toward the belligerent powers."[16]

Genêt had in his sights the liberation of both Florida and Louisiana, but it was the Louisiana mission that would lead him to Michaux. Genêt understood that Kentuckians' long-standing disputes with the Spanish over navigation rights on the Mississippi might incline them to join with the French to free Louisiana. He turned to his well-connected countryman Michaux to facilitate just the sort of political machinations that Washington's neutrality proclamation was put in place to prevent.[17]

Michaux met with Genêt twice during the first two weeks the minister was in Philadelphia, and Genêt instructed him to travel to Kentucky to gauge the sentiments of the people there on the question of joining with the French to end Spain's control of Louisiana. Should the situation appear promising, Genêt instructed Michaux to meet with General George Rogers Clark, William Clark's brother, about spearheading both a land and amphibious assault on New Orleans. If Clark was so inclined, Michaux was to commission him general in what Genêt was calling the Independent and Revolutionary Legion and provide him with commissions for those he would appoint to join him. From the moment he arrived in the United States, Michaux had seen his mission as a botanizer's dream come true, but he never forgot that his primary duty in the New World was to serve France. He accepted this new charge from the republic, placing the American Philosophical Society expedition to the far West on hold. He spent most of June preparing for the journey to Kentucky.

On July 16, Michaux departed Philadelphia armed with his commission from Genêt. The journey, east through Pittsburgh, and then southeast through Ohio, took just a few days shy of two months, which suggests a lack of urgency on Michaux's part. Part of this was the result of his frequent stops to meet with people that Genêt had suggested, and part was unavoidable, the consequences of weather or horse problems. But there appears to be more to it than that, for by this point Michaux had learned that his days as royal botanist were over. However, the Girondin government had continued his appointment as botanical ambassador for the republic and so he could, in all good faith, do some botanizing en route to Kentucky, and his many journal

entries along the way made it clear that is just what he did.

In late August, as Michaux was at last approaching Kentucky, Citizen Genêt was the subject of much discussion in the political circles of Philadelphia. By this time, Washington had learned of Genêt's plans for Louisiana and Florida. On August 23, after consulting with his advisors, Washington sent a request to the French government to recall Genêt. There was no public announcement of the recall request, nor did it leak to the press, and Genêt was not informed until at least September 15, and perhaps a few days later. Genêt was furious at the recall request but reasoned that such a request might very well be denied by his government. In any case, he saw no reason to have it interfere with Michaux's mission, and there is no evidence that he informed his botanist-turned-operative of any change to the plans.

Michaux arrived in Danville, Kentucky, on September 10 and met with George Rogers Clark twice during his first two weeks there. Clark informed him that "I every day meet with encouragement and am anxious for us to commence on our operations," and that he would be honored to work with France and accept a position in the Independent and Revolutionary Legion. Clark made it clear that he could provide the troops, but that he needed boats, supplies, and money to achieve the goal of freeing Louisiana from the Spanish. Michaux assured Clark that he would provide everything needed, but before that, he would need to return to Philadelphia to secure resources.[18]

Arriving back in Philadelphia on December 12, Michaux met with Genêt. In a letter to Clark two weeks later, he informed him that Genêt fully supported his plan and was working to obtain the resources needed, but "the difficulty, or rather impossibility, to [effect] a diversion

with the navy forces the Minister to delay the operations until next Spring." That delay was a death knell for the mission, as just a week after Michaux's letter to Clark, Genêt learned he was no longer acting as a representative of the French government. Washington's recall request had at last arrived in France in October, and the Committee of Public Safety heeded that request and ordered that Genêt be recalled. News of that decision reached Philadelphia in January 1794 and quickly became common knowledge. On January 10, Michaux noted in his journal that he "returned to Minister Genêt the warrants he had entrusted to me for General Clark . . . I told him I wanted to use my time for research in natural history as much as possible." The mission to use French and American forces to free Louisiana from Spanish control was over.[19]

Michaux's desire to employ his "time for research in natural history as much as possible," would not translate into reviving any journey to the Pacific. Though there was no formal decision to scrap the project, the "Genêt Affair," as it came to be known, had reached its dénouement. All things Genêt were politically and socially toxic, and the American Philosophical Society, including fundraiser Peale, understood it would not be proper for Michaux to be first to explore the far West. Michaux too had likely had enough. He had grown weary of others, be they the American Philosophical Society or Genêt, managing his life. He wanted his freedom back so he could botanize to his heart's content, which is precisely what he did until he eventually sailed back to France two and a half years later.

Just as his mission was collapsing, Michaux visited Peale at the museum. There are no records of their conversation, but one expects that Michaux informed Peale that there would be no journey to the

Pacific, and that any natural history specimens that may have been gathered on such a trek, and which might have ended up in his museum, would have to wait for some future mission west.[20]

At the time that the Genêt Affair came to light in early 1794, running the museum was all-encompassing for Peale. On April 24, a month after his new son, Charles Linnaeus, was born, he penned an article to inform his fellow citizens that he was "so engrossed with his museum that he finds it necessary that he should bid adieu to portrait painting, it is his fixed determination to increase the subjects of the museum with all his powers, whilst his life and health will admit of it." This fixed determination had already led to more samples than he could possibly display in the museum. What Peale needed first and foremost now for his ever-expanding collections was space. As he had earlier, when they had tabled his request, he again turned to the Pennsylvania state legislature for assistance. In February, he applied to the State House for a construction loan for a new museum building on a lot that he already owned next to his home. By this time, Peale had made it clear to friends that if he couldn't expand, he might need to move the museum out of Philadelphia, prompting an anonymous newspaper article in which the author warned Philadelphians that "the removal of the museum would not only be severely felt by the votaries of science, but also diminish that circulation of wealth which arises from the commerce of liberal arts."

Interactions with the state government were never as smooth or straightforward as Peale expected they would be. He saw his request as one to support a public good, but the legislature took his appeals both

in that light and as an attempt by Peale to forward his business interests. A committee at the state legislature was established to consider the matter, and the following month, committee state representatives visited the museum and deeming it "meritorious," recommended granting the loan. But when the report and recommendation were presented to the full committee, the loan was voted down. Peale's letters and autobiography do not shed light on his response to the loan being declined, but we do know he did not seriously consider following up on his threat to leave the city, as in May he turned to the American Philosophical Society with an alternative expansion plan. Would the Society, he queried, consider renting him Philosophical Hall, a building virtually adjacent to the State House, as a new home for his museum? Philosophical Hall had more space than the society needed for its meetings, and they leased it out as needed. When Peale approached them, only one room was being rented to the College of Physicians, but that lease was set to expire. The committee reviewing the request deemed Peale, a longstanding society member, to be a "desirable tenant," and they agreed to lease him all of Philosophical Hall, save two small rooms, for 10 years, at an annual rent of £130. This was not just a change of venue for the museum. Peale and his family too would move into Philosophical Hall, living in the cellar, once a kitchen was constructed there. He also quickly applied for, and was granted, the right to build an outdoor menagerie, larger than that at Third and Lombard; it would measure "the breadth of Philosophical Hall and extending from the southwest end of it about half the square."[21]

In many ways, Philosophical Hall was the ideal venue for the

museum. A two-story redbrick, Federal Style building that had opened in November 1789, it sat on a plot of land granted to the American Philosophical Society five years before that. Located on the west side of State House Square on Fifth and Chestnut, it was a 30-second walk to hallowed Independence Hall, placing it in the political and intellectual heart of the city. The elegant State House gardens and their amenities also made it a location Philadelphians gravitated to.[22]

Recognizing the allure of the move itself, which would include all the museum exhibits, as well as the denizens of its menagerie, Peale decided to take "advantage of public curiosity . . . [and] contrived to make a very considerable parade of the articles," marching in grand fashion along the two blocks west and four blocks north from Third and Lombard to Fifth and Chestnut. Indeed, he commenced to arrange a series of parades, as the bulk of material to be transported demanded just that. Peale hired some burly men to carry the museum's mounted buffalo and panther on their shoulders, but then, realizing that "boys are generally fond of [a] parade," he "collected all the boys of the neighborhood," and had them placed at the front of each parade carrying "a long string of animals of smaller size" with them. The two-week-long series of parades was also an ingenious cost-saving endeavor. Peale noted it "saved some of the expense of the removal of delicate articles," adding the caveat that he was, of course, "obliged to use every means to prevent injury and loss" to the men and boys and exhibits along the parade route. It was quite the show and achieved the desired effect with "all the inhabitants to their doors and windows to see the cavalcade." Peale was ecstatic, writing Nathaniel Ramsay, whose comments on the mammoth bones back in 1786 had set Peale

on the museum path, that "the whole city, as far as come within my knowledge, seems pleased" with the move.[23]

Once the move was complete, Peale rented his house on Third and Lombard, did some minor renovations to Philosophical Hall, and arranged for a new set of glass exhibition cases to be built. Next, dozens of times in various papers for the next two months, he announced to citizens that the museum doors in Philosophical Hall were now open. In the advertisements, Peale reminded readers that this was just the first step in the next stage of the museum's life and that "the proprietor will continue, as much as possible to improve it in such a manner as must tender it in every sense a public benefit."

While visiting New York City around this time, Peale—open to new ideas on how to best make the newly moved museum a public benefit—made a point to stop by Baker's museum. Known as the American Museum, it occupied a 30-by-60-foot room in a building at the intersection of Pearl and Broad Street. The grand language of the museum's mission statement noted it was established "for the sole purpose of collecting and preserving whatever may relate to the history of our country and serve to perpetuate the same, also all American curiosities of nature and art." Peale was not impressed. He saw it as "in an out of the way dirty part" of New York City, a place of disorder that boasted of "a perfect horn . . . five inches in length," from the head of a New York City woman, and a working guillotine with a "wax figure perfectly representing a man beheaded." It was stocked with exhibits "arranged without method . . . promiscuously jumbled together." Peale took it as a lesson about the importance of the presentation of his exhibits and the Linnaean order he imposed in Philadelphia.

The Philadelphia public too might have ideas on how to make his museum a public benefit. A few weeks after the museum reopened, Peale added a visitor's book that was open to museum guests "to insert all such discoveries, inventions, improvements, schemes, observations, projects, hints or questions relating to the arts or sciences, as any of his visitors . . . may from time to time communicate." As part of his outreach program, Peale added placards with quotes from *Paradise Lost* and Job ("Ask the Beasts and They Shall Teach You") around the exhibits. He also made the museum home to meetings of the Columbianum, or American Academy of Painting, Sculpture, Architecture, and Engraving, an organization he chaired.

Peale may have retired from portrait painting for hire, but his love of the arts still burned just as strong as ever in Philosophical Hall. It was at a Columbianum exhibition that Peale unveiled his trompe l'oeil *Staircase Group* (*Portrait of Raphaelle and Titian Ramsay Peale*), an oil on canvas more than seven feet tall that soon was hanging in the museum. In it, Raphaelle, carrying an artist's palette, appears to be climbing up the stairs as younger brother Titian appears to be walking down. On the bottom step, below both boys, is a ticket to the museum. If this trompe l'oeil was not already lifelike enough, Peale placed in it a doorframe and added real steps before the painted ones. Many years later, Rembrandt wrote that when Washington came to the museum and passed the painting, he "bowed politely to the painted figures, which he afterwards acknowledged he thought were living persons."[24]

As ever, new specimens were flowing into the museum. Peale made a point of keeping Philadelphians apprised of all this with periodic

"recent acquisitions" updates in the newspapers: updates that would, on occasion, have him raising the idea of public support for the transformation to a national museum. Most new acquisitions came from donations, the result of never-ending advertisements soliciting new items. However, Peale's hunting and collection expeditions provided their share of the recent acquisitions, including not only new bird, mammal, amphibian, and reptile samples, but insects as well. Charles proclaimed a true admiration for "these little animals whose life is spent perhaps on a single leaf, or at most on a single bush." There were also new exhibits from two 1793 collection trips that 19-year-old Raphaelle had taken to Georgia and South America. Over the years, Raphaelle, along with 15-year-old Rembrandt, and to a lesser extent as of yet, nine-year-old Rubens had lived in a museum, learned preservation techniques, and spent time in the museum workshop. They had accompanied Charles on some of his collecting trips and watched their father manage the day-to-day running of a museum. Unfortunately, virtually nothing is known of the details of Raphaelle's Georgia and South America trips, except that, as Peale wrote a friend, they were "to preserve and collect subjects for my museum."

The bird collection, which within a few years would number 750, now included, among many other new acquisitions, Brazilian moorhens and a group of 30 birds, including eider ducks, sent by a leading Swedish naturalist. There were new exhibits of marmots, antelopes from Senegal, an orangutan, violet crabs from the West Indies, flying fish, a live coati, a live elk, and more mammoth bones placed alongside new elephant bones. Alongside these were monkey exhibits, seeds of the mahogany tree, scores of new ore and mineral specimens, a tube

of vitrified sand from a lightning strike, and even a preserved two-headed kitten and an 80-pound turnip Peale had recently acquired. New human artifacts included the slippers of an Indian mogul, shells used as windows in Malabar, a Chinese lantern, an American Indian hatchet made of crystal, assorted American Indian moccasins and peace pipes, a grass rope from Kamchatka, and a Turkish knife.

All these artifacts, as well as those already present, soon became even more accessible to the public. Peale announced in the newspapers, right below his now recognizable Book of Nature with rays of light bursting forth, that he had added oil lamps to allow for "handsomely lighted" evening hours on Tuesdays and Saturdays "to accommodate those who may not have leisure during the day light to enjoy the rational amusement which the various subjects of the museum afford."[25]

In 1795, Peale published a catalog of the now 87 paintings hanging in the museum, with the catalog cover emblazoned with Alexander Pope's verse, "The Proper Study of Mankind is Man." Each entry was accompanied by either a brief biography of the subject or description of the scene depicted. With an eye toward both increasing ticket sales and formalizing his ever-growing inventory of natural history, mineralogical, and anthropological artifacts, Peale also began working on a series of printed catalogs about the scientific holdings of the museum not long after moving to Philosophical Hall. For this project, he worked with Ambroise Marie François Joseph Palisot de Beauvois, a French natural historian who had spent time in Africa and then Haiti, where he had fled the slave revolt. Upon arriving in Philadelphia, Palisot de Beauvois, who had exchanged a few letters with Peale

earlier, befriended Charles, took a special liking to Titian, and began establishing contacts for Peale at the vaunted Muséum National d'Histoire Naturelle in Paris.

As he worked on the scientific catalog with Palisot de Beauvois, Peale approached the Library Company for access to their books on all aspects of natural history. At the same time, he took to the newspapers to advertise his collaboration and to solicit catalog subscribers. Reminding readers of "the arduous undertaking that has almost exclusively occupied the last ten years of his life," he outlined a catalog that would not only "facilitate an acquaintance with the subjects of natural history in his repository," but also "present to the American, as well as the European world, an evidence of progress in a department of science." Peale was thinking grand, envisioning a series of catalogs to be published in English and French and priced at 25 cents each, with the total combined page count between three hundred and five hundred. Names of subscribers would "appear as patrons of science in the last number." But, no such list of "patrons of science" would ever appear.

The first catalog was published in 1796, with the Book of Nature on the cover, emanating rays of light as on tickets to the museum. It was also the last, in part because Palisot de Beauvois returned to Paris shortly after that. Also the subscription numbers were not sufficient to continue, and Peale found it "troublesome to collect the money from those who had given their names." The lone issue of *A Scientific and Descriptive Catalogue of Peale's Museum* is really no such thing. Because Peale saw this as an introduction to a series, he and Palisot de Beauvois "content[ed] ourselves with giving those general

principles which are necessary for understanding the work." What they published was some very general thoughts on natural history and a tribute to Linnaeus, listing and presenting an anatomical key to a few dozen species at the museum. Peale would later use the information from *A Scientific and Descriptive Catalogue of Peale's Museum* in a series of lectures he would present at the museum, but as a stand-alone effort to catalog the museum, in part to attract new visitors, it was an abject failure.[26]

As he worked on that catalog, however, Peale's campaign to transform his museum into a national institution moved from private to public. In a newspaper article titled "Memorial to the Pennsylvania Legislature," Peale, addressed the governor and both the Pennsylvania Senate and House. He wrote that "among the various subjects which claim your attention, none brings with them so uniformly their own reward, as those connected with the encouragement of the arts and sciences." Peale told "that a large portion of his life has been devoted to the establishment of a Grand National museum . . . that though he has done much, there still remains much to be done . . . yet he contemplates the great incompetency of an individual to give that degree of perfection to a grand deposit of the works of nature and art, which can alone flow from national encouragement." This petition for national support was initially tabled in both the State Senate and State House, then eventually read and dropped. The very same week that he published "Memorial to the Pennsylvania Legislature," Peale wrote a short note to a congressman from Massachusetts to solicit aid, but again to no avail. Not long after, he was proclaiming that "if a well-organized museum is an epitome of the world . . . then I ought to receive the aid of all public bodies."[27]

That dream of a national museum was always tied to the creation of an establishment that would be a "successful rival to the boasted museums in Europe," but be more inclusive, not merely serving "particular classes of society only." While the path to such an internationally renowned Enlightenment temple in Philadelphia did not necessarily require recognition and assistance from the very museums and collections in Europe that Peale wished to share the stage with, such recognition and assistance would certainly speed the process. Above and beyond the new samples from collectors, naturalists, traders, and enthusiasts from Europe, including Adrian Valck, consular for the Netherlands, slow progress was being made toward recognition and assistance. In one instance, Jefferson wrote Peale: "I have received a proposition from Europe which may perhaps be turned to account for the enlargement of your museum. The hereditary prince of Parma, a young man of letters . . . is desirous of augmenting his cabinet of natural history by an addition of all the American subjects . . . [and] will give those of Europe which can be procured or of which he has duplicates in exchange." Jefferson suggested that perhaps it "would suit you to enter into this kind of commerce." It did indeed suit Peale, who wrote the prince, and sent along "a small collection of birds" to start such an exchange program. The young man of letters, for reasons unknown, appears not to have reciprocated. Much more promising, and indeed much more important in terms of international standing, was an exchange Peale was involved in with the leaders of the Muséum National d'Histoire Naturelle in Paris.[28]

Initially working through Palisot de Beauvois, his former collaborator on the scientific catalog, who was now back in Paris,

Peale had made it clear to those at the Muséum National d'Histoire Naturelle that he was keen on an exchange of material. To his delight, a reply came from the two most powerful men at the museum, Jean-Baptiste Lamarck, a disciple of Buffon's who was now director, and his colleague Étienne Geoffroy Saint-Hilaire, professor and the museum's secretary of administration. "We are pleased to seize an opportunity which can afford us some communication with a naturalist of your merit," Peale read, no doubt with a smile on his face. "We shall send you with pleasure and care a collection of the European productions in exchange for the Americans, which your love for the science of nature impels you to collect, be so kind as to correspond with us on this subject." Lamarck and Saint-Hilaire made special note of how much they would relish some mammoth fossils, an opossum, if there was one that could be spared, as well as bear, roe-buck, weasel, bat, and beaver specimens. They added that, in case preservation was an issue "as to great animals . . . we would be satisfied with the skins but for God's sake leave to the skin the skull and bones of the feet."

Peale seized the opportunity, and in a series of letters to Saint-Hilaire, described in minute detail the specimens that he was sending. Preserved specimens included a screech owl, grey squirrel, crow, and "scarlet sparrow." He also managed to ship over a live opossum, black snake, raccoon, hawk, and bald eagle, as well as a copy of Titian's *Drawings of American Insects*. "In short," Peale told his new colleagues, "I will send specimens of every kind of animal of this country which I can procure in duplicate . . . so that I hope to be able to afford you ample matter for researches into natural history and a comparative view of the production of the New and Old World." And unlike the

prince of Parma, Saint-Hilaire kept true to his word: "depend on the reciprocation on our part," he had written Peale, and upon his return from a trip to Egypt sent along 54 bird specimens."[29]

In late 1796, shortly after the birth of his newest son, Benjamin Franklin Peale, Charles, working with now 18-year-old Rembrandt and 22-year-old Raphaelle, concocted a plan to open a satellite branch of the museum in Baltimore. There were enough items in Philadelphia to seed such an enterprise. Rembrandt and Raphaelle could run the operation, and should it succeed, the Baltimore Museum would contribute to his mission to enlighten, generate another source of reliable income, and serve as evidence of the reach of the Philadelphia Museum. What's more, Rembrandt and Raphaelle would get some training in curating a museum, which might prove useful when 55-year-old Charles eventually decided to retire. In the October 25 issue of the *Federal Gazette and Baltimore Advertiser*, readers were "respectfully informed that Raphaelle and Rembrandt Peale, late of Philadelphia, having collected a number of articles of natural and artificial productions, together with their paintings, they have opened rooms at their house in Frederick Street, next door to the S.W. corner of Water street . . . under the title of BALTIMORE MUSEUM."

The Baltimore Museum would take its mission from the Philadelphia Museum, to "become more and more worthy [of] the attention of gentlemen of science, who well know that from natural history the wants of man are satisfied." Admission, as back home at the main branch, was set at a quarter, and half that for children.

When the doors opened, the Baltimore Museum was already home to 64 portraits of "illustrious persons," and more than two hundred

preserved birds, mammals, amphibians, and fish, as well Native American artifacts. Details of the short life of the Peale Baltimore Museum—or more accurately the first iteration of the Baltimore Museum, for it would be reborn much later on—are sketchy. It seems that attendance was not sufficient to keep the doors open for long, and soon Raphaelle was back in Philadelphia, and Rembrandt had taken the portraits to New York to exhibit there."[30]

The Baltimore satellite had failed for now, but back in Philadelphia, the museum was attracting attention for a most unusual visit. The Philadelphia Museum had long housed relics from Native American cultures, and Peale was keen on attracting Native Americans as visitors, although scant details of such visits are in the museum records. That changed in a dramatic way in December 1796 when representatives from two Native American confederations visited. Based on the lengthy coverage in the newspapers, which dubbed the event "an accident of so extraordinary and interesting a nature," this visit was the talk of Philadelphia. A group of representatives from the Chickasaw, Choctaw, Cherokee, and Creek—four of the five tribes that made up the Southeastern Nations or the Five Civilized Nations as white people referred to them—had come to Philadelphia to negotiate rules for new trading posts with the United States government. While they were visiting, they stopped in at the museum. Unbeknownst to them, representatives from a rival confederation, including the Delaware, Kickapoo, Ottawa, Chippewa, and Shawnee, were also in the city, negotiating the last bits of the Treaty of Grenville, and they too were at the museum the same day. Each was shocked at the presence of the other, "manifest[ing] some degree of jealousy and indisposition to

associate together," the *Philadelphia Gazette* reported, but soon, "the obstacles to a friendly intercourse were gradually removed and the chiefs of the different tribes cautiously approached each other."

Chiefs from both groups agreed to return the next day to sign a friendship pact. When word of this reached the Washington administration, housed across from the State House in Congress Hall, the president dispatched Secretary of War James McHenry to oversee the ceremony with a message that might strike our ears today as grotesquely hypocritical. "Men of every color and language," McHenry told those gathered in the museum, "should live in peace and love each other." At that point, the chiefs "withdrew to a private room and entered into an alliance of peace."[31]

Not only was this turn of events a publicity coup, but it further solidified Peale's belief that the environment he had constructed in his museum promoted not just art and science, but our better angels. Before these groups met at the museum, they had "recollections of former scenes of bloodshed," Peale wrote. He continued in a self-congratulatory tone, noting that they now found "themselves in peace, surrounded by a scene calculated to inspire the most perfect harmony, the first suggestion was that as men of the same species they were not enemies by nature, but ought forever bury the hatchet of war." What Peale was soon calling "the grand conference held at the museum" prompted him to add two wax figures of Native American chiefs who signed the peace alliance. The wax renditions of Red Pole and Blue Jacket were likely based on life masks that Peale made shortly after the alliance was signed on December 2. These figures, as well as others he installed, were generally regarded as welcome additions, though a few,

such as William Cobbett (a.k.a. Peter Porcupine) thought otherwise, writing in *Porcupine's Gazette* that he would just as soon gaze at "a dozen Democrats stuffed with straw." He added for good measure that he had "seen more for a half penny in the travelling hutch of an itinerant brute monger."[32]

As the new century approached, Philadelphians had more options than ever to Peale's museum, should they seek entertainment alternatives, rational or otherwise. Indeed, when Peale had rented his home at Third and Lombard, he did so to a Mr. Cress, who used it for his performing monkeys act, starring Co-Co the rope dancer and Gibbone, who, Cress claimed, would regale the audience with card tricks. Many of the alternative venues to the museum were advertised side by side in the same newspapers where Peale ran both his own ads and his "recent acquisition" notices. There were theatres, dances, concerts, fireworks shows, circuses, and gardens to visit. In addition, there were, for the price of a ticket that ranged between 25 and 50 cents, an elephant on display at Market Street, a three-thousand-square-foot panorama of London and Westminster at the corner of Market and 10th Streets, a "curious optical machine representing the scenes which took place in the dungeons of the Bastille," at the corner of Market and Third Streets, and an "exhibition of paintings on vitrified stained glass." There were also, for those with such inclinations, a "solar microscope," in which "the wings of a mosquito will be exhibited as large as an umbrella and a louse the size of an ox," as well as "a carriage, which runs without the assistance of horses, and goes as fast as the best post chaise . . . [with] an automaton in the shape of an eagle, chained to the

tongue of the carriage, and guided by the traveler, who holds the reins in his hands."[33]

Despite the availability of these alternatives and more, Peale's museum, which now housed a machine that produced static electricity, did more than hold its own. It thrived, with an annual attendance of around 12,000 to 14,000. The manner in which the museum had become part of the cultural milieu of Philadelphia is evident not only in attendance figures, a prominent spot in city guidebooks, and the now-famous Native American peace treaty, but in how it worked its way into everyday vernacular. During a public dispute over the position of port inspector, the *Aurora* quipped that the official involved would make a fine new specimen for Peale's museum. In an unrelated incident, the *Federalist Gazette* suggested that if Peale was looking for rare specimens to add to his exhibitions, he might consider trying to find an issue of its competitor, the *Aurora*, that was bereft of lies. And when Connecticut Congressmen Roger Griswold and Vermont Representative Matthew Lyon came to blows on the floor of the United States Senate, *Porcupine's Gazette* and the *Aurora* mocked the latter as the Lion of Vermont, and that "for farther particulars," regarding the Lion of Vermont, readers should visit Mr. Peale's Museum in Philadelphia," where "a specimen . . . may be seen every day."[34]

The success of the museum was tempered by a devastating blow to Charles and his entire family, when on September 18, 1798, Titian, who had only just turned 18, died of complications associated with intestinal problems. "Thus departed a youth whose talents for preserving subjects of natural history was very general, birds and

quadrupeds or fish were equally easy to him, and few men could equal him," Peale wrote. "He possessed also a genius for painting, and would, had he lived, with practice, excelled." Both father and son had seen this young man's future bound up with that of the museum. "He [had] laid a plan to furnish his father's museum with subjects of every quarter of the globe," Peale continued, "and had actually began his labors to accomplish this great object—to preserve duplicates of the animals of North and then of South America, putting what might be wanting in the museum . . . America has cause to mourn the loss of this promising youth." As Titian was laid to rest, an ode that his brother Rembrandt had composed was read to mourners:

> His early loss let science mourn
> Responsive with our frequent sighs
> Sweet flower of genius! that had borne
> The fairest fruit beneath the skies.

By this time, Peale had Moses Williams and a former Baker Museum employee helping him preserve and categorize specimens. In an attempt to assuage the loss of Titian, as well as to keep attendance at the museum strong Peale began an ambitious outreach program in 1799 to impress "on the mind of our citizens the importance of both of the study of natural history and the possession of a museum." First in that year, and then again, in even more expanded form the following year, Peale presented a series of natural history lectures for the public: 28 lectures the first year and 40 the second. While there certainly were other natural history lectures to be had in Philadelphia, none came close to rivaling these in scope.[35]

Peale advertised heavily in the Philadelphia newspapers, under the heading "LECTURES ON NATURAL HISTORY. MUSEUM." He informed readers: "The Book of Nature, is written in a character that everyone may read . . . The subjects in my museum being now sufficiently numerous and systematically arranged . . . I have prepared a course of lectures on this pleasing and instructive science." A ticket to admit one gentleman and one lady for the entire series of lectures cost $10 and came with the added benefit of free entry to the museum for one year. Ladies were not merely being used as a tool to encourage gentlemen, for the advertisements continued: "It is my wish to behold ladies among my hearers, for female education cannot be complete without some knowledge of the beautiful and interesting subjects of natural history," making this the first series of science lectures in the country to explicitly encourage female attendance.

In the first round of lectures, Peale presented two talks per week, one on Wednesday and another on Saturday, and to reach as broad an audience as possible, each lecture was presented twice, first at noon and then again at 7:30 p.m. The introductory lecture was held at the University of Pennsylvania on the evening of November 18, 1799, in the very same month that Peale's newest son, Titian II, was born. This lecture was not on a specific topic in natural history, nor a particular grouping—birds, mammals, and so on—but an opening salvo, designed to demonstrate the beauty and utility of the subject. "What more pleasing prospect can be opened to our view than the boundless field of nature?" Peale asked his audience. "A taste for natural enquiries is not only useful in the highest degree, but a never-failing source of the most exalted enjoyment: a more rational pleasure cannot possibly

occupy the attention or captivate the affections of mankind." Peale the deist extolled "the study of a science, whose truths so immediately interest him and contain the strongest evidence of an existing all-perfect and omnipotent author," and regaled his audience with tales of the birth of his museum, including Ramsay's offhand comments about the mammoth fossils 15 years earlier. For added effect, he told his listeners that some had called him mad for creating the museum, though he did not indicate who had dubbed him so.

In these lectures, Peale preached the practical benefits of natural history, including the domestication of animals, the mastery of crops, and the danger of tinkering with what today we would call ecosystems. He tapped into patriotic fervor, suggesting it is only when his museum gained international standing that the country would be respected as a true member of the league of enlightened nations. And as ever, he drove home the point that "the very sinews of government are made strong by a diffused knowledge of this science," which was why his "unremitted labor for years" was aimed at "establishing a national museum . . . with the pleasing hope, that my exertions, if not immediately, may ultimately tend to the PUBLIC GOOD.[36]

The 27 subsequent lectures that year were held in the parlor of the Peale home in Philosophical Hall—a rare instance of the museum encroaching on what was otherwise living space. Although the notes on those lectures are lost to time, based on the introductory lecture, and the 40 lectures presented the next year, all of which have survived, we know the first round of lectures were organized taxonomically and based primarily on material in the museum. This was supplemented with knowledge Peale had garnered on his own expeditions and

through his readings of Linnaeus, Buffon, and other natural historians. Naturalist and theologian Nicholas Collin, who attended, published a series of six articles about these lectures lauding "the well directed zeal of Mr. Peale to promote the Science of Nature." Collin, who was especially interested in the lectures as a representation of the museum as "a temple which no thinking person can frequent without adoration of the Creator," was pleased. He noted that "when proper instruction improves these devout sentiments, they will cause a deeper impression and higher elevation. Mr. Peale has done this."[37]

Perhaps empowered by the lecture series, two months into this outreach campaign, in an "Address to the Public," published in the *Aurora,* Peale declared, "I want public aid to enable me still further to extend the utility of the museum . . . a collection of everything useful or curious—A world in miniature!" He threatened yet again that "if the citizens of Philadelphia will not make exertions to foster an important school for their own and their children's use . . . I am willing to accept a proper provision to render my museum a public establishment . . . [in] some other city in the union." As before though, he took no such action when newspaper appeals fell on deaf ears at the state and national level.[38]

It was the following November, in the second round of lectures, when Peale expanded the number to 40, that Philadelphians got a true sense of just how grand the museum had become. Tickets were initially priced at $12 for the entire series, then lowered to $10. Advertisements again emphasized that women were not only welcome, but that Peale "will spare no exertions to accommodate those who may honor

him with their company." Lectures were held three times a week, on Tuesdays, Thursdays, and Saturdays. As with the first series, the introductory lecture was held at the University of Pennsylvania but was a grander affair this time round. An advertisement lauded an event that would be "accompanied with vocal and instrumental music, two pieces of which have been expressly composed for the occasion."

The subject matter of the introductory lecture was similar to that of the opening lecture the prior year, though Peale did add in the tale of the Indian peace treaty signed in the museum, some general thoughts on the history of museums, particularly the British Museum, the Muséum National d'Histoire Naturelle in Paris, and the Natural History Museum in Madrid. Perhaps the most notable addition to the introductory lecture was Peale's moralizing about both war and the role of women in an enlightened society. While his arguments on these matters were not completely radical, they were anything but mainstream at the time. Peale bemoaned the horrors of war, explaining that natural history teaches us that this is a uniquely human phenomenon, unknown among animals. He implored his audience that "if one hundredth part of the sum lavished on war were applied to the encouragement of science, would not the condition of millions be ameliorated and the world then be a paradise compared to its present situation!" With respect to the role of women in an enlightened society, he told his listeners, that because the "science of nature, when viewed in its full extent and true meaning . . . is the foundation on which morality is built . . . our daughters have an equal right with our sons," to such knowledge, "and if we consider what kind of education is most useful, we will find generally that which benefits our sons, may

equally be serviceable to our daughters." At the same time though, the introductory lecture does see Peale breaking from his normal Enlightenment trope that his museum was meant for all, noting that one reason to charge admission to the museum was to "keep out the idle rabble, who, otherwise . . . might injure the subjects."

The introductory lecture, like so much else, was also a pitch that the museum merited national recognition and national support. Peale went so far as to tell audience members that foreigners were shocked that such support was not already in place, and, that at times, he had "to screen my country from obloquy which some strangers, on finding government does nothing to aid my labors, have said it deserves." It need not be that way, he told the lecture audience: "We have the resources, or may obtain them, by some exertions."[39]

The 39 subsequent lectures, which when transcribed by Peale ran more than seven hundred pages, were again held in the parlor of his home in Philosophical Hall. A tour de force on mammals and birds (but not fish or amphibians), these lectures covered the natural history of everything from orangutans, baboons, elephants, mammoths, mongooses, bats, anteaters, hyenas, seals, weasels, cougars, porcupines, opossums, beavers, coati, zebras, hippopotami, tapirs, and dolphins to vultures, eagles, hawks, owls, and parrots, toucans, magpies, peacocks, partridges, pigeons, and larks, along with hundreds of other bird and mammal species. In each case, Peale, using visuals from the museum when they were available, did his utmost to convey not just what the animals looked like, both when young and mature, but what habitat they lived in, what they ate, what vocalizations they made, how they behaved in the wild, including

mating rituals and acts of parental care, and, on occasion, what role they played in their larger community of animals.[40]

Peale sent the introductory lecture to President-elect Jefferson. Jefferson "read it with great pleasure," and only "lament[ed] that while I have been so near to your valuable collection, occupations much less pleasing to me have always put it out of my power to avail myself of it." When Peale replied on March 8, 1801, Jefferson had been inaugurated president all of four days earlier, and the museum had remained lit all week in honor of his friend's ascendance to the highest post in the land. Peale told the president that his response "afford[ed] me much gratification." Presuming that Jefferson might "still find leisure to devote some attention to the minutiae of public good, in objects which promise the economy, convenience, and comforts of life," Peale next described, at great length, his "new hobby horse," a new fireplace/stove "that occupied all the leisure time this winter that could be spared from my lectures." Among other uses, the stove would help warm winter visitors to the museum.[41]

Shortly after both this exchange with Jefferson and the completion of the lectures, Peale boarded a stagecoach from Philadelphia to New York City to commence an expedition that would bring the museum and its proprietor into the international spotlight.

CHAPTER 4

Dinner for 13 Inside a Mammoth

In September 1800, between the two lecture series, Peale came across a pair of letters, one from Sylvanus Miller and one from James Graham, reprinted in the *Medical Repository Journal*. Both letters were directed to Peale's colleague Samuel Latham Mitchill. Peale feasted his eyes on Miller and Graham's description of a treasure trove of mammoth bones found in a marl pit on John Masten's farm near Ward's bridge, a few miles west of Newburgh, New York. A year earlier, a huge thighbone had been dug up on Masten's farm, and not long after that, locals joined in a three-day gathering that was part dig and part celebration, with "men requiring the use of spirits." They uncovered many more mammoth bones, all of which were now laid out on the floor of Masten's granary.

The *Mercantile Advertiser* was soon running tantalizing headlines like "Bones of a Mammoth or some other Wonderful Animal." The articles titillated readers with tales of "a monster so vastly

disproportionate to every creature; as to induce a momentary suspension of every animal faculty but admiration and wonder . . . a fearful figure—his head extended to the summit of an ordinary tree, he could seize his prey if sheltered among its branches." Peale had written many times how the mammoth bones he had sketched 16 years earlier had given rise to the museum. Now the giant beast had him in its grip again.[1]

The area around Newburgh was peppered with sites where mammoth bones had been uncovered over the years, leading Graham to speculate on "the great probability that these animals must have been very numerous in this part of the country." But it was not just the hoof bone that had been found at Masten's, or the rib, or the massive thighbone, 40 inches in circumference, or the skull section suggesting nostrils eight inches in diameter, that captured Peale's fancy. Nor was it just the quality of specimens that had been uncovered so far: "a spectacle truly astonishing," Miller wrote, "they appear little decayed by the lapse of time." The real lure was the promise of something truly remarkable. Though Peale read that "the bones here [already] discovered lay buried about ten feet under this marl and earth," what caught his imagination was Miller's assessment that "there were now prospects of procuring the whole of the skeleton . . . nothing but want of exertions, or means to defray expense, will hinder the whole of them from being procured."[2]

Who better than he, Peale reasoned, to procure and piece together the mammoth for the first time ever? He certainly did not want of exertions on the subject and his credentials for the job were unmatched: natural historian, curator of the only true natural history museum in

America, tinkerer with all things mechanical, as might be needed for such an expedition. And, with just a little help, he could generate the sizable funding needed to undertake such an endeavor. It would be a prize, an over-the-top specimen, sure to both enlighten and generate ticket sales for the museum's coffers.

At the time, only one large-scale skeleton in the world had been reconstructed from fossil remains: a megatherium or giant sloth that had been discovered in Argentina and then shipped to Spain in the early 1790s, and that reconstruction was at the hands of a different group than those responsible for its discovery and exhumation. Peale's mind was set to racing as he read Miller and Graham's tale of a vast repository of mastodon bones laid buried for millennia, patiently waiting for a bold soul to bring them forth from the earth and make them whole once again. As Rembrandt recalled, his father "immediately proceeded to the spot," which though a bit hyperbolic, since preparations would take time, and Peale did not set out for Newburgh for months, did capture the spirit of the moment.[3]

Peale was not the only person, or even the first, to make a concerted effort to get his hands on the bones in and around Masten's farm. Jefferson, along with Peale, had been part of the American Philosophical Society's 1799 "bones committee," whose mission was "to procure one or more complete skeletons of the mammoth." He badly wanted them, as decades earlier the mammoth had played a role in an argument over American degeneracy that he been embroiled in with the Comte De Buffon. When Jefferson heard of the trove of bones in Newburgh, he set to action. As he waited for Congress to settle the fiery 1800 presidential election, he wrote to New Yorker

Robert Livingston. Jefferson offered his colleague from New York the secretary of navy position should he become president. He also informed Livingston that he had "heard of the discovery of some large bones, supposed to be of the mammoth, at about thirty or forty miles distance from you, and among the bones found, are said to be some of which we have never been able to procure . . . The bones I am most anxious to obtain are those of the head and feet." Could he trouble his ally, Jefferson continued, dangling a cabinet position before his eyes, "to engage some of your friends near the place to procure for me the bones above mentioned? If they are to be bought, I will gladly pay for them whatever you shall agree to as reasonable." No one was better connected in New York, and so the request to Livingston rather than to others, including Peale, made sense. Livingston gave it his all, but his inquiries suggested that neither Masten nor the folks who helped dig up the bones saw them as "common property" and they were not keen on giving up their find. Although Livingston was unable to procure any of those mammoth bones for Jefferson, some of his letters to Jefferson on the mammoth were read to the American Philosophical Society, turning up the mammoth volume in Philadelphia.[4]

On the morning of June 5, 1801, Peale boarded a stagecoach from Philadelphia to New York City to examine what was and wasn't at Masten's farm, what was and was not for sale, and how feasible future digs would be. It was a crowded coach, and Peale's fellow passengers included a Frenchman who spoke no English alongside a loquacious Englishman, each keen on peppering Charles with political queries. He tried to parry their questions with general comments on "the folly

of nations making war." However, when "John Bull having wetted his whistle," began criticizing the United States, Peale felt obliged to show the Englishman the error of his ways.[5]

Upon arriving in New York City, Peale called on his DePeyster in-laws. There he caught up on family matters and taught them how to use a portable steam bath he had constructed to stave off, or if need be, cure disease. Peale had to employ the device himself shortly thereafter when he took ill "with a sick stomach . . . chilliness . . . gripping in [his] bowels." Four days after alighting in New York, he was introduced to Dr. Mitchill, to whom the original *Medical Repository* letters on the Masten mammoth bones had been addressed. Mitchill promised him a letter of introduction to one of the authors, James Graham, who lived near the Masten farm. That letter arrived on June 17 and soon thereafter Peale hired a sloop, the *Priscilla*, to sail him up to West Point, 15 miles south of Newburgh.[6]

Weather delays held up Peale's ship's departure, during which time he conversed with a physician, who told him of his new device to preserve potatoes. Peale immediately "wished to make the experiment" to test it. The *Priscilla* lifted anchor and set sail up the Hudson on June 19. Along the way, though he "regretted that [he] had not made better provision for [his] designs . . . [for he] had no sort of colors with [him]," Peale sketched the views from Fort Lee, the Palisades, and the spot where Benedict Arnold had escaped after committing his treachery. When things got boring, he and the other passengers threw some logs overboard and measured the speed at which they moved in the waters around them.[7]

Disembarking at Fort Putnam, near West Point, Peale stayed briefly

with the fort's commander. Two days later, he boarded an eight-oared barge up to Newburgh, and after a few inquiries about the bones, he secured a horse and arrived at the home of James Graham. Graham told Peale that he would be happy to accompany him to the Masten farm the next morning. The farm was located near a large pond three miles due west from where Peale's barge had docked on the Hudson.

Before him, on the granary floor of the Masten farm, though "many [bones were] still wanting," Peale was treated to the "head and neck and the greater parts of 3 legs, also the bones of the hips" of a mammoth. He asked, and was granted permission, to make life-sized sketches of each bone using a quire of paper he had brought with him, so "a better idea would be had of them." As he began drawing, the Masten family asked him to join them for dinner. While they dined, one of Masten's sons asked Peale if he might be interested in buying the bones. Peale was surprised, as he had been told by "everybody in the neighborhood . . . that I should have no chance of getting [the bones]." But he saw the offer as sincere, as he had heard that Masten was charging people to have a look, and that not many of the locals were taking him up on the offer, and so the Mastens might have reason to sell after all. Peale inquired about price and the family suggested he make them an offer. Sensing "it would be best to make as liberal a price as I could well afford," Peale proposed a generous two hundred dollars for the bones and an additional one hundred dollars as an option "for the liberty of getting up the remainder." The Mastens balked and asked if he might not do better. Peale suggested they ponder his offer that evening and see what might come of it in the morning. After a bit of horse trading, a deal was struck. Peale would buy a "handsome gun" for Masten's son and pay the farmer

himself two hundred dollars for the bones and the rights to return and excavate for further mammoth remains. For good measure, and to see that all the Mastens were rewarded for their hospitality, when he sent the gun for Masten's son, he also included some calico for the farmer's wife and a silk handkerchief for his daughter.[8]

On June 25, Peale scouted sites at the Masten farm for future digs. The pits there had been dug by Masten to gather marl, a lime-rich calcium carbonate clay that was used as a fertilizer. Marlstone also happens to be especially conducive to the process of fossilization, not that Masten knew that or would have cared had he known. Many of the pits Peale found were 12 feet deep and full of water, and he quickly recognized the "Herculean task to explore the bottom where the remainder of the bones are supposed to lay." The next morning he packed the bones he had already purchased into a wagon for the ride to Newburgh where they and he would board a ship down the Hudson, eventually reaching New York City on June 28. But before he departed, Peale needed to deal with one last matter, which was Masten's surprising skepticism that he would ever return with the necessary equipment for a full-blown paleontological dig. Peale allayed any such notions. "I told him that completing the skeleton was an object of vast magnitude with me and he might depend on it," which Peale noted in his journal "seemed to satisfy the old gentleman."[9]

Word of Peale's arrival in New York City with the bones, "flew like wildfire," and more than 80 visitors, including Vice President Burr, came to see the remains of the behemoth. Peale savored the attention the bones received. It was pleasing "[that] everybody seemed rejoiced that the bones had fallen into my hands," he recorded in his diary.

"It seemed to me a general sentiment that with me they would be preserved and saved to this country." He heard but one lone criticism, and that was from Dr. David Hosack, a physician and botanist who was working on a grand botanical garden for New York City. Hosack thought the bones should remain in their home state of New York. Peale recognized both the scientific and pecuniary value of what he had in his possession. Using a tactic he had used before, Peale told Dr. Hosack to "give me sufficient encouragement and I would bring them and the museum also to New York," and further noted he "was a citizen of the world and would go to that place which would give most encouragement to my favorite science." Hosack was in no position to provide such encouragement, and so on June 29, the bones were packed into two hogsheads and two barrels and deposited on a schooner back to Philadelphia and the museum. With an "ardor to return and explore the boggy bottom," that very same day, Peale began writing of what he was certain would come next. "The grandeur of this skeleton when completed," Peale wrote Jefferson, "will I hope excite your curiosity so far as to produce me the favor of a visit to the museum and that you may enjoy pleasure while contemplating the magnitude of the animal and the manner of its support." The president's curiosity was indeed excited, with Jefferson congratulating Peale on his "zeal enough to devote himself to the recovery of these great animal monuments."[10]

Peale next took a coach ride from New York back to Philadelphia that included an impromptu rescue mission of a man who had fallen down a well, as well as having to suffer a fellow passenger, a "disagreeable fellow . . . a blockhead . . . and his nonsensical prattling." He arrived back in Philadelphia on July 3, one day shy of a month

after he had departed. Not long after that, he wrote Graham about his plan to return to the Masten farm for a dig. That dig would be time-consuming and expensive, and so after showing his drawings to the American Philosophical Society on July 17, Peale approached Robert Patterson, the society's vice president, as well as the person who had donated the first specimen, a paddlefish, to his museum. Peale asked Patterson about a loan of five hundred to underwrite the return to Masten's farm. The loan was granted. At the same time that he was trying to piece together the bones he already had—which was no easy task because of "the rash methods which the farmers took to drag them up from the morass"—Peale began preparations for the next steps in the hunt for a full mammoth skeleton to display in his museum.[11]

In late July, Peale found himself again on the stagecoach *Diligence* en route to Masten's farm for a full-fledged paleontological expedition, this time accompanied by Rembrandt and James Woodhouse, a professor of chemistry at the University of Pennsylvania. Word of his intentions was already spreading. A week earlier the *Weekly Gazette* in Carlisle, Pennsylvania, noted "Mr. Peale of Philadelphia has lately returned from a trip up the North River, [and] within the space of two or three months he expects to have it in his power to put together a complete [mammoth] skeleton for the museum."

On the way back to Masten's farm, Peale tracked down the captain who had been at the helm on his last cruise from Newburgh, and inquired where he might obtain a pump to use to drain the marl pits that Masten had dug, as the timing had not worked out for receiving a navy frigate pump he had requested from President Jefferson. The

captain was more than obliging, lending him such a pump as well as "the use of tools of every sort . . . [and] quoils of rope . . . [to] be paid for on my return." Peale, Rembrandt, and the supplies then boarded a sloop and set sail up the Hudson, this time with Rembrandt doing the scenic sketches along the way. Landing in Newburgh on August 2, they purchased blankets, lumber, nails, axes, shovels, and sundry items needed for the expedition, and then worked with Masten to secure six wagons to transport the supplies, along with the pump and ropes, to the farm.[12]

Peale had sketched a device for emptying the marl pits, and he next began working with a carpenter and a wheelwright who began constructing the device. They pieced together a giant "Chinese" wheel, 20 feet in diameter, supported by a pyramidal truss system that Peale called "the crab." Attached to this was an elaborate pulley system with one-and-a-half-gallon buckets connected by chains to siphon the pits: a device that some have suggested was a "metaphorical chain of being." In addition to the pump he had borrowed, Peale had the wheel powered by the efforts of three people, who walked inside the wheel, "as in a squirrel cage." The wheel walkers, except for some exuberant local youths who wanted a go for the pure thrill of it, were paid nine New York shillings, or about a dollar per day plus a tempered measure of grog. Another team of men emptied the buckets into the trough and gathered bones in the pit when such were uncovered.

The whole operation caught the fancy of the locals. "Every farmer with his wife and children, for twenty miles round in every direction flocked to see the operation," wrote Rembrandt. "A swamp always noted for being the solitary and dismal abode of snakes and frogs, became the

active scene of curiosity and bustle . . . the greater part astonished at the whim of an old man in travelling two hundred miles from his home, to dig up as a treasure, at incredible risk, labor, and expense, a pile of bones, which, although all were astonished to see, many imagined fit for nothing better than to rot and serve for manure."[13]

Peale's initial trials, recorded in meticulous detail, found 20 buckets of water were being filled and emptied into the trough system per minute. Soon mammoth bones were being raised from the morass, the first being a leg bone. An energized Peale then found workers who, after a clergyman deemed it "a work of necessity" would labor on the Sabbath, provided he agreed to cover any fine that might be assessed by others not as evangelically liberal as the cleric who gave his blessing. By August 16, they had dredged up more foot bones, a tusk, a partial sternum, parts of grinders [teeth], but not yet a complete under jaw, the key to reconstructing the head. At that point, Peale determined "that the difficulty of obtaining any more bones [at the Masten farm] would be a waste of money." But the mission and the skeleton were far from complete.

At the advice of Graham and others, Peale moved the operation 11 miles west, and slightly north to the farm of a Captain Barber. Years earlier, a few mammoth ribs had been found in marl pits there, and when Peale approached Barber, he was granted ready access to the site and made a gift of the already discovered ribs. The dig at Barber's was hard going "with quick sands which caved in as fast as the men dig through it." The first hit was a toe bone, but Peale issued orders to leave the fossils where they were found, so he might get a sense of the whole from the pieces. Eventually they excavated 43 foot bones,

10 tail bones, numerous vertebrae, a scapular (shoulder) bone, and then a matching tusk to that found earlier at Masten's farm. But still no lower jaw or other critical bits that would allow for a complete skull reconstruction were uncovered. By September 2, diminishing returns—another rib here, another vertebra there, but not much else—led Peale, again at the advice of Graham, to explore a third marl pit. This pit was eight miles due west, on the tenant farm of Peter Millspaw, who had recently dug up a few bones of his own. Peale set up shop on August 7, making slight tweaks to the wheel-and-pulley system, and his team quickly uncovered rib, knee, and heel bones from the marl pits there. They also a found a skull top, that though decrepit, would help fill in some holes on the facial structure. Then when they were about to call it quits, a Mr. Fenton called Rembrandt over when his spear hit something that felt like a large bone. Exploration of the area uncovered a humerus, scapula, and then as if to "crown our labor," Peale wrote, the much sought-after lower jaw. "The woods echoed with repeated huzzas, Gracious God, what a jaw!" wrote Rembrandt. "How many animals have been crushed between it! was the exclamation of all, a fresh supply of grog went round, and the hearty fellows, covered with mud, continued the search."[14]

Peale paid off the workers and arranged for Graham to have his friends send him assorted mammoth bones they had collected, so that he would have as many pieces as possible when doing the reconstruction. He began the journey back to the museum on August 18 with four large crates weighing nearly 1,500 pounds in tow. On the way, citizens in New York City again flocked to see the bones. While Peale knew that "this exhibition of the bones might to some appear a

disadvantage in the gain of my future exhibition of them," he saw it as a strategic move to display the mammoth, even if not yet reconstructed, banking that the bones "only served to excite their curiosity to see the entire skeleton and I doubt not but many of those citizens of New York will come to Philadelphia on purpose."

Years later, beginning in 1806, he and Rembrandt helped found the Pennsylvania Academy of the Fine Arts. At the same time, Peale, in a juxtaposition of fact and fiction, put the mammoth dig to canvas in his painting, today called *Exhumation of the Mastodon*: a piece, he confided to Jefferson, he took to be one of his best. This was a historical painting, a painting that would satisfy his mentor Benjamin West's proclamation to him that "the art of painting has powers to dignify man, by transmitting to posterity his noble actions, and his mental powers . . . such subjects are worthy of being placed in view as the most instructive records of a rising generation."[15]

Exhumation of the Mastodon is set at Masten's farm against an ominously dark and threatening sky, with Peale's technological contraption penetrating the water-filled marl pit. Its pyramidal truss, wooden wheel spun by workers, bucket pulley system, and sluice for transporting water are all in place. Farmer Masten is seen emerging from the pit in the foreground in what some art historians have called a "faintly Satanic position . . . halfway in and halfway out of the marl pit, as in Milton's *Paradise Lost*." Peale paints himself in with one hand resting on a large drawing of mammoth bones, and the other hand pointing to a laborer in the pit holding a newly discovered leg bone. Workers abound in a painting with more than 70 subjects, some fully clothed, other half naked, some standing tall, others hunched, some

digging with their hands, others with tools, capturing the gamut of laborers of the day.

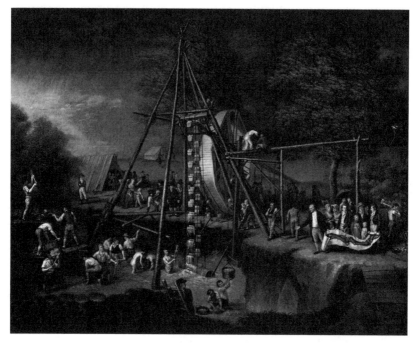

Exhumation of the Mastodon, by Charles Willson Peale, 1806–1808.
Used with permission from the Maryland Historical Society.

Though only Charles and Rembrandt were at the dig, invoking his artist's prerogative and a cavalier attitude between past and present, Peale added in a slew of absent relatives, turning this 49- by 61-inch oil on canvas into something of a family portrait. Sons Franklin and Linnaeus are seen stabilizing a log that keeps the water flowing away. Rubens is there in his characteristic hat and glasses, as is Raphaelle, holding a scroll, and Sophonisba under an umbrella. Daughters Sybilla and Elizabeth are there, and Peale's brother James, has been painted

in. To the left, the viewer sees Peale's deceased wife Elizabeth—she had died in 1804—between the mastodon dig and the painting of *Exhumation of the Mastodon*. She is pointing to the oncoming storm and lecturing to Titian II, while Peale's current wife, Hannah, has a more central place beside Peale. Absent relatives were not the only fictional additions. Likely in a nod to all he had done to help the museum by 1806, ornithologist Alexander Wilson, not present for the dig, is seen with arms folded in front of a nearby tent.[16]

Once back in his museum, Peale, working with Raphaelle, Rembrandt, Moses Williams, and sculptor William Rush, determined he had enough bones to construct not one, but two, mammoth skeletons, "filling up the deficiencies in each by artificial imitations from the other, and from counterparts in themselves." Rembrandt was adamant about the veracity of these reconstructions: "nothing is imaginary, and what we do not unquestionably know, we leave deficient; which happens in only two instances, the summit of the head and the end of the tail." The reconstruction was near perfect, though later Rembrandt would realize that he should have stuck with his first instinct, and placed the tusks pointing up, rather than down.

One skeleton, nearly 12 feet tall at the shoulder, nine feet tall at the hip, and 19.5 feet from tusk to tail, was ready for a museum unveiling by late December 1801. Peale made that known to all in a December 4 advertisement that he placed in the *Aurora*. This was to be no ordinary display. The mammoth was given its own room at the museum in Philosophical Hall, and an additional charge of 50 cents, above and beyond the normal quarter admission, was put in place.

Peale decided to have a celebrity preview to generate excitement before the exhibit opened to the public. He invited members of the American Philosophical Society to a Christmas Eve soiree for the unveiling and placed the invitation in plain view in the *Aurora*. This served not only to gather some of the elite together, with the hopes of their then spreading the word, but also as a thank-you to the society for advancing him the five hundred for the expedition.[17]

The mammoth room was opened to the public for the first time on Christmas day, and word spread quickly. "In another century the proofs of the existence of such an animal as the mammoth would have been totally lost," the *Aurora* wrote. "The skeptical part of mankind would have then called in question even the truth . . . Thanks to the indefatigable exertions of Mr. Peale, who at an expense of 2000 dollars has, as it were, embodied the truth, brought to light, that which had lain in obscurity for ten thousand moons, and would have puzzled the naturalist for ten thousand to come." All over the country, the public was going mammoth mad. There was talk of mammoth squashes, mammoth radishes, mammoth peaches, and mammoth loaves of bread. But that was nothing compared to the newspaper stories of a 1,300-pound mammoth cheese made from milking the cows of each of the 186 farmers in the town of Cheshire, Massachusetts. The cheese was sent to President Jefferson, who was delighted at what he deemed "an ebullition of the passion of republicanism."[18]

While delighted with the free mammoth madness advertising, Peale had no intention of relying on it. This was an extraordinary specimen, and an enlightened public needed to see it. And there was the matter of $2,000 of expenses that needed to be recouped. He advertised

the new exhibit in many newspapers, but it was in "Skeleton of the Mammoth," the most melodramatic of all the broadsides the museum ever produced, that he captured just how important a display this was. "Of this animal, it is said the following is a tradition, as delivered in the very terms of a Shawnee Indian: 'Ten thousand moons ago, when naught but gloomy forests covered this land of the sleeping sun, long before the pale man . . . a race of animals were in being, huge as the frowning precipice, cruel as the bloody panther, swift as the descending eagle and terrible as the Angel of Night. The pines crashed beneath their feet; and the lake shrunk when they slaked their thirst.'" The legend, the broadside indicated, was for all intents and purposes, true, and though "numerous have been the attempts of scientific characters of all nations to procure a satisfactory collection of bones," Peale wrote, he had at last "accomplished this great object." Such an animal, the broadside continued, was waiting at the museum every day and every evening (by lamp light) except Sunday. If that was not enough to whet the appetite of a public hungry for rational entertainment, Peale had Moses Williams distribute the broadside throughout the city while on horseback wearing "feathered dress" and preceded by a trumpeter. The advertising worked. Of the $2,000 in expenses, including the loan from the American Philosophical Society, $1,831 was recouped from mammoth room ticket sales in the first year alone, and, over the next decade, the exhibit yielded almost $7,000 in receipts. In 1801, annual attendance at the museum sat at about 12,000; over the next decade, largely as a result of the mammoth, that figure tripled.[19]

When visitors entered the mammoth room in the southeast corner

of Philosophical Hall they saw mounted monkeys, greyhounds, and parrots, as well as the jawbone of a whale, but all eyes naturally settled on the mammoth skeleton. Its massive frame appeared even grander in contrast to the mouse Peale had placed right by its side. The effects were palpable. Peale was certain that visitors would be in awe of the wonder before them, as was the Quaker lass many years later staring at the great beast in *The Artist in His Museum*. He was right. In the memoirs of lawyer, poet, and satirist Charles Godfrey Leland, he fondly recalls being a boy of eight "standing in awe before the tremendous skeleton." Francis Hall, a British Army lieutenant who traveled through America many years after the war, was struck by how "the human stature is, indeed, pygmean [*sic*] beside it." John Duncan, a visiting Scotsman concurred, writing, "a human being shrinks into insignificance beside the bony fabric of this enormous antediluvian." Journalist James Silk Buckingham described the grandeur he felt staring at "the huge creature that once ranged the prairies and forests of the West."[20]

The contrast between human and mammoth struck fear into some museum dwellers. "I looked on its enormous remains with astonishment," recalled Deborah Logan, granddaughter of a former lieutenant governor of Pennsylvania. Mrs. Logan's friend had told her of a lady that "went to bed after she returned home from seeing it with the terror it inspired." For those, like a Mr. William Blane, with a more biblical leaning, visions of the book of Genesis sprung to mind: "Perhaps we ought to imagine that Noah," Blane mused, "found it too large and troublesome to put in the ark, and therefore left the poor animal to perish."

To pair knowledge with awe and wonder, Peale had engravings

of the skeleton mounted on the walls, and shortly thereafter had an information packet of sorts. Rembrandt's *A Historical Disquisition on the Mammoth: A Great American Incognitum, an Extinct, Immense, Carnivorous Animal, Whose Fossil Remains Have Been Found in North America* was displayed in 92 gilded frames, some of which included speculation on what may have led to the extinction of the great beast. Though Rembrandt did not rule out humans as the cause, he thought it more likely they "must have been destroyed by some sudden and powerful cause; and nothing appears more probable than one of those deluges, or sudden irruptions of the sea which have left their traces (such as shells, corals, etc.) in every part of the globe." Whatever the exact cause, Rembrandt was "forced to submit to concurring facts as the voice of God—the bones exist: the animals do not."[21]

Peale knew how to seize a moment. What better time to renew his campaign for federal support for the museum? The mammoth exhibit was creating waves and his friend, Jefferson—natural historian savant and president of both the American Philosophical Society and the United States—was sitting in the Executive Mansion. Less than two weeks after the mammoth exhibit was opened to the public, and while he still was soliciting friends for any additional mammoth bones, no matter how minor they may think them, Peale wrote to the president. "The laborious, tho' pleasing task of mounting the mammoth skeleton being done," he began his letter, "gives me leisure to attend to other interests of the museum." Those other interests including pondering what to do with the large amount of material that had been collected or donated to the museum. "Huddled together," he told Jefferson, "[they]

lose much of their beauty and usefulness, they cannot be seen to advantage for study." What he needed was space and money: a means to "dispose them for exhibition and public utility."

Waxing poetically on the matter, Peale told Jefferson of his never-ending aspirations to create a museum that would diffuse "a knowledge of the wonderful and various beauties of Nature, more [so] than any other school yet imagined." His museum as it stood was a step in that direction, but a major expansion was needed for such plans to come to fruition. And not just any expansion, but a federally supported one, such that "in the end these labors would be crowned in a national establishment of my museum."

Peale knew that architect Benjamin Latrobe had drawn up plans for a new building on the south side of the State House in Philadelphia. He told Jefferson that he was "expecting that some grant," perhaps funded by a lottery, would "be made to erect such a repository to preserve this museum [in Philadelphia]," but, he added, perhaps such a grant might be unnecessary, that there might be another way forward. He enclosed an address he planned to make directly to the Pennsylvania legislature on the Latrobe space and the museum. "The time is now fully arrived when it has become expedient to decide the fate of the museum to which Pennsylvania has given birth," Peale's enclosure declared. "Means must be devised for its durability, perfection and public utility . . . for some permanent arrangement . . . if public, some of the states or the United States, may secure all the advantages of such an institution, by an inconsiderable appropriation."

Given this state of affairs, Peale next leveraged the possibility of a state museum by asking Jefferson about the possibility of a true

national museum in the country's new capital instead. "I wish to know your sentiments on this subject, whether the United States would give an encouragement, and make provision for the establishment of [my] museum in the city of Washington." It was true, Peale told his friend, that if he moved from the bustling hub of Philadelphia to much smaller Washington, ticket receipts would drop, "yet if some funds were provided to make up such deficiencies, the donations which would naturally flow in would amply repay the expense." Closing his letter with a reminder that "the mammoth skeleton is admired by numbers and many encomiums are bestowed on my labors of putting it together," Peale awaited the president's reply.[22]

Jefferson was sympathetic to his friend's appeal for national support: after all, this was a president who would soon be using the East Room of the Executive Mansion to lay out his own mammoth bones. "No person on earth can entertain a higher idea than I do of the value of your collection nor give you more credit for the unwearied perseverance and skill with which you have prosecuted it," Jefferson replied, "and I very much wish it could be made public property." Yet, despite pushing the constitutional limits of the executive branch to the breaking point the next year with the Louisiana Purchase, Jefferson claimed his hands were tied by Congress when it came to national support for his friend's museum. "I must not suffer my partiality to it to excite false expectations in you, which might eventually be disappointed. You know that one of the great questions which has divided political opinion in this country is whether Congress [is] authorized by the constitution to apply the public money to any but the purposes specially enumerated in the Constitution," Jefferson wrote. Alas, "those who hold them to

the enumeration, have always denied that Congress has any power to establish a National Academy." He reminded Peale a second time that the blame lay with unenlightened congressmen, not with him. Jefferson then added that a few in Congress would support federal aid for such worthy endeavors. "I am persuaded the purchase of your museum would be the first object on which it would be exercised," but that would not suffice as "I believe the opinion of a want of power to be that of the majority of the legislature." Jefferson closed his letter by telling Peale that should his own dream for the University of Virginia ever come to be, he would be pleased to house Peale's museum there, but that might never happen and so "the legislature of your own state furnishes at present the best prospect."

Disappointed, Peale accepted Jefferson's decision, or at least told the president as much. "Your communication has satisfied my mind," he replied, as it "seemed from the present nature of the constitution, it would be an unproductive [effort]." Instead he would again appeal to the state legislature to "advance the interest of science" and ask that they hold a lottery, the funds to be employed to pay for construction of a new building near the State House Garden that would serve as an extension to his museum.[23]

That attempt came in the form of an open letter from Peale to the state legislature published in the *Philadelphia Gazette* on February 19, 1802. In it, Peale modified the details, but not the message from the enclosure he had sent Jefferson and played to early American nationalism in a more direct manner than he had to the president. In his "Memorial for Public Assistance to [the] Museum," Peale presented himself "not solely as the proprietor of the museum, but

as an American having at heart the importance of an institution." He reminded members of the legislature, as well as the citizens of Pennsylvania, of "the honors and advantage which Europe derives from similar establishments in all her capital cities." America, he believed, deserved its share of such advantage, and he provided the opportunity through an avocation that had "occupied [his] unceasing attention for years, but has been restricted, not so much from the difficulty of collection and arrangement, as the want of a SUITABLE BUILDING." Surely, Peale thought, an astute and enlightened political state legislature could see that "numberless advantages are now within their easy reach; they will without delay, be securing them, acquire a high rank of honor and the everlasting gratitude of science."

The request was, as was the wont of the legislature, sent to committee. Never one to sit by idly and let events unfold as they might, Peale wrote Isaac Weaver, the speaker of the House. Peale said that he hoped that the museum would be viewed as a "place to diffuse universal knowledge of things," if for no other reason than that "those the least acquainted with the merits of a well-organized museum, must be sensible, that nothing which human invention has yet found out, can so forcibly impress sentiments of piety, and a reverence for the supreme Creator, as a sight of that infinite number of animals that are found in the various climates of the globe, inhabiting the air, lands and seas being placed in such order." Such a place as his museum, as it stood, and as it might stand expanded, should inspire and enlighten. "Whatever may be the religious sentiments of men," Peale wrote Weaver, "all that enter into a house so furnished, are inspired with awe, and real piety." What's more, if the state adopted the lottery system to fund a new building in

the State House complex, Peale, noted, this could all be accomplished "without the least expense to the government of Pennsylvania."[24]

Weaver and the Pennsylvania legislature were swayed, to an extent, by Peale's case. Although "Impressed with a sense of the general utility of Mr. Charles W. Peale's museum, and of the public spirited exertions by which he has endeavored to render it a national benefit," the legislature decided, that they would not provide the funds or a lottery to construct a new building. However, now that the state capital had moved to Lancaster, they would "highly approve of the appropriation of part of the [old] State House" for use by the museum. This was the building where both the Declaration of Independence and the Constitution were debated and signed. In particular, in exchange for assurances that he would maintain all rooms in good stead, and for a guarantee that all citizens would have access to the State House Gardens, both of which Peale agreed to, he was granted use of one room on the lower floor of the State House [except on election day] as well as the entire second floor. Neither this space nor the space at Philosophical Hall was enough for Peale's expansionist dreams, but together they came close.

Peale immediately began moving some material to the State House. He posted a sign reading "MUSEUM: GREAT SCHOOL OF NATURE" over the door on the Chestnut Street entrance to the new wing of the museum. Over the entrance from the State House yard, he added "SCHOOL OF WISDOM: The Book of Nature open, explore the wondrous work and institute of laws eternal." Once visitors entered, another sign above the stairs proclaimed, "Whoso would learn wisdom, let him enter."[25]

Peale had to decide what should stay in Philosophical Hall and what

should be moved to the State House space? He opted to move most of the items in the museum, including many he had not previously had the space to display, to the State House. These were housed in the State House's Long Room, on the second floor, where bird displays sat under two rows of portraits of "distinguished personages," including Franklin, Priestley, and Humboldt, and thousands of insect specimens were displayed. The Arts and Antiquities Room held 1,400 antique gem casts and items of Native American, Chinese, Greek, and various South American cultures, and the Antiques Room was filled with Greek and Roman statues. The Marine Room in the State House would be home to fishes, amphibians, corals, sponges, and a 185-pound bivalve with its three-foot shell. The Quadruped Room would house a grizzly bear, orangutan, giant anteater, llama, elk, peccary, jackal, various African antelopes, as well as many other species, but not the largest of all the museum quadrupeds. For remaining in the Philosophical Hall section of the museum, next to the Arts and Antiquities Room and adjacent to the Antiques Room stood the mammoth in its eponymous Mammoth Room, where it would remain for almost another decade. Or at least one of the mammoths resided there, for recall that Peale and his team had reconstructed two from the sortie to Newburgh, but only one had seen the light of day. That was about to change, and in a rather dramatic fashion, for behind the scenes, Peale had been gestating the idea of an international tour using the doppelgänger of the mammoth drawing all the attention in Philosophical Hall. This second, mobile, mammoth would serve as a statement that the museum was a major player on the world stage.

For the international mammoth tour, Peale recruited Rembrandt and 18-year-old Rubens. Because his poor eyesight would preclude Rubens from many occupations, Peale was priming him for an administrative position in his museum. The trip would provide Rubens with invaluable exposure to the museums in Europe, Peale wrote Jefferson, facilitating "a good and sure correspondence for a reciprocal exchange of natural subjects" between his museum and those in Europe. And, as with the Philadelphia Museum itself, the trip was not just about natural history, but art. Rembrandt had long wanted to study the masters and their works in Europe, and Peale concurred wholeheartedly. He wrote to Jefferson about how delighted he would be should Rembrandt, while on tour with the mammoth, also "take the portraits of distinguished characters in the large cities of Europe." Tickets sales from the mammoth tour would, if things went well, pay for Rembrandt's studies.

Though Peale worried about convincing "John Bull or Jack Frog that what they are looking at, nay holding in their hands, is really bone, is really a tooth . . . not a damned English impostor," he and his sons began preparations. The duration of the mission was left open-ended, but it was assumed it would be years, rather than months. At one point, Peale speculated they would "probably not return in less than four or five years." Venues would be determined as the tour progressed. After a planned exhibit in New York City to generate some start-up funds, England would follow. From there they would improvise. Paris was a likely next stop, perhaps Madrid after that, though Peale told a friend that "all the capital cities" of Europe were a possibility. Even an exhibition in Russia was not ruled out.[26]

They gave themselves a bon voyage present—one that they thought would surely gain some press, which it certainly did. On the evening of February 17, Rembrandt and Rubens hosted a dinner for 13 *inside* the rib cage of the mammoth that was staying put in the museum, a "collation WITHIN the BREAST of the animal, all comfortably seated round a small table and one of Mr. Hawkins's Patent[ed] Portable Pianos." The convivial atmosphere, combined with an ample supply of spirits, led to a round of toasts, including to "the biped animal man— may peace, virtue and happiness be his distinguishing character," and to "The American people—may they be as pre-eminent among the nations of the earth, as the canopy we sit beneath surpasses the fabric of the mouse," referring to the mouse skeleton placed beside the mammoth skeleton. Delightful and amusing as the dinner and toasts were, in addition to positive coverage in many papers, they were also lampooned mercilessly the next day in the *Port Folio*, a Federalist magazine that chided Peale for sending "Raphael [*sic*] and his Rembrandt round, Wherever toe-nails of a flea are found," and mocked the beast itself—"What toasts roar'd loudly thro' the mammoth's ear, or, were sweetly sounded thro' his wide posterior."[27]

On March 27, 1802, Rembrandt, his wife and daughters, and brother Rubens, along with the crated mammoth, arrived in New York City. After obligatory visits with their mother's side of the family, Rembrandt and Rubens began reconstructing the mammoth. An excited Rubens wrote to his father that soon they would be regaling him with tales of throngs of spectators "coming in to see our pet." Rembrandt posted a broadside, *A Short Account of the Skeleton of the Behemoth or Mammoth*, with a sub-header that the "Earth Sinks Beneath Him as he

Moves Along." The *New York Evening Post* ran an advertisement noting that the "extraordinary and enormous bones" would be on exhibit at Adam's Hotel on Williams Street from 9:00 a.m. to noon and 3:00 p.m. to 6:00 p.m., with additional evening hours from 7:00 to 10:00 p.m. on Tuesdays, Thursdays, and Saturday evenings.

The Peale's pet did not disappoint. People visited in throngs. Rubens reported to his father they had grossed $340 in the first four days as "visitors were much gratified," though there were some grumblings about the replacement wooden tusks that had been carved based on the originals on the Philadelphia exhibit. By April 19, gross receipts had topped eight hundred dollars. The exhibit was carried over from its originally advertised "short time," through June, and eventually brought in $2,000, which funded the voyage overseas, and then some.[28]

Sometime during the last few days of June or the first few of July, the Peale crew, with the yet-again-deconstructed mammoth in tow, boarded a ship to England. Peale had laid some of the groundwork, at least what was possible from Philadelphia, sending letters of recommendation to his friend Joseph Banks, president of the Royal Society, alerting Banks of who and what was on the way. "Your love and knowledge of natural history," Peale wrote his friend, "and exertions to throw light on so pleasing a science, induced me to offer my sons to your notice and patronage . . . aiding them with your opinion, how, and where, they should exhibit the skeleton, will, from your knowledge of mankind be of vast importance to them." He wrote a similar letter of introduction to Benjamin West, his mentor in art, and to Étienne Geoffroy Saint-Hilaire, his colleague in Paris.[29]

Peale also dispensed much in the way of paternal advice to his

Old World-bound sons, particularly young Rubens. He implored him to look to his older brother for guidance, to avoid all discussions of politics and religion, and to be leery of European dandies and "the frivolity of the coxcombs of any country you visit."

Harking back to his days as ambassador to France, Jefferson also had some thoughts to share with the Peale boys on the nature of the European audience that they wished to attract. Many people, Jefferson noted, would gladly pay to see the mammoth, and do so over and over, but "they revolt at being mixed with pickpockets, chimney sweeps . . ." And so, the president suggested, "Set three different divisions of the day therefore at three different prices, selecting for the highest when the beau monde can most conveniently attend; the 2nd price when merchants and respectable citizens have most leisure, and the residue for the lower description."[30]

Arriving in London in early September, Rembrandt and Rubens moved into a small third-floor apartment made up of a garret, parlor room, and bedchamber at Number 12 Fludyer Street in the Westminster area. Both to help plan for a mammoth exhibit and so that Rubens could gain some experience in the curatorial arts, they quickly took to visiting the British Museum, Gilbert Pidcock's menagerie of exotic beasts, John Francillon's collection of seven thousand insects, and the Leverian Museum, the latter of which, though not open to the common people, was open to Rubens. He reported to his father that it "had the completest and most interesting collection of natural curiosities." Young Rubens even managed to sneak in a masquerade ball with "Ms. Marsha," the daughter of their landlord, and seemed quite smitten with this "most beautiful and majestic looking young lady," all of which he

conveniently failed to mention to his father.[31]

Rembrandt and Rubens next rented a 22- by 30-foot room, with a 16-foot high ceiling, for the mammoth exhibit. The room sat in what had been part of the Royal Academy in the upscale Pall Mall area of London near the Shakespeare Gallery, the Historic Gallery, and assorted coffee and chocolate shops. The walls and floor of the soon-to-be mammoth room were covered in a green baize, and Rembrandt and Rubens took to painting the pedestal railing and gallows green as well. Advertisements touting "The very extraordinary SKELETON of the MAMMOTH, a species of gigantic animal which is not known to exist," were published in the *Morning Post*, and broadsides were distributed around London. The mammoth was reconstructed, and after a preview for "medical gentlemen whom Rembrandt invited" on October 2, the exhibit opened to the public the following day.[32]

Hopes were high that the response to the mammoth would be similar to that seen in New York. Those hopes were soon dashed. Less than two weeks after the exhibit opened to the public, ticket sales were only a tenth of what they had been for the corresponding period in New York. Rubens wrote his father, "I wish we were only in America once more, with the skeleton; I have no doubt we would make more than we shall here, for we pay so dear for everything, the expenses run away with the profits."

Peale encouraged them to persevere. Though initially optimistic that ticket sales would soon enough take off in London, soon he too became less sanguine. His first hint came from lack of contact from his sons. "The want of spirits," he wrote daughter Angelica, "prevented Rembrandt from writing for seven weeks." If that was not enough,

he feared all this might impact Rembrandt's focus and "prevent the improvement of his talents for portrait painting." Peale scolded his sons, writing "the imagination of a fond parent will paint disastrous scenes," when uninformed by far-off children. When his children did at last write of the exhibit, he learned that "very few Englishmen love to pay for looking at a dead set of bones." Though it was gratifying to learn that the likes of the Duke of York had visited, such visits would hardly serve to cover expenses, let along produce profit. Peale's friend Joseph Banks wrote that the fault lay not in Rembrandt, Rubens, or their pet, but on his fellow Londoners. "Everybody of real curiosity I believe went once at least to see it," the president of the Royal Society wrote his friend, "but sir, in the best peopled quarters people of this description are not so numerous as we would wish them to be."[33]

Peale consoled himself with thoughts of Rubens's growing knowledge of museums and his securing some specimens for the Philadelphia Museum, and with the notion that, at the very worst, Rembrandt could go to Paris and sell the mammoth to recoup costs. But the mammoth was never to see Paris or any city in continental Europe. "The best news I can tell you, is that we are all well from influenza, coughs and colds, and feel the balmy breath of spring," Rembrandt wrote, but though "every nerve has been strained . . . every cell in my brain has been racked," he knew the exhibit was doomed.[34]

On June 18, the London exhibit closed. Because England had withdrawn from the short-lived Treaty of Amiens and declared war on France the prior month, a mammoth visit to Paris was unfeasible. Rembrandt and Rubens instead took the "damned heavy load" on the road to Reading, where the mayor allowed them to use the council

hall to exhibit it, and in return, Rembrandt painted a portrait of the mayor's son. The mammoth next moved to Bristol. Its perambulations through the British countryside were followed closely and excitedly by those in Philadelphia, spurring visits to the museum back home, but changing venues did little to stir Brits from their apathy. "Perhaps a dancing bear would afford me more profit or almost any living foreign animal," Rembrandt wrote from Reading. Ticket sales remained paltry, driving the project further and further into the red.[35]

Peale stood good for his son's debts, and soon his sons and the mammoth were sailing back to America, arriving home in Philadelphia on November 13. The family and citizens of Philadelphia welcomed them all, though some in the press were not as kind. "We are happy to hear of [the return of] our great fellow countryman the mammoth and suite," opined a piece in *New York Morning Chronicle*. "Various reasons have been given for his [the skeleton's] abrupt departure from Great Britain, some say that he was expelled as an alien, others that Mr. Peale was apprehensive he might be seized as a war horse for the first consul, and others again, that Mr. P. had heard of the voracious appetite of the French soldiers, as also their late invention of extracting soup from bones, and feared his precious skeleton might be stewed down into a kettle of 'bone soup' for to refresh the army, after the grand expedition."

Following their father's advice that there might be "handsome profit by exhibiting it in the large towns in America," Rembrandt, with Raphaelle now replacing Rubens, packed up the second mammoth yet again. They headed out on an abbreviated tour of Savannah in January 1804. Charleston, South Carolina, was next that March. The skeleton was billed as "The Great Aborigine of America . . . the largest

and most extraordinary remains of the antediluvian world." But a law ostensibly enacted to "prevent puppet show exhibitions" was twisted into one taxing all exhibitors, and increased costs forced Rembrandt, Raphaelle, and the mammoth to leave. Next came Baltimore in May, where it went on exhibit in the Baltimore Assembly Room, which had formerly housed soirees hosted by the Baltimore Dancing Assembly. And though the tour of the south was not the disaster that the England circuit had been, the traveling mammoth never drew crowds like those of its doppelganger that remained in Philadelphia.[36]

THE MARMOT SLEEPS AND THE MAGPIE CHATTERS

The Peales' pet may not have engaged the hearts, minds, and wallets of the British, but back in Philadelphia, the fame of the mammoth had catapulted the museum to the status of not just a scientific icon, but a cultural one as well. Such an icon deserved its own guide, and so it was that in 1804, Peale printed thousands of copies of the "Guide to the Philadelphia Museum," one of the first documents to come off the museum printing press he had recently acquired. Eight pages long, the guide, in conjunction with *A Walk Through the Philadelphia Museum*, an unpublished 100-page-plus document that Charles penned both for his friends and for posterity, paints an unparalleled picture of the museum during the first decade of the 19th century.[1]

Peale's delight and pride in the opportunity to describe the museum radiates from the opening page of the guide, which informs the reader that the institution they stand within rivals "in value and utility any of a similar nature," and that the recent expansion to the State House

branch speaks to "the importance of the institution, and [makes it] more worthy of the State which gave it birth." And why not, the guide notes, quoting poet James Thompson:

Here, undisturb'd
By noisy Folly and discordant Vice,
On Nature muse with us and Nature's GOD!

The guide first covers the State House branch. A chime of bells near the great stairs at the entrance was rung when a visitor entered, at which point an attendant collected the 25 cents for a ticket and, in exchange, handed over a copy of the guide. The first entry in the guide made it clear that visitors should expect twists and turns above and beyond the world-class natural history collection and portrait galleries. Should they choose, visitors might even find it a shocking experience, for the first room described was the lobby, wherein sat a "galvanic device," a machine that generated static electricity charges for the brave of heart.[2]

From the lobby, visitors entered what Peale called the Quadruped Room, but what more accurately might have been labeled the Mammal Room, for it contained bats as well as quadruped mammals. Though the quadruped of quadrupeds—the mammoth—was over in Philosophical Hall, the mounted orangutan that greeted visitors as they entered the Quadruped Room was sure to grab their attention. The room ran 40 feet long and housed almost two hundred different species "mounted in their natural attitudes." The larger mammals were on one side of the room "placed on pedestals behind wire-netting . . . with their names in frames" gilded by Peale's daughter Sophonisba. Each specimen had

been mounted using a new technique Peale had devised that involved placing finely carved wood replacements where muscle had been "to preserve perfectly the true form." Smaller mammals were housed in individual glass cases on the other side of the room with "numerical catalogues in frames over each case [stating] the genera to which they belong, and their specific names, in Latin, English, and French." Peale felt obliged to apologize to the visitor "that this room large as it is, does not afford space sufficient for perfect arrangement," by which he meant that he could not, as much as he desired to, always group items in clusters defined by the Linnaean classification system.

Once the shock, or perhaps joy, of meeting the orangutan was complete, what greeted visitors was a cornucopia of all things mammal. Other primates included a red howler monkey, a mandrill that had been part of Peale's menagerie before it died, and what Charles labeled a "pygmy ape," likely a chimpanzee or a bonobo. Past the primates, as well as on the other side of the room, there were sloths, anteaters, hyenas, jackals, wolves, panthers, foxes, lynx, civets, coatimundi, weasels, otters, skunks, polecats, grizzly bears, badgers, opossums, shrews, hedgehogs, porcupines, guinea pigs, hamsters, marmots, various kinds of squirrels, hares, llama, deer, elk, and antelope. The latter had additional racks of antlers mounted about them. The last of the mammals, those of the flying sort, from the common bats of Pennsylvania to the long-eared bats of Batavia to the hooded Madagascar bats, were mounted over the doorway leading to a room devoted to their airborne brothers and sisters in the class Aves.

Members of Peale's "feathered tribe" resided in what Charles described as "an uncommonly elegant display" in the Long Room,

which ran 100 feet. When visitors entered, they first looked up a wall with Linnaeus's classification of birds printed in gilded frames. Interspersed between the many windows were 140 cases extending the length of the Long Room, each of which housed a bird set against "insides . . . painted to represent appropriate scenery; mountains, plains, or waters." And again, above each case was a frame in which Peale listed the species and genus name of the occupants and their common names in English, French, and Latin.

The glass cases, Peale proclaimed in the guide, were often stacked up, "rising twelve feet from the floor," and included birds from not only North America, but "a considerable number from South America, Europe, Africa, Asia, New Holland, and the new discovered Islands in the South Seas." Here were rapacious eagles, hawks, falcons and owls beside crows, rooks, nuthatches, sparrows, wagtails, jackdaws, thrushes, buntings, bullfinches, ducks, turkeys, chickens, geese, snipes, sandpipers, petrels, terns, cuckoos, quail, larks, woodpeckers, jays, and the like. The cases also included the more colorful or exotic members of the feathered tribe, including toucans, blue macaws, yellow macaws, purple crackles, hoopoes, bee-eaters, boobies, purple water hens, peacocks, golden pheasants, cockatoos, parrots, orioles, hummingbirds, flamingos, storks, ostriches, cranes, spoonbills, frigates, phaetons, and pelicans. It was not without cause that when Benjamin Latrobe needed a mounted eagle to use as a model for a frieze he was preparing for the center hall at the new legislative buildings in Washington, it was to the Peale collection in the Long Room that he turned for inspiration.

Above the cases sat 70 of Peale's most famous portraits, including an oversized painting of George and Martha Washington. In a loft over

the room, that at times had a small orchestra playing, sat a "well-tuned organ" that was, on occasion, played by a Mrs. Eberely "whose songs have given great satisfaction."

The Long Room was also home to the physiognotrace machine, where for a charge of eight cents, visitors could have cutouts of their profiles made by having an operator move a thin brass rod along the shadow of an individual's profile, with the rod transferring a miniaturized version of the outline onto a piece of paper that had been folded twice. When the outline was cut and the paper unfolded, each of the quarter sheets had empty space that outlined the sitter's likeness, often subsequently backed with dark colored fabric. These facilitated the exchange of copies of one's profile with family and friends. While the majority of sitters were male, Peale had initially targeted women, advertising in the *Aurora* that "while ladies are getting their charming faces delineated, gentlemen may be amused in examining the birds." Charles and his sons had trained Moses Williams on this device, and he was responsible for hundreds, perhaps thousands—the exact number is not known—of the eight thousand or so profiles sold each year at the museum. Peale allowed Moses to keep the proceeds from the profiles he cut. Peale freed the 27-year-old, now with a stable income, from his indentured servant role in 1802, though Moses continued cutting profiles at the museum, as a freeman, for decades.

At the far end of the Long Room sat cases that housed four thousand plus insect specimens. Here, Peale the tinkerer devised a new method for display. "Those species which are too small to be examined with the naked eye," he wrote in the guide, "are placed in microscopic wheels," to be viewed under "compound microscopes of

a new construction, adapted to a large collection of choice insects, one for opaque, and the other for transparent objects." In addition to the birds, insects, profile-making machine and organ, sitting at the east end of the room, between a series of windows, were cases upon cases of minerals and fossils. These included "various fine colored earths, proper for pigments; a variety of handsome crystals and precious stones, a [petrified] encrustation of a bird's nest and eggs; a petrified fish . . . Vesuvian lavas . . .amber enclosing perfect insects; sulphurs, bitumens, native gold, silver and other ores."

Next came the Marine Room, which was more than that, housing not just fish and sharks, but amphibians and reptiles, corals, sponges, and an eye-popping centerpiece housing the shell of a three-foot-long chama clam. This room was home to everything from swordfish to sunfish to the skin of a 16-foot South American snake.[3]

If the State House exhibits did not overwhelm, and if visitors were willing to shell out an additional 50 cents above the 25 cents they had already paid, they could head across the gardens and peruse the Philosophical Hall branch of the museum. Therein was the Antique Room. Peale described the contents: "several fine casts from the celebrated statues of antiquity, deservedly the admiration of the world, such as the Apollo de Belvidere, the fighting and dying Gladiators, the Antinous, Meliager [sic], Venus of the Capitol, Venus Calliope, the couching Venus, Paris, together with Houdon's Diana, besides 12 busts . . . and 10 Basso Relievo's." But, as it had been from the day it went on exhibit back in December 1801, the mammoth was the showstopper in Philosophical Hall.

Upon entering the Mammoth Room, visitors would cast their

eyes on a creature immortalized many years later in *The Artist in His Museum* and described in the guide as "valuable as it is stupendous, being an almost perfect skeleton, the bones belonging to one animal, and very few deficient. It is 11 feet 10 inches high and 19 feet long." That mouse was skeleton still placed next to the mammoth for scale and effect. Rembrandt, or perhaps Raphaelle, it is not clear which, used the juxtaposition of major and minor as an advertisement for the museum, penning "Dialogue Between the Mouse and the Mammoth" for the *Federal Gazette*, replete with verses like this between the cheeky rodent and the more introspective mastodon:

Mouse:
Gigantic monster without fear
I dare invoke thy mighty ear
Once wast thou terrible in might
And ruled, the dreadful lord of night!
Alas! how many year have fled
Since thou was numbered with the dead?

Mammoth:
Consult the aged Indian's lore
Ten thousand moons ago and more
What tho'o'er mountain lake or plain
Our mighty race no longer reign
Still I recollect with pride.
My gambols on the oceanside.[4]

The mammoth was not alone in its room, as it shared the space with "the skull of an unknown animal of the ox kind, the pith of the horn measuring 21 inches in circumference . . . small skeletons such as the monkey . . . encircling the door are the lower jaw-bones of a Whale, 13½ feet long." Nearby, in the Model Room, were wax figures of a "Chinese laborer . . . an African; a Sandwich Islander; an Otaheitan [Tahitian]; a South American; and Blue Jacket and Red Pole, celebrated Sachems of North America."

The effect of a visit to both branches of this museum in these years was palpable. "Knowledge is power," wrote one visitor in a small book Peale made available to those who wished to jot down a thought or two on their experience at the museum. "The ends virtue, the means pleasure" wrote another. "These are thy glorious works, parent of good," was how Joseph Priestley, quoting Milton, summed up his visit. But Charles's favorite entry in this visitor book must surely have been one by "E," who wrote: "Nature and Nature's laws lay hid in night. Till Peale . . . brought the dance to light."[5]

The museum was thriving, both as an Enlightenment bastion in the early republic and as a business supporting Charles and his family, and aspirations were, as ever, high. "The museum must be great," he wrote Jefferson, "as mediocrity, will stamp no value on it." It was already a large-scale operation and Charles ran every aspect of it. Still, by 1804, he knew he needed help both in the here and now, and as an eventual successor. Franklin, who was building toys and already displaying a bend to the mechanical, and Linnaeus were just school-aged children; Titian II was not even that old. Titian I would have been a candidate, but he was long gone. Twenty-six-year-old Rembrandt was one logical

choice, having been steeped in museum life since his days as a toddler, but he had thrown his lot in with painting and only painting, or at least so it seemed at the time. With his father's help, he had secured an art studio on the first floor of the State House, right below the museum, in the room where the Declaration of Independence had been signed. When he was not off in Washington painting portraits of President Jefferson or members of Congress, Rembrandt was in that studio, brush in hand, and showed little interest in the everyday running of a museum. Raphaelle, almost 30 and married and with his own children, was something of an itinerant painter. Although he did have a gregariousness that would have served him well interacting with museum visitors, he was already showing signs of his debilitating alcoholism, which may, in part, have been an attempt to mask the pain of arsenic poisoning from the taxidermy work he had done and continued to do at the museum.

Twenty-year-old Rubens, who had been chosen to accompany Rembrandt and the mammoth to London specifically to study the museums there, was the obvious heir apparent. He had been at his father's side on many a collecting mission from when he was a child, and Peale had been training him on taxidermy, taxonomy, recordkeeping, and advertising at the museum since he was barely a teenager. Rubens even took courses in botany and mineralogy at the university to add to his practical experience in such matters. When Peale was on the road and encountered a natural history collection, as he did on a July 1804 trip to New York City, it was to Rubens that he wrote that Mr. Delacoste's Academy of Natural History at 38 Williams Street was small, but "classically arranged and kept in neat order." Peale

wrote friends and family that Rubens was "a charming youth, he has a head equal to those of maturity, and besides is anxious to put the museum into neat and good order as it can be." He described a young man who "does wonders to aid me," and is "very capable of conducting my business in my absence." Rubens, for his own part, seemed content with his ordained role.[6]

In 1804, the year that Peale published his guide, he also saw personal tragedy. Elizabeth, pregnant again, was overdue, and both she and Charles were concerned for her health. Ann Emes, a midwife, had been brought in three weeks prior to live with the family in Philosophical Hall, so as to be handy when the time came. Elizabeth went into labor at 2:00 p.m. on February 17. With Charles and Ms. Emes present, after five hours of grueling labor, "in one of her exertions, when the child was just on the entrance to a new life," Peale documented, "a rupture of the uterus took place . . . the child had then fallen on the intestines." Peale called in Dr. William Shippen, along with two other of Philadelphia's finest physicians, to operate. On February 19, the stillborn child, "the largest boy perhaps ever seen," was delivered. Elizabeth died during the delivery.

Writing Elizabeth's twin brother, John DePeyster, Charles bemoaned, "It is a dreadful conflict to part with those we hold most dear, we have lost the most valuable of her sex. Discreet and thoughtful, and prudent in advice and conduct to the last moment! . . . I could innumerate a thousand facts to substantiate the great and good deeds . . . since she was my dear partner." Peale's immediate concern was his younger children. "I shall now only live to watch and direct their

conduct . . . to cultivate these tender-endearing plants, every kind of knowledge with the means I possess shall be given to make them good and useful members of society." Growing up in a museum would make that easier, but a new mother for the younger members of the family, Charles quickly decided, was also required.[7]

Peale may have comforted himself during this very difficult period in part by recollecting advice that he had given to Jefferson a year earlier, in a piece he wrote entitled *Epistle to a Friend on the Means of Preserving Health, Promoting Happiness and Prolonging the Life of Man.* It was originally meant as a letter but transformed itself into a pamphlet and sold for a quarter in bookshops like William Duane's. Charles, having heard the president's health was "much impaired" by dampness of the air in the Executive Mansion, dispensed almost 50 pages of unsolicited advice. Especially relevant to coping with the loss of Elizabeth was Peale's deistic *Epistle* counsel. "If we are not guided by our reason, and determine our conduct by an impartial examination of our feelings, what cause have we to boast of being a little above the brute creation?" That reason led him to conclude that "whether we receive a shock by accident or imprudence . . . [we must] use the best means [to combat it]," and those best means involved the mental, as well as the physical, for "the mind has such amazing influence on the external form." In Peale's own case, that passion was for his museum, and he would devote his utmost to it as he had so many times in the past, to get him through the loss of Elizabeth. A visit by Baron Alexander von Humboldt, the famed explorer and naturalist, would help in this matter.[8]

Peale described Humboldt as "without exception the most

extraordinary traveler I have ever met with . . . a fountain of knowledge which flows in copious streams . . . a great luminary defusing light on every branch of science." Humboldt had recently arrived in Philadelphia after years exploring Central and South America. The 35-year-old had initially planned to sail from Cuba back to Paris, but he wanted to meet fellow naturalist and thinker Jefferson, whose "writings . . . actions . . . and liberality of . . . ideas," Humboldt wrote the president, "have inspired me from my tenderest youth." Knowing Jefferson's interest in mammoths from having read his *Notes on the State of Virginia*, Humboldt told Jefferson, "I would like to talk with you . . . about an object that you have ingeniously treated." Jefferson was equally enamored with the notion of meeting Humboldt, to talk about both science and the politics of South America, and so Humboldt added a short stopover in the United States.

A month after departing Havana, on May 23 or 24, 1804, Humboldt, along with his companions, the French botanist, Aimé Bonpland, and Don Carlos Montúfar of Ecuador, arrived in Philadelphia. The American Philosophical Society held a special gathering in Humboldt's honor, and it was there that Peale offered to accompany the baron and his team to Washington to meet the president. Before commencing on that journey, Charles hosted a small dinner party at the museum in Humboldt's honor. Those in attendance included Alexander Wilson, William Bartram, and a teenaged John Bachman, who would long tell of the thrill of it all. Then, on May 29, Peale and Humboldt boarded a stagecoach, with stops in Chester, Wilmington, Charleston, and Baltimore. On the way, Peale and Humboldt, who "spoke English very well, in the German dialect," discussed "botany, minerology,

astronomy, philosophy and natural history." Just the sort of remedy Charles had lauded in *Epistle to a Friend*. And, as they passed a series of forts along the way, Peale shared more with the baron: "how absurd is the conduct of man, to spend so much wealth to acquire and possess the means of destroying one another . . . now what an infinite deal of good might have been done with such a sum in promoting arts, science and manufactures." After a three-and-a-half-day journey on roads that were "bad owing to the late rains and at all times not good because exceedingly hilly," they arrived in the capital and took up residence at the City Tavern.[9]

The first morning in Washington, Peale met with President Jefferson, who told him that he was well acquainted with the baron "as a philosopher and ingenious observer of nature." A few days later, Peale and Humboldt joined others for a dinner with Jefferson at the Executive Mansion. "We had a very elegant dinner," Peale noted in his diary, "and what pleased me much, not a single toast was given or called for, or politics touched on." Instead "subjects of Natural History" led to "agreeable conversations [animating] the whole company." This alone would have made the journey worthwhile, but Peale was sensing something more. "All these circumstances," he wrote, "made me at this moment think it very probable that some provision will be made to induce me to remove my museum to this city and I think the time is not far distant that some proposals will be made to that purpose."

Jefferson had explicitly and unambiguously turned down just such a proposal from him in the past. But Peale's hope was bolstered yet again when, just before he was ready to go to sleep that night, "the

Baron came to my room and told me that he had been conversing with the President about me and my museum, that he [Humboldt] wondered that the government did not secure it by purchase." As Peale listened, no doubt with a growing smile, the baron continued, "The President replied that it was his ardent wish and he hoped that period was not far distant and he thought that each of the States would contribute means and thus it might be made a National Museum." There's no reason to think Humboldt was exaggerating or that Peale was embellishing his journal account of events, but whatever was exactly said between Humboldt and Jefferson—and we don't know the details as neither man wrote of them—nothing came of it. No federal support for the museum, or even an offer to move to the capital without support, followed. Still, the whole natural-history-laden travels with Humboldt and the time with his friend Jefferson were just the sort of things that Peale needed to take his mind off Betsy's death, if only for a few weeks.[10]

Peale and Humboldt were not quite finished with one another. Upon arriving back in Philadelphia in late June, Peale had the baron sit for a portrait at the museum. Soon it was hung among the others in the State House branch. A few months later, Humboldt boarded a ship headed to Bordeaux. He had with him 60,000 specimens of plants and notebooks jammed with notes on thousands of geological and meteorological observations he had made in South America. Nevertheless, Peale, the museum curator, felt obliged to give him a stuffed alligator that he asked to be delivered to Étienne Geoffroy Saint-Hilaire at the Natural History Museum in Paris, as part of their ongoing exchange program.[11]

In early 1805, Peale and his museum would become even more deeply intertwined and inseparable, as the latter, albeit indirectly, provided a new wife for the former. Elizabeth Sellers, a relative by former marriage, was visiting the museum one day, and she and a friend were having their profiles made on the physiognotrace by Moses. The next day Elizabeth Sellers showed Charles both profiles. He was taken by the profile of Elizabeth's friend, a Quaker woman by the name of Hannah Moore. An introduction was arranged, and courtship quickly ensued, as Peale was both smitten and openly in search of a wife. Writing to both Rubens and Sophonisba, he described Hannah as "mild, kind, attentive, and affectionate to her friends . . . I will hasten our marriage as much as possible, since we have a union of hearts." Hasten he did, and they were married less than a month later, on August 12, in the home of one Squire Roberts, on a day on which wedding guests "never beheld a more serene sky."[12]

Peale craved order, and things were now back in order at home. The museum could once again become his primary priority. With 17,000 or so visitors (though some fraction were repeat visitors), and the doors open not just during the day but, as they had been for years, at least two evenings a week, things were going well on that front. So established an institution had it become that not only was the museum mentioned in directories and guides to the city, but it had gained such name and place recognition that Peale felt it a moral duty to employ it as a safe haven for lost children, especially lost orphans. Charles would bring such unfortunates into his home in Philosophical Hall until he could locate their parents or guardians. "Nothing can more deserve the acknowledgements of the community than the kindness of Mr. Peale

of the Museum, in affording his house as an asylum for stray children," read one unsigned note of appreciation. The author of the note had seen "ample evidence, shown to a sweet little boy who had been lost the whole day, and in the evening was found in a perishing situation and taken to Mr. Peale, who in very short time had the satisfaction to restore him to a disconsolate mother."[13]

Peale's Philadelphia was the largest city in the United States and was quickly becoming a major international destination, with more than five hundred foreign ships bringing in imports in 1805 alone. It was growing more beautiful and more city-like each year, with streets "paved with cobblestones and bordered with ample footways . . . kept cleaner than those of any city of Europe, excepting the towns of Holland." London was the only city in the world that was better lit at night. The Latrobe-Roosevelt pumping house at Broad and Market Streets, designed to provide Philadelphia with water and to be beautiful as well as functional, was successful on all counts. The Swedish traveler Baron Axel Klinckowström would soon call the city "one of the loveliest . . . in the world." It was a place that both the Library Company and painter Gilbert Stuart dubbed "the Athens of America."[14]

In such a city there was much to see. Cultural icon or not, Peale's museum could never be allowed to rest on its laurels. Citizens could always frequent alternative forms of entertainment if they so desired. They could opt to buy a ticket, typically for a quarter or 50 cents, not only to a play, concert, or circus, but to automata, freak shows, or giant panoramas, among many other options. Even the old museum at Third and Lombard was still competition, though Mr. Cress had apparently

retired Co-Co, the rope-dancing monkey, in favor of a phantasmagoria exhibition.[15]

Peale saw unending growth as the means for the museum to maintain its status as a scientific and cultural icon. "What should be and can be put in the museum today," he wrote in a museum ledger he kept, "should never be postponed till tomorrow." The State House provided much-needed space, but Peale had his work cut out for him, as new acquisitions—from preserved specimens to additions to the menagerie, from minerals to archeological and ethnological samples—continued to flow into the museum. Indeed, soon he was writing Jefferson "the want of room for a display will shortly be a great perplexity to me, the State House is too small to hold my quadrupeds and birds." What he really needed, he confided to Nathaniel Ramsay, was "a whole square of buildings." Until then, though, he would make do with what he had.

Inside the State House and Philosophical Hall, new preserved animal specimens included a platypus, lion, jaguar, seal, hedgehog, baboon, tiger, walrus, ferret, flying dragon lizard, and the jawbone and ribs of a whale. Other specimens included a trumpetfish, eel, penguin, black-and-orange flycatcher, scarlet tanager, red macaw, as well as a "handsome ostrich egg," a "collection of East Indian insects," and a "collection of shells from Christchurch." Just cataloging all this would not suffice. Peale wanted to learn more about all these new specimens, and so the museum reference library grew to include all volumes of Buffon's *Natural History, General and Particular* and Erasmus Darwin's *Zoonomia: or Laws of Organic Life*, to name just a couple of additions.[16]

It wasn't just the collection of preserved specimens that was

growing. The menagerie in a fenced-in section of the State House Garden had many new denizens. These included a ring-tailed lemur from Madagascar, a coatimundi, two bears (one of whom broke out of its cage, but caused no injury), an opossum with its young, porcupine, peccary, crown bird, mud iguana, chameleon, alligator, and giant turtle. And some were characters: "the marmot sleeps," Peale wrote Jefferson, "and the magpie chatters."

The list of minerals, gems, and similar items housed in the museum grew as well. It now included gold, silver, platinum, uranium, assorted iron ores, copper ore, zinc, iridescent and assorted other forms of coal, flint glass, iron-infused mica, gypsum, asbestos, phosphate, sulfur, manganese, granite, toadstone, Epsom salt, rock salt, stone coal, loadstone, shell marle, agate, assorted lava samples, mineral oil from Burma, red chalk, rubies, sapphires, ivory, marble, alabaster, amber, and "237 specimens of wood from Brazil." Not to be outdone, the archeological and ethnological collection now boasted gold buttons from the vest Washington wore at the Battle of Braddock's Field, Apache arrows, a pipe from the Sioux nation and one from Turkey, poisoned arrows from Sierra Leone, a Moorish saddle and slippers, and a canteen made of ivory and buffalo horn. It also included a bow, arrow, whip and drinking cup from Burma; a wooden pillow (headrest) and a war club from the Fiji islands; a comb from Mexico; wooden bellows and a hookah from China; bark clothing from "the South seas"; a ball from St. David's Island in Bermuda; a necklace of pearls; a scarf from Cuba; a purse from Africa; and a grass belt from New Zealand.[17]

Of all his recent acquisitions, the most indicative of the status of the museum were the scores of items from the Lewis and Clark expedition

that were displayed there. Indeed, Peale's museum was *the* public face of the expedition's finds. Most of the specimens came to Peale after the expedition was complete in September 1806, but as early as July 1804, Jefferson shared with Peale a copy of diagrams that Lewis and Clark had sent him of a new lizard species. Starting in October 1805, 17 months after their departure, Lewis and Clark began sending occasional samples like the skeletons of two deer, a big-horned sheep, a badger, a prairie dog, and a "burrowing wolf of the prairies," as well 13 fox furs, and the "skins of the male and female antelope and a live magpie." All that material was shuttled through Jefferson, who took his pick. "There are some articles," he wrote Peale, "which I shall keep . . . at Monticello." Much of the remainder the president sent to Peale, and to a lesser extent, the American Philosophical Society.

Peale was naturally delighted. "Everything that comes from Louisiana," he wrote Jefferson, "must be interesting to the public." And he also dispensed some detailed advice regarding ethnographic material the president would have likely received from Lewis and Clark. "As you wish to keep some Indian dresses at your Mansion," he wrote his friend, "and parts of them may be liable to the depredations of *Dermests*, the mode of preserving may be applied to the perishable parts as I do with my large animals." Once the expedition was complete, even more animal samples arrived at the museum, but they were swamped by Native American relics. These included a war headdress of eagle feathers, clothing and a tobacco pouch from the Sioux Nation, a Winnebago decorative belt, a Crow nation wool mantle, a cooking pot, water cups, pipes, necklaces, wampum from various tribes, and various breads and other Native American foodstuffs.[18]

Meriwether Lewis visited Philadelphia upon his return and sat for a portrait that Peale hung in the museum. Charles also created a wax figure of Lewis for the museum. He made no qualms about the function of the wax figure. He told Jefferson he "placed it in the Museum, my object in this work is to give a lesson to the Indians who may visit the Museum, and also to shew my sentiments respecting wars . . . I am pleased whenever I can give an object which affords a moral sentiment to the visitors of the museum." The figure, Peale continued, "has its right hand on its breast and the left holds the Calmut [a type of pipe] which was given me by Captn. Lewis." In a tablet under the figure, Peale tells its story:

This mantle [a loose-fitting cloak], composed of 140 ermine skins was put on Captn. Lewis by Comeahwait, their Chief. Lewis is supposed to say, brother, I accept your dress—it is the object of my heart to promote amongst you, our neighbors, peace and good will—that you may bury the hatchet deep in the ground never to be taken up again—and that henceforward you may smoke the Calmut of Peace and live in perpetual harmony . . . Men are not too numerous for the lands which are to cultivate; and disease makes havoc enough amongst them without deliberately destroying each other—if any differences arise about lands or trade, let each party appoint judicious persons to meet together and amicably settle the disputed point.[19]

Had he had access to the journals and diaries of his travelers visiting from this period, Peale no doubt would have been pleased with the effect that all these new acquisitions, in conjunction with what

was already in his museum, were having. Englishman Charles Janson was impressed by "the long-clawed grisly [sic] bear . . . the American buffalo, or bison—the great anteater—the orang[utan] . . . a variety of antelopes," and, of course, "the skeleton of this non-descript animal," the mammoth. Janson describes the museum as "a striking instance of the persevering industry of an individual, while the grant of the old State-House for its exhibition does honor to the city . . . considering the short time since this collection was commenced, it is surprising to find such a number of natural curiosities in this museum." Visiting Englishman John Melish too was impressed. After a stop at the Library Company in September 1806, he "passed to Peale's Museum," calling it "a very excellent collection, principally of subjects in natural history, and does honor to the ingenuity and taste of the proprietor. Among other curiosities it contains an entire skeleton of the mammoth, well worth the attention of the naturalist."[20]

So many were enamored with the museum. And not only powerful friends like Jefferson, who often sent missives that included gems such as "by the immense collection of treasures contained in your museum you have deserved well of your country and laid a foundation for their ever cherishing your memory. Accept my friendly salutations and assurances of great esteem." Others of note were also impressed, including the self-described "biographer of the feathered tribes of the United States," Alexander Wilson. His 1808 monumental *American Ornithology* would earn him a reputation as both a foremost naturalist and one of the fathers of the study of American ornithology. Rubens recalls how Wilson gladly accepted an invitation to visit the museum. "I don't remember ever to have seen anyone," Rubens noted in his

memoirs, "so much delighted, especially with the birds."[21]

A Scotsman by birth, in 1794, Wilson, after a less-than-notable career as a poet and ballad writer, weaver and peddler, migrated to the United States. Following a brief stint in Delaware, he made his way to Philadelphia, where he became a schoolteacher. He also took to studying art and ornithology with William Bartram. At some point in 1803 or 1804, he decided to commence on an encyclopedia of American birds, writing a friend back home that "I have had many pursuits since I left Scotland—mathematics, the German Language, music, drawing, etc., and now I am about to make a collection of all our finest birds."[22]

What better place to find hundreds of well-preserved and mounted American specimens, and close to a thousand avian specimens in total, than Peale's museum? Wilson visited the museum, notepad and sketchbook in hand many times. He contributed 279 specimens from his birding expeditions to Peale's collection. So impressed was Wilson with the bird collection at the museum that in *American Ornithology*, he listed the museum's catalog numbers for all entries that corresponded to species found there. Peale, too, was impressed with Wilson. He wrote to his friend Étienne Geoffroy Saint-Hilaire at the museum in Paris that Wilson "was indefatigable in his researches to acquire a knowledge of the manners and habits of our birds." He told David Ramsay that he "knew more of the American birds than any man I have ever been acquainted with." Indeed, Wilson had made a sufficient enough mark on Charles that though he was nowhere near the excavation site, Peale had painted him into *Exhumation of the Mastodon*.[23]

The success of the museum was a tribute to not only Peale's business acumen, but to his creativity as well. But no single creative outlet, not even one that would seem to many as all-encompassing as amassing a world-class natural history museum, seemed enough for Peale. As the museum's fame grew, some of Charles's creative juices were devoted to his other passions, especially painting and tinkering. His brush, after a bit of a hiatus for the first few years of the 19th century, was still prolific. There were the paintings of Humboldt and Meriwether Lewis, and in 1806, *Exhumation of the Mastodon*. There were also many more, including portraits of the new Mrs. Peale, Rembrandt Peale, Jefferson, inventor Robert Fulton, satirist and author Joel Barlow, law professor and Jefferson's mentor George Wythe, fellow artist Gilbert Stuart, explorer and general, Zebulon Pike, and assorted self-portraits, to name just a few. His love of the arts during this period also led Charles, together with Rembrandt, William Rush, and others to form the Pennsylvania Academy of the Fine Arts. The academy's 1805 mission statement—to "promote the cultivation of the fine arts, in the United States of America, by . . . exciting the efforts of artists, gradually to unfold, enlighten, and invigorate the talents of our Countrymen"— sounds like it came straight from Peale's pen, though he was just one of the document's authors.[24]

In addition to his painting, Peale was obsessed with two devices. One was the physiognotrace that Moses and others were using to cut profiles. Peale was forever making small tweaks to it, going so far as to build a miniature portable version for Raphaelle and for Rembrandt, who had taken it with him on the failed overseas mammoth adventure. The other outlet for Peale the inveterate tinkerer was the polygraph,

another brainchild of visiting Englishman John Isaac Hawkins, the same fellow who had created the physiognotrace and built the organ in Peale's museum. The polygraph was a mechanical contraption that used a second pen to make a copy of whatever was being written. When Hawkins returned to England he assigned Peale the patent rights to the device in America. So above and beyond the sheer pleasure of modifying the device to increase efficiency and precision, there was money to be made, with each polygraph selling for $50. Jefferson purchased polygraphs from Peale for both the Executive Mansion in Washington and for Monticello, writing Charles that "the use of the polygraph has spoiled me . . . I could not, now therefore, live without the polygraph." Over the years, Peale and Jefferson exchanged dozens of letters about this device, replete with detailed sketches, in which they went back and forth proposing and then testing modified versions of the device. Both took obvious pleasure in the exchange, with Peale writing his long-time friend, "such instruments as we are daily in the habit of using should be made as perfect as possible, or as human invention can make them." And if the polygraph and physiognotrace were not enough to satisfy Peale, there were also the constant improvements to be made to his ideas on fireplaces and bridges, and some experiments on bird flight that he and Alexander Wilson ran using weighted kites.[25]

At the museum, Peale was nothing if not persistent, and despite numerous failures to establish it as a national institution of some sort, he continued to hope, and a not-so-new-idea was then circulating in Washington, DC that might provide an avenue. Since George Washington had first floated the idea of a national university, every

president looked positively on the notion, though no action had yet been taken. Then in 1806, "Hartford wit," and soon to be ambassador to France, Joel Barlow, began circulating a pamphlet entitled "Prospectus of a National University." He called for a national seat of learning that would foster "the advancement of knowledge by associations of scientific men, and the dissemination of its rudiments by the instruction of youth." Barlow's prospectus made its way to a United States Senate committee, and on March 4, Pennsylvania Senator George Logan submitted a modified version of it as "A bill to incorporate a National Academy."

For Peale, who had heard of, but had not yet seen Barlow's prospectus, what better institution to partner with his museum to make it a national one? "I have heard of a proposal by Mr. Joel Barlow to form a National Institute at Washington," he wrote Jefferson. "I have not seen the pamphlet, and therefore don't know whether my museum might not be embraced amongst the first of its establishments—at my time of life I cannot help feeling some anxiety to know the fate of my labors. Everything I do is with a view to a permanency. Yet at my death there is a danger of it being divided or lost to my country." The proposal did not mention Peale's museum, but Jefferson informed Charles that, should the plan come to fruition, "it will be no small part of the gratification I shall receive from it, that the means will be furnished of making your museum a national establishment." What those means were Jefferson did not say, but that quickly became a moot point as the bill died in the Senate, and with it another attempt at making the museum a national one. [26]

The following year, 1807, the museum would again be a matter of

much discussion between Peale and Jefferson. In that year, with his grandson Thomas Jefferson Randolph now 15 years old, the president felt it time he placed the young man into an environment to spark his creativity and prepare him for his station in life. Philadelphia's reputation as the intellectual capital of the country made it the obvious choice. Jefferson floated an idea by Philadelphia physician Casper Wistar, a mutual colleague that he and Charles shared. "I think Mr. Peale has not been in the practice of receiving a boarder," Jefferson told Wistar, "but his house and family would, of themselves, be a school of virtue and instruction and hours of leisure there would be as improving as busy ones elsewhere." Why Jefferson did not approach Peale directly is hard to know, but when Wistar told Peale of Jefferson's aspirations for young Thomas, he immediately opened the doors of his home—and the museum—offering to board the young man and act as his mentor. The offer was not without conditions though and included a lengthy list of house rules that applied to all living under the Peale roof. Peale warned Jefferson that "the discipline of my house may be too rigid for a Virginian . . . ten o'clock is the hour of our locking our doors, unless on some extraordinary occasion, such as a concert or play, an indulgence rarely given." That was more than fine with Jefferson, whose wish was that his grandson "be solely occupied with his studies, not that he should be at all immersed in the society, and still less in the amusements and other abstractions of the place." Jefferson accepted the offer, informing Peale that "the circumstance which has guided us in fixing on the subjects of study for our grandson has been the exclusive possession of Philadelphia of your museum."

Thomas's transfer to Philadelphia was delayed for a combination

of logistical reasons, but starting in October 1808 and lasting through June 1809, he stayed with the Peales. He shared a room with Rubens, who Charles was calling "his right-hand man" on museum matters. Peale intended nothing less than providing Thomas with an "abundance of food for the mind." He used the museum's unrivaled (at least in America) collections to instruct Thomas in natural history, anthropology, minerology and art, and arranged at Jefferson's request for the young man to receive training in botany at William Hamilton's botanical garden in West Philadelphia. Thomas studied mineralogy through the lectures of Silvain Godon (as well as the mineral collection at the museum), chemistry at the hand of Dr. Wistar and in lectures by James Woodhouse at the University of Pennsylvania, and received exposure to the medical sciences by observing surgical operations at the city hospital and by attending Sir Charles Bell's lectures on the anatomy of the human body. Jefferson periodically sent Peale funds to cover the costs of his grandson's education, room, and board, and implored his friend to see to it that young Thomas made use of these extraordinary opportunities, "press[ing] him much after hearing a lecture to commit it to writing in substance."[27]

Throughout the course of those nine months, Peale sent Jefferson updates on his grandson's studies—"Mr. Randolph is very attentive to his studies, and I have not a doubt that he will be a valuable member of society by his skill and disposition to elevate the miseries that our species are liable to." He also sent updates on his moral development as well. "I do not discover the least turn of extravagance in him," Peale reported. "On the contrary, he conducts himself in every respect with prudence and respectability and is daily gaining the love and esteem of his acquaintances."

For Peale, Thomas's time lodging and studying with him was yet another indication of the regard in which he and the museum were held by everyone from the common citizens who were frequenting the museum to the country's elite. When the president and the country's leading polymath, sought a place to enlighten his grandson, it was to Peale, the museum, and Philadelphia that he turned. And by all accounts, it all went wonderfully well. Once Thomas had returned to Virginia and settled back in, Jefferson wrote to say just how pleased he was. "I have now to thank you for all your kindnesses and those of your family to my grandson: and at the same time to convey to you the expressions of his gratitude and affectionate remembrance. He speaks of yourself, Mrs. Peale and the family always as of his own parents and family . . . I cannot describe to you the hope and comfort I derive from his good dispositions and understanding."

As his grandson's time with Peale was coming to a close, Jefferson wrote his friend that, "I begin already to be much occupied in preparing for my departure to those scenes of rural retirement after which my soul is panting." Peale was beginning to think the same thing. He was now 68 years old and had devoted the last third of his life to the museum. Although he was generally in good health, on occasion he "felt some bodily weaknesses," and he relished the notion of a simpler life devoted primarily to leisure, tinkering, a healthy dose of farming and gardening, and of course, painting. The museum was doing better than ever, and he intended a smooth hand-off of power to keep it that way and avoid its contents from being scattered far and wide. His plea to President Madison that his museum "meets with the approbation of all scientific men who have visited it, foreigners as

well as Americans, everyone agreeing in the sentiment that it ought to be national property," had come to naught. Yet the collection of natural history, anthropological, ethnographic, and mineralogical artifacts sat at 100,000 items, with at least 20,000 on display. Annual attendance was approximately 33,000 and finances were strong, allowing Peale to know that economically he would be helping, not burdening, his successor.[28]

As he mulled over retirement, the time had come to pass the museum down to one of his sons. Raphaelle was out of the question, as his problems had only gotten worse, having been admitted for a stint in the Pennsylvania State Hospital with a diagnosis of "delirium." Soon Peale would have to financially support Raphaelle's family. Rembrandt, it seemed, could never be away from his brush long enough to take the helm. In late fall 1807, he had taken it into his head to visit Paris to paint the great men there. Charles approved of his journey overseas. Indeed, a few years earlier, he had briefly contemplated a trip to France with Rembrandt to set up some exchanges with the natural history museum in Paris, but there was simply too much to do to allow an overseas jaunt, and so he satisfied himself by keeping active his correspondence with Saint-Hilaire and others on the continent.

In 1810, Rubens was the only man for that job. It was he, who among other things, had recently begun giving lectures on galvanism and chemistry at the museum, creating for visitors "a fondness for finding the treasures contained in the bowels of the earth, that otherwise would be lost." It was he who purchased a small plot of land that contained a special ore that was being used to produce a new vibrant yellow color that would enhance the portraits in the museum. And it was Rubens

who had recently gotten "the museum in the State House entirely overhauled, the walls and ceiling whitewashed, upwards of 2,450 feet of glass cleaned." In many ways, it had been a fait accompli, as many times over the last decade, Charles had "left the whole labor of the museum to Rubens," who had "acquitted himself with honor by his judicious management of it." Peale soon relayed the changing of the guard to Jefferson. "I addressed him [Rubens] thus, I am growing old and may be taken away soon, it will be a satisfaction to me to see the museum well managed without my attention to it," he wrote his friend. "I wish you to receive all the honor of it in future, I wish to be out of sight, by retiring to the country, to muse away the remainder of my life . . . he accepted my offer."[29]

On January 4, 1810, more than two decades after Peale had opened the doors to the museum, the official transfer of the museum to Rubens took place. The agreement between father and son was a simple one:

"By mutual agreement, Rubens to have whole charge and care of the museum beginning of this year, and he paying all the charge of the same and for further improvements of the same and said Rubens is to pay quarterly to C. W. Peale one thousand dollars, i.e., four thousand dollars per annum."

While Peale technically retained ownership of the museum, it was now squarely under the directorship of 26-year-old Rubens.

And so it was that Charles purchased a 104-acre farm called Belfield for $9,500, a short ride into Philadelphia proper. Belfield, which was originally called Farm Persevere, with its estate house, barn, stable, mill, meadows, stream, and more, was just outside the city limits and

Peale moved there with his wife and youngest children. He had dreams of spending his retirement painting, cultivating his gardens, tinkering and farming. However, events would soon show that his claim to Jefferson that he only wished the museum "to be well managed without my attention to it" was written more as a humble note for posterity than a true reflection of the role he intended to continue to play.[30]

WHOSO WOULD
LEARN WISDOM

On May 29, 1810, with Peale nestled at Belfield and Rubens at the helm of day-to-day operations at the museum, Katherine Fritsch, a sister in the Moravian Church, boarded a private coach in Lititz, Pennsylvania, along with a group of her friends. On a morning "when the robins in the square were singing gaily," they commenced the 75-mile trek east along the Philadelphia-Lancaster turnpike to the big city. Frisch's diary entry of what she experienced provides a glimpse into the museum during the transition to Rubens.

As soon as she had settled in, when "the heat on the streets was most oppressive," Fritsch went "down Chestnut Street to visit what of all city sights I most wished to see: namely Peale's Museum." She was immediately enchanted by the State House Square, with its rows of trees and manicured lawns and its brick wall, planted and constructed respectively by Peale. "In the museum menagerie, two great bears amused us exceedingly by their clumsy play," she noted. "On top of the

bear's house two parrots, apparently quite contented." Near the parrot's cage sat another larger cage with a live eagle sitting "right majestically on his perch—above his head a placard with this petition on it: feed me daily for 100 years." If that was not enough, "there was a monkey," she noted, "who kindly showed us his whole assortment of funny capers," and though Fritsch did not witness it, on occasion that same monkey could be seen walking hand-in-hand with supervised children.

From the yard, Fritsch went into the State House museum proper, through the door with "Whoso would learn Wisdom, let him enter here!" posted above. She walked past a turnstile that rang chimes to announce visitors, and over to the ticket office, above which sat a room that Peale often called his "lodge," and which was used for preserving specimens. Fritsch, whose diary suggests a predilection for order, took note of "affixed rules of behavior for visitors." Although she did not elaborate on what those rules were, others did, and they included warnings against intoxication, rough handling of the exhibits, scratching initials into the giant clam shell, and smudging the display cases.

At the ticket office, Fritsch would have been offered the opportunity to purchase Peale's *An Epistle to a Friend*, as well as a *Historical Catalogue* of the paintings in the museum. After buying her ticket, she was handed a copy of "Guide to the Philadelphia Museum," then she walked up the stairs and made her way through the lecture hall into the main part of the museum. She meandered through the Quadruped Room, which included a small "children's case" for the youngest of visitors, along with a moose, llama, bear, bison, prong-horned antelope, hyena, jackal, and more. She also explored the Marine Room, stocked

with fish, amphibians, lizards, sponges, corals, and the like, and then the pièce de résistance, at least for the State House branch, the Long Room, with its nine windows all looking out on Chestnut Street. The glass cases were filled with birds set against backdrops matching their natural environments, insect cases in which the smallest specimens could be rotated under a microscope, a vast array of minerals, dozens of portraits, and the organ sitting above in the loft. Fritsch was struck "with astonishment, [at] the many different animals, birds, and fish, and the infinite variety of exquisite butterflies and insects," as well as the "finely painted portraits of distinguished men."

Like most visitors, Fritsch was keen on going over to the Philosophical Hall next. "I was looking forward to seeing the mammoth," she wrote in her diary, but then "a gentleman who had just come from the Philosophical Hall, where the great skeleton was kept, told us that he had seen it and had to pay ½ dollar for the privilege. All the party, but myself declared that the price was entirely too high—a quarter they would give willingly, but not a cent more! I was keenly disappointed, yet I did not wish to go alone and be there among the strangers." Instead she and her friends remained in the Long Room and went over to a man, perhaps Moses, although she does not note that he was African American, who "was making silhouettes." Fritsch's friend tried to coax "me to have mine cut . . . but I couldn't think of it—with my big nose!"

These diary entries provide the first hints of a pattern that would grow more pronounced under Rubens's leadership: though he certainly respected the "rational" component of the rational entertainment that his father so cherished, he would continually expand the

"entertainment" component. Fritsch writes of an "oracle . . . in a lion's head" that was some sort of system in which a visitor in one room—we don't know which—could speak and be heard in the Quadruped Room with the sound transmitted, and perhaps magnified, in a whispering tube that ran across the rooms. "Had I talked into it I should have fancied myself a priestess of a heathen temple," she noted, "but we knew not where the sound outlet was, and it was only after we had gone through the three rooms that I discovered it . . . at the other end of the tube." Another gimmick, though perhaps that is too strong a word, that had been recently introduced, was a "magic mirror." Fritsch noted it "afforded us much amusement—you might take your choice of a giant face, or a dwarf's, or have seven heads!" Rubens would often play entertainment off the rational, as with a table where chemistry experiments were run for visitors, advertised as "Phantasmagoria."

The menagerie, paintings, natural history, anthropology, and mineralogy exhibits, combined with the oracle and magic mirror had their intended affect. "As we left the State House," Katherine ends her diary entry, "all our talk was of how delightful had been our visit to the museum. Had our time permitted it, I could have spent a whole day there."[1]

About the time of Fritsch's visit to the museum, Charles wrote his colleague Nicholas Biddle about the current state of affairs there. "The museum contains between two and three hundred quadrupeds, upwards of 900 birds, besides duplicates, a great variety of amphibious animals . . ." he begins, "4,000 insects; of minerals, fossils and shells, a very valuable collection; also a collection of

dresses, arms and utensils of the inhabitants of almost every part of the world . . . [and] about 90 portraits of men distinguished in the American Revolution and other dignified characters." It was a place, Peale told Biddle, not just for collecting, displaying, and generating knowledge, but for propagating it as well. There was the printing press "to print descriptions of every subject of the museum in order that the visitors may have a comprehensive and easily acquired knowledge of [the] multifarious production of nature and art in a large and extended museum." The museum also contained a library stocked with treatises on natural history, various apparatuses for use in lectures, and much in the way of samples available for exchange with museums in Europe. All of which is to say that Rubens stepped in at a time when the museum was prospering intellectually, as well as financially, with annual net revenues sitting at an all-time high (to that point) of approximately $7,500.[2]

It had been a long journey for Rubens. Compared to his brothers and sisters, he had always been rather sickly and frail. "When 3 or 4 days old," Rubens writes in an autobiographical sketch, he could have been "put into a silver mug and the lid shut down over him." A "very delicate boy," on occasion he was so feeble he needed to be carried to school by Moses Williams. He was kept out of the direct sun and "not permitted to play in the streets with other boys." His fondest childhood memories centered on his siblings and the many pets he kept, particularly birds. Rubens's eyesight was such that he "had to put the book or paper so close to [his] face that [his] nose would frequently

touch the page" and he was helpless without the wireframe glasses that are so prominent in portraits of him.

As a boy, Rubens recalled Benjamin Franklin coming up to him as he was copying an illustration from Buffon's natural history encyclopedia, and, in classic Franklin style, telling him, "Persevere young man, you will make a painter yet." Still, his eyesight made it obvious he was not going to be an artist per se. He did, however, show a proclivity for natural philosophy, and at age 12, he ran "an experiment to demonstrate that electricity could be communicated by water any distance." In part because of this bend to science, and in part because of the problems with his vision, Charles had sent him, along with Rembrandt and their pet mammoth, to England years earlier, an obvious step in the grooming process that led to the transition of power now underway at the museum. Rubens understood that well; indeed, he had always been an active and willing participant in the process. "From an early period," he noted, "my father instructed me in the art and mystery of birds and other subjects of natural history. I attended several courses of lectures on mineralogy and botany, and afterwards the lectures at the university," but, he emphasized, "not with the intention of becoming a physician." He savored those subjects for their inherent value, and his interest in mineralogy was further fueled because of the role of minerals in paint colors. All good signs for a natural history/art museum proprietor-to-be.[3]

When he took the helm in 1810, Rubens made some repairs to the museum and quickly began following his own passions. He commenced "a series of . . . experiments in chemistry and natural philosophy, especially in electricity [and] pneumatics . . . lectures

[that] took place at a given hour in the lecture hall of the museum to all the visitors without further charge of admission." Foretelling a general trend in increasing museum activities beyond science and art, Rubens also "introduced fine music, both vocal and instrumental, in the course of the evenings." He notes with some pride that the music "made the museum much frequented." He also redesigned the admission ticket to the museum, replacing the Book of Nature with light rays bursting forth with a tree in a meadow and the word "Perseverantia" placed over it.

In his autobiography, Rubens claimed "in the first year I increased the income more than double what it had been," which the record shows is an exaggeration, though that year revenue did increase to a new high of $8,380. One of his first substantive moves, arguably his first stamp on the museum, was moving the mammoth from Philosophical Hall over to the State House. To make space, all the material from the Marine Room, including the giant chama shell, was moved bit by bit up to a part of the third floor that had not been used since before the museum occupied the State House, and the old Marine Room was transformed into the new Mammoth Room. In addition, Rubens began adding other material to the new Marine Room that leaned toward the entertainment end of rational entertainment. This included stuffed costumed monkeys, a snake that had died trying to consume a toad, and various monstrosities, like a tattooed human head. Charles had accepted monstrosities as donations on occasion, and understood, as he wrote to James Madison, that the museum provided both "amusement and instruction." However, he almost always kept them away from general viewing. Rubens would not go quite that far, though

such specimens were "removed from the sight of those that do not choose to see them." For those who did choose to see, Rubens made available such items as a six-footed, two-tailed cow that Charles had acquired, but had chosen not to display.

With the mammoth now residing in the State House, there was no longer an additional charge for viewing it. Behind it sat Charles's *Exhumation of the Mastodon* and nearby was the ever-present stuffed mouse for comparison, as well as a large part of the Lewis and Clark material the museum owned. Rubens wanted to move the rest of the material from the museum branch in Philosophical Hall and place it all under the State House roof, in part because he thought it easier to run a business from one locale, but the American Philosophical Society would not allow him to break his lease.[4]

In addition to the animal, anthropological, and mineralogical specimens, Rubens introduced a fascinating mechanical contraption to the museum not long after he took over. An inventor named Charles Redheffer claimed to have built the forever-sought-after perpetual motion machine, and he was displaying it in the Henry Cress Tavern in the Chestnut Hill area of the city. At some point, Isaiah Lukens, "a good mechanic and of philosophical mind," was asked by his friends to build a replica of Redheffer's device so they could figure out how, indeed if, it worked. Lukens, desiring to expose "the folly of this discovery," showed that a set of ingeniously hidden cogs and springs could deceive the observer into believing that Redheffer had achieved the impossible. Lukens built a model to show exactly how.

Rubens was fascinated with Lukens's device. When members of the American Philosophical Society suggested that he display this

model in the museum, Rubens thought it a good idea. He "consented to receive it, not as the perpetual motion machine," but as a lesson in chicanery—"to show that a machine could be constructed that no one could discover the moving power." The effect was immediate. "The museum," Rubens wrote, "was densely filled with visitors."

The next morning, an apoplectic Redheffer appeared at the museum and demanded that the Philadelphia Council appoint a committee to examine his, not Lukens's, device. The counsel consented, with the proviso that one of their members always be in visual contact with Redheffer and the machine. Redheffer tried every ruse in the book. At 9:00 p.m. on the first night, he told council members he was ill, and as it was late, the committee should head back to the city. The council would have none of it, telling him "they intended staying with it as long as it was in motion." Redheffer next feigned an attack of colic. Again, the council members would not leave. Soon Rubens joined the council members and together they discovered the hidden mechanism providing power. Even that didn't suffice for Redheffer's acolytes, who penned a nasty editorial in the *Aurora*, accusing Rubens of treating Redheffer with "much injustice." Rubens didn't budge. Exposing Redheffer as a charlatan was too important, and it did not hurt that "the excitement continued for months and increased the income of the museum considerably."[5]

New specimens flowed into the museum, with Rubens, at least initially, as active as Charles had been on that front. Chameleons, rattlesnakes, sloths, hawks, sparrows from Java, starfish, squirrels, turtles, "several beautiful birds from Senegal," widowbirds, a "deformed pig with

[an] elephant's proboscis," shark teeth, mammoth teeth, a collection of eggs from marine birds, as well the eggs of a bald eagle, were among the new animal specimens to rotate onto the museum floor. There was also another monkey and a three-legged sheep that had joined the ranks at the menagerie. New anthropological samples included Roman coins "struck 30 years after the birth of Christ," silver coins struck by Peter the Great, "elegantly ornamented" slippers from Calcutta, sand from Egypt, Roman lamps, chopsticks from China, a feather cap from the Pacific Islands and one from South America, arrows from the East Indies, and leather gloves from Russia. Along with all this were countless coals, ores, and other minerals being sent from around the world.

Rubens was keenly aware, perhaps more so than his father, that there were many other venues beside his museum where Philadelphians could spend a quarter or half a dollar on entertainment, rational or not. In addition to theatre performances and musical concerts scattered throughout the city during Rubens's early years running the museum, there was a 3,000-square-foot panorama of the city of Baltimore at Chestnut and Tenth, "grand military maneuvers" to watch at the New Circus, and a "tournament and ball," in which a "Mr. Hippolite, the fencing instructor, will demonstrate mock assaults, followed by dancing." There was also "Zera Colburn, the astonishing Vermont calculator of six years old," answering "difficult questions in Multiplication, Division and Subtraction," a meteor stone from Connecticut, and wax figures of the first four presidents for view, to name just a few of the alternatives available.[6]

This sort of entertainment would in time develop into "dime store" museums around the United States, that would advertise to prospective customers:

Come hither, come hither by night or by day,
There's plenty to look at and little to pay;
You may stroll through the rooms and at every turn
There's something to please you and something to learn.
If weary and heated, rest here at your ease,
There's a fountain to cool you and music to please.

Dime store museums, with their magicians, musicians, actors, charlatans, freaks, ventriloquists, and animal acts, each claiming to be the grandest, most marvelous of them all, did not become a true force until the 1840s. They were still in their infancy when Rubens took the helm at the museum. But precursors like the Washington Museum at Second and Market in Philadelphia, with its nude paintings and other titillating exhibits, were starting to spring up.[7]

With all this competition, Rubens ran a series of newspaper ads to remind the citizens of Philadelphia that, while they might see this or that at some other venue, the Peale museum, displayed "more than 20,100 objects," and housed another 80,000 objects, many of which would eventually rotate onto the museum floor. Still, Rubens was always looking for something new to draw in visitors. He turned to his fondness for chemistry and began illustrated shows on astronomy using a "magic lantern," an early slide show projector backlit by candles or oil. New attractions need not be so educational, as long as they entertained. Signor Hellene, for a charge of five dollars per night, would perform his one-man band concert that included a viola, cymbals, and pan flute (Pandean pipes) along with the bells he wore as a crown.

Rubens had also learned museum diplomacy well. When a ticket

seller at the museum had failed to recognize Joseph Allen Smith, who had lent the museum some statues and portraits, Rubens immediately went into action. "I have to apologize to you and beg your indulgence for the rudeness of one of the attendants at the museum in consequence of his not knowing you," he wrote Allen. "His fidelity wears a rough aspect, and although you may already have forgotten it, I feel uneasy till you accept my apology." He also enclosed free passes for any future visit.[8]

Just outside the city limits, at Belfield, Charles wrote to Rembrandt, who in 1810 was back in Paris painting again. Charles said he was experiencing "the greatest complacency of mind both of the present and future, evils incurable I quietly submit to, and I believe I am as happy as the lot of human nature can make anyone." Rembrandt and Rubens were thriving, as were his daughters and the younger boys, Titian and Franklin, and even Raphaelle, with all his problems, was exhibiting his still life paintings at the Pennsylvania Academy of the Fine Arts. Familywise, his only real concern was teenager Charles Linnaeus who had declined an apprenticeship with Fry and Kammerer Printing that Charles had procured for him, with the promise of running a printing press at the museum when he was done. Charles Linnaeus opted instead for the "seafaring life," and worse yet, indicated an interest in joining the army. Aside from the Revolutionary Army, Peale abhorred the "murderous life of a soldier whether on the sea or land."

Charles was now leading the life of a gentleman farmer with a penchant for both the paintbrush and the mechanical. Much of this can be seen in his continued exchanges with his fellow retiree, Jefferson.

"I have heard that you have retired from the city to a farm," the ex-president wrote soon after Peale settled at Belfield, "and that you give your whole time to that. Does not the museum suffer?" The rest of the letter is an expansion of Jefferson's passion for the land. "Here, as you know, we are all farmers, but not in a pleasing style. We have so little labor in proportion to our land, that although perhaps we make more profit from the same labor, we cannot give to our grounds that style of beauty which satisfies the eye of the amateur." In his reply, Peale spent as little time as his friend on the question of the museum. "[Rubens] has improved the museum far beyond my expectation and I think you will frequently hear from those who visit it, how neat and handsomely it is arranged . . . how very beneficial to the public." Peale then quickly turned to their mutual interest in tilling the soil. Interspersed with enclosed drawings of various farming implements, Peale begs for his friend's patience with a relative novice on these matters. "I shall get instruction in my new occupation, that of a farmer," Peale wrote, "which thus may be diffused to others, as I am willing to put into practice everything that promises to meliorate the condition of man!" From there he praised Jefferson's moldboard plow, which "ought to be studied by every man that makes a plow."

"Knowing his ignorance of good agriculture," Peale the pastoralist writes of "visit[ing] other farms in the vicinity," busily gathering information. He soon felt more at home on his farm, at which point his tendencies to tinker and experiment led him to making false teeth for friends and family in need, improving the physiognotrace and the polygraph, and creating tools for his new occupation. "I have an idea of a machine to thrash grain," he wrote Jefferson, and "also another

for getting out clover seed." And the tinkering bled from physical equipment to technique as well. "Since my last letter," Charles tells his friend at Monticello, "I have made a trial of my potatoes and find that those which we planted with stable manure [are] not so good as another field in which we used long straw only."[9]

The bucolic setting of Belfield drew Rubens out for the occasional visit. He saw it as a sanitorium of sorts, a healing place for some of the detrimental side effects of life at the museum. "My health not being very good," he wrote in his autobiography many years later, "it was recommended that I should be as much in the country as I could possibly spare time for . . . in preparing natural history subjects we have to make use of arsenic and corrosive sublimate . . . these poisons so affected my stomach that it brought on indigestion, sick headache and piles, the working in the garden seemed to be of great benefit to me." And so Rubens would work with his father "laying out the garden, planting trees," and tending grapes that they would press for wine. He even built a few early bicycles called velocipedes that he, his father, and his brothers and sisters would ride around Belfield as "the walks of the gardens [were] well arranged for this kind of exercise."[10]

Life at Belfield gave Peale time to pursue so many of his passions. In the two years prior to retirement, he painted just three portraits. He took to his brush and easel with renewed vigor at Belfield, painting 13 portraits from 1810 to 1812. He also wrote Rembrandt a very long "account of the painters that came within my knowledge in the commencement of the arts in America." Peale now also had the time to muse and write about matters of philosophy, as he had done in *Epistle to a Friend*. In 1812, he penned a long letter that stemmed from

a "meeting at a friend's house with a young man intoxicated, who was endeavoring to make apologies for his conduct." That evolved into a pamphlet entitled *An Essay to Promote Domestic Happiness.* Ostensibly about dispensing advice to husbands and wives through turning to scripture and anecdotes—"this brings to my mind a story I heard in London of a gentleman who laid a wager with his friend," or "the story of Farmer Jenkins and his wife is a good lesson"—Peale saw this essay as having more general implications. "Marriage is a social bond," he wrote, "contracted as well for the benefit of society in general, as the parties in particular." These parties, Peale demanded, set "a good example to induce others to marry; by which harmony, industry, and the wealth of the nation are promoted." He sent the essay to close friends, including Jefferson, who told him that "it is full of good sense and wholesome advice and I am making all my grandchildren read it married and unmarried."

At Belfield, Peale was careful not to feel that he had to be doing something every moment, having come to the realization with the years that meditation and contemplation, in small doses, were vital to a healthy mind. He built a few small "summer houses," after a Chinese model. There he would mediate on "the wonderful variety of animals inhabiting the earth, the air, and the waters: their immense number and diversity; their beauty and delicacy of structure," pondering all this and then asking himself, "why am I here?" In other parts of the garden, he built small obelisks and pedestals, inscribed with "sentiments, all of a moral tendency," to gaze upon as he strolled about.[11]

None of this, the farming, gadgeteering, philosophizing, meditating,

or painting, is to suggest that Peale was not still integrally involved with the museum, for a complex array of reasons, both psychological and practical. While it was true that "the concerns of the farm and the amusements had by making machinery, made [him] neglect to see the museum for months," and that Rubens "was fully capable of doing everything necessary" there, Charles had devoted the greatest chunk of his life to the museum. It would, in a sense, always be his. Together with his paintings, many of which hung on its walls, the museum was Peale's legacy to the world, his personal, heartfelt contribution to the enlightened ethos of the time. "The education it is capable of diffusing through the mass of citizens is all important," he wrote Jefferson. Tied to all this, because his name and the museum had become synonymous in many circles, Peale sensed that his reputation and the museum's reputation were one. There was also the matter of money. Charles was still the legal owner of the museum, and his chief source of retirement income was the quarterly payments of one thousand dollars that Rubens made as per their contract. If the museum should falter, so might those payments.

Though he only visited the museum itself on occasion, Peale began wielding his still considerable influence in Philadelphia power circles on the museum's and Rubens's behalf not long after settling at Belfield. In 1810, as the Pennsylvania House of Representatives debated selling the State House complex to the city of Philadelphia, Peale, via his friend Representative William John Duane, used the opportunity to lay before the House a proposal to expand the museum. For "with the progress of time, this institution has greatly increased in importance, and the treasures of nature and art, have been so abundantly furnished

from all quarters of the globe, that the rooms heretofore and at present occupied, are not sufficiently spacious for their exhibition, for the gratification of the eye, or for the more essential purpose of improving the taste and understanding of the public." Appealing to "an enlightened policy and patriotic dispositions, on the part of the present legislature," Charles proposed that fireproof offices be built in the east and west wing annexes of the State House that bordered the main building housing the museum. More to the point, he proposed that he be granted use of "the second floor rooms connecting and corresponding with those now used as the museum, so that sufficient scope might be had for a display of all the useful and curious productions of nature, science and art, which are now or may hereafter be collected." It was an interesting strategic gambit that combined the political (as the State gained by fireproofing offices) with the scientific, artistic, and patriotic, as "the State will have placed the great school of nature and art upon a permanent foundation, to the honor of the present and to the advantage of each rising generation." He made similar appeals to Governor Simon Snyder, with a nod to the legislature, for all it "had already done for the museum commands my warmest gratitude, and gratifies every patriotic breast, because it has shown the value of the establishment, and, the necessity of preserving it." The bill lingered in committee in various forms for years, and the city did not buy the State House. In the end, Peale won something of a Pyrrhic victory: when his bill was finally signed into law, it made provisions for the fireproof offices, but not the additional space.

Charles also worked to promote the well-being of the museum from behind the scenes. In his never-ending quest that the museum become

public, either at the state, or ideally, at the federal level, less than a year into retirement, he wrote a letter to his friend Nicholas Biddle, another representative in the Pennsylvania House of Representatives. After describing the current state of affairs at the museum, he planted the idea that the state might acquire the museum and make it part of the University of Pennsylvania. "In order to make the utility still more apparent, as a public school," Peale proposed "that it may be made an appendage to the University of Pennsylvania, and that the professors of said university shall have the use of the museum, to deliver lectures, free of expense to their pupils during each time of lecture." Again linking science, politics, and patriotism, he asked Biddle to envision "a noble exhibition and school of nature; thus becoming the wonder and admiration of nations, and a lasting monument of the wisdom of the legislature of Pennsylvania." As with the attempt to get more space by appealing directly to the House of Representatives, this effort failed to yield fruit, but shows just how vested Peale still was in the continued success of the museum.[12]

Things were going well under Rubens's day-to-day leadership. In 1813, revenue was a robust $7,600. He spiced up the evenings when the museum stayed open with "chemical and philosophical experiments."

All in all, the museum staples remained strong. An 1814 incomplete inventory included 269 painting and portraits, 1,824 birds, 250 quadrupeds, 135 reptiles, 650 fishes, 363 specimens "preserved in spirits," 800 Indian costumes and implements, 8,000 minerals and fossils, 33 cases full of shells, countless insects, and 313 volumes in the library. As in 1810, an estimate of all items, seen or stored, sat

at approximately 100,000, not because new items were not flowing in after 1810—they were—but because Rubens (and Charles) had given Rembrandt hundreds of items for the second incarnation of his Baltimore Peale museum. The 1796 attempt at a satellite museum there had petered out quickly, but this time Rembrandt was better prepared.

After his November 1811 return from Paris, where he had been mastering encaustic painting, Rembrandt reopened his Philadelphia portrait gallery, at times called the Appolodorian Gallery of Paintings. At some point in the first half of 1812, he took it into his head to try again to open a museum in Baltimore, this time modeled after the one Rubens was now running. Rembrandt knew Baltimore well, not only from his former attempt to open a museum and his family relations there, but from multiple trips associated with selling, commissioning, and exhibiting his paintings, as he had with his recent Napoléon Bonaparte portrait.

From the start, both Charles and Rubens thought it a bad idea, doomed to the same fate as its predecessor. "You will do well to weigh with a great deal of circumspection all the advantages and disadvantages," Charles wrote Rembrandt, "and make proper allowances for your abilities to undergo disappointments." To Rembrandt's sister, he was even more forthright. "I have said everything I could in reason," he told Angelica, "to induce your brother Rembrandt from making settlement in Baltimore." To his friend Nathaniel Ramsay, whose comments had spurred the museum's birth two and a half decades earlier, Peale noted that he "touched every string that I thought would vibrate to discourage him from such an undertaking." Rubens thought this so risky an

endeavor that he made Rembrandt a stunningly generous offer: if his brother would forsake Baltimore, he would hand him directorship of the Philadelphia Museum. Rembrandt declined and forged ahead with the new museum, one, as he described to Thomas Jefferson, that would be "a museum of arts and sciences . . . without neglecting any branch of natural history." Once the deed was done, despite their misgivings, both Rubens and Charles threw their support behind Rembrandt.[13]

Baltimore, which George Washington called the "risingest town in America," had a relatively healthy economy, driven in large part by its textile mills, ports, and growing banking industry. It was the third-largest city in the country behind New York City and Philadelphia, the largest city in all the south, and its population of 46,555 had ballooned more than 50 percent since the census of 1800. In 1813, shortly after his wife Eleanor gave birth to twins, Rembrandt, using his own savings along with a loan from Rubens, hired architect Robert Cary Long Sr. to construct the first-ever building in the United States that, from blueprints onward, was designed to house a museum. Long estimated the cost at $5,000, saddling Rembrandt with significant debt, as both his father and brother had feared, and forcing him to make the museum a joint stock company, funded by a group of wealthy investors.

The three-story-tall brick museum sat at 225 North Holliday Street, half a mile from the tip of the Patapsco River. It was 51 feet wide and 40 feet deep, with 15 large windows looking out on North Holliday Street and a steel front door bordered by a flat arch with two rectangular columns. The museum was advertised as "an elegant rendezvous for taste, curiosity and leisure," and "an institution devoted to the improvement of public taste and the fission of science." The doors to

what was most often called the Baltimore Museum, though at times was advertised as Peale's Museum and Gallery of Fine Arts, opened on August 15, 1814, just a month before the Battle of Baltimore, in which the city's successful defense of Fort McHenry was the turning point in the War of 1812.

The museum was stocked with Rembrandt's own portraits, including *The Roman Daughter*, and copies he made of many of his father's paintings that hung in the Philadelphia Museum. It also held "electric machines" he had acquired, various items he purchased from a Mr. Boyle's Museum at 57 Water Street in Baltimore, and, arguably most important, duplicate natural history, anthropology, and mineral samples Rubens gave him. Most notable among the samples Rubens contributed was the second of the two mammoths Rembrandt had helped excavate a little over a decade earlier.

Unlike his father, Rembrandt never strived for state or federal support or recognition. From day one, it was a for-profit operation, and was competing against rival museums. There was one at the corner of Lexington and Howard Streets that lured in visitors with promises of paintings of "naked beauties, as large as life, from Paris," along with tumblers and high-wire walkers. Other attractions included a ventriloquist show at Mr. Bullet's room on South Charles Street, a 360-foot-long painting entitled *The Temple of Flora* at Gibney's Room, a snake swallower from India, the Vilallaves, a family of acrobats doing life-defying stunts at the Circus, a "cabinet of learned turkeys which will dance to music" at the Pavilion Garden, and an establishment that boasted of having two dwarfs from Santo Domingo. Prices for these attractions ranged from 25 to 75 cents.

Admission at Rembrandt's museum was set at 25 cents, and the museum was open every day but Sunday, with evening hours on Tuesdays and Thursdays. Annual passes were also for sale, though they did not include admission to evening shows. Visitors entered into a long corridor flanked by four rooms which housed all items besides the paintings, including "birds, beasts, fishes, snakes, shells, antiques, Indian dresses [and] war instruments." Here too were "miscellaneous curiosities" that included "injected preparations of a human heart, lungs, and arm . . . [a] chain made of the toe-nails of birds . . . [a] dress made of the intestines of fishes, ornamented with porcupine quills and hair . . . an elegant feathered helmet cap from the Sandwich Islands." A physiognotrace, so that visitors could have their silhouettes made, was soon added.

Paintings and other artwork were housed on the second floor in a large, open gallery, illuminated by skylights. Rembrandt's copy of Benjamin West's *King Lear in the Tempest* was the first portrait visitors would see upon entering. On King Lear's right was Rembrandt's own *The Death of Virginia* and on the left his *The Roman Daughter*. Under these three large paintings was what visitors called a "Gallery of Heroes," a series of portraits including Washington, General Zebulon Pike, Commodores Stephen Decatur and Oliver Hazard Perry, and future president William Henry Harrison. The second floor was also home to a room where experiments in chemistry or physics took place, where music recitals could be heard on an organ Rembrandt had purchased, and where lectures were presented on a wide array of subjects. These two floors and everything on them were designed, Rembrandt wrote in his *Prospectus of a Museum of Arts and Science*, to be part of his "school

of universal knowledge . . . the means of rational Amusement, even to the most idle." The third floor had two studios that Rembrandt hoped would house students in an art school he envisioned, an idea that never came to fruition.

Early reviews, such as an unsigned editorial in the *Federal Gazette and Baltimore Daily Advertiser*, were positive. The editorial praised the proprietor as "a gentleman not less distinguished for his correct deportment, than for his talents as an artist and his knowledge in natural history." The museum itself was praised as an establishment that "besides the great number of quadrupeds . . . [had] a variety of birds, reptiles, war-like instruments of savage nations, articles interesting for their antiquity, and those which may be termed curiosities." Others wrote in the same paper lauding "the exertions of the proprietor of the Museum . . . recently established in this city, to amuse rationally."

The Baltimore museum quickly established the reputation of "a fashionable lounge" when Rembrandt illuminated it for New Year's Eve in 1814. The festivities, which included touring the museum, drew in somewhere between three and six hundred visitors and $161 in ticket receipts. This first year also saw Rembrandt the businessman realize that many in the city were not happy that he had actively avoided any military action in the Battle of Baltimore, and indeed, in any part of the War of 1812. "I found it impossible to shoot at a human being," Rembrandt wrote. "I never had borne arms and never could." In a public relations move to stem any effect on ticket sales of his decision, he ran an advertisement in the *Federal Gazette and Baltimore Daily Advertiser* announcing that all the ticket revenues from the following Monday would be donated "to aid the fund for the defense of the City

. . . and given to the Committee of Vigilance and Safety."[14]

Although he had initially discouraged Rembrandt, as Peale learned what his son had created, he wrote him, with no small dose of pride, "there is scarcely a difficulty in art or science that you cannot find some mode to overcome its difficulties." Early on, revenue in Baltimore was good. In 1815, the first full year, the museum saw $4,871 coming in, with the figure ballooning to $7,195 in 1816. The people of Baltimore were drawn in to experience the ever-growing exhibits, which by mid-1815 included a large portrait collection, one of which was Rembrandt's nude entitled *Jupiter and Io*. Charles had objected to the painting in a letter he had written his son, and he no doubt discussed it in a very brief visit he made to Baltimore in the fall of 1815. The natural history, anthropology, and mineralogy collection on the first floor had grown to include "a valuable collection of preserved animals from Africa," a Bengal fox, Klipspringer antelope, polecat, armadillo, duckbilled platypus, cuckoo, ornamented war clubs from the Caribbean, swords, daggers, shells, shoes from China, and assorted minerals. And it was more than the exhibits themselves that caught the fancy of the public, for Rembrandt's museum was soon employing a radically new—at least for America—type of lighting for evening hours.

Until 1816, both the Baltimore and Philadelphia Museums had used oil lamps, particularly Argand oil lamps, to light the way for evening crowds. Rubens had been tinkering with gas lighting for many years, and in 1815, working with Benjamin Kugler, and using Fredrick Accum's recently published *Practical Treaty on Gas Light*, he began serious experimentation. After a series of failures, and tapping $5,000 from the Philadelphia Museum coffers, on April 17, 1815, to the joy of

a dazzled crowd, Rubens lit one part of his museum using gas emitted from burning coal. Attendees were impressed, though there were some in the city who were still frightened of gas power after a well-known explosion at a gas plant in England. Rubens shared everything, save the $5,000 start-up costs, with Rembrandt, who lit the halls of the Baltimore Museum for the first time on the evening of June 17, 1816. Rembrandt then went one step further and working with investors, many of whom owned stock in the museum, formed the Baltimore Gas Light Company and subsequently successfully petitioned the city to dig up streets and lay pipes to install gas lighting.[15]

Back in Philadelphia, Charles had placed 16-year-old Titian into the museum to help Rubens, and to give the young man some direction after an apprenticeship in machine work that he and Franklin had completed. Franklin, now 21, continued to display a talent for the mechanical arts, as well as chemistry. He had gone on to a draftsman's position at a cotton factory at Germantown and then a position as machine maker, but often visited the museum to assist with any mechanical or engineering issues that needed to be addressed, and on occasion, to assist Rubens with chemistry displays. Rubens, ever concerned about the bottom line, had introduced a new means for generating income at the museum. Now, for the price of a separate admission fee, on certain evenings visitors could enjoy music and an illuminated display of the paintings in the museum, but not the other exhibits, turning the museum into a high-end lounge on those evenings.

In 1815, Pennsylvania changed the rules of the financial agreement

with the museum. Previously, the state had granted the museum space in return for maintenance and repairs. Now, they demanded four hundred dollars a year rent. That, in and of itself, was not a bad deal, as it included the State covering the repairs and maintenance, which on any given year might exceed four hundred dollars, and Charles agreed to pay the rent from the $4,000 a year he received from Rubens.

The situation became complex and burdensome in April 1816, when the City of Philadelphia at last purchased the State House and grounds from the state for $70,000. Within two months, the city was considering raising the rent on the museum to $1,600 a year and insisting that Peale buy insurance as well. In response, in July and August, Charles issued a public appeal in the form of "An Address to the Corporation and Citizens of Philadelphia." "I humbly beg your kind indulgence and patience, to hear my feeble attempt to illustrate the importance of the study of natural history, by the aid of a museum," he began. He proceeded with a mini history lesson on the museum and its role in Philadelphia for the last 30 years, including the pecuniary benefits to the city. "Strangers have often been heard to declare," Peale proclaimed, "that the greatest inducement they had to come to Philadelphia was to see the Museum and some have said that it was the first place that they came to. Consequently, it certainly in some degree must be the means of bringing wealth into our city."

Peale's "Address to the Corporation and Citizens of Philadelphia" argued that his museum had provided Philadelphians with not only an Enlightenment temple, "a school of useful knowledge . . ." diffusing "its usefulness to every class of our country" but a place to unwind. "We all know that relaxation from labor is often salutary,

and we know that amusements will be sought for," he told the council. "Are the morals vitiated by visitations here? I believe not in the least degree, but certainly improved." He went on to remind the council he had paid the four hundred a year rent with no objection, but that the new proposed rate "far exceed[s] my abilities to pay, and consequently will bring me into extreme distress and also take from me all the means of improving the museum." Peale implored the city to keep the rent at four hundred dollars and then suggested that the City of Philadelphia assume ownership of the museum, with the Peale family maintaining it, in effect making it a city museum. He closed with an appeal to their patriotism juxtaposed with an unveiled threat. It was up to the council to determine:

Whether the establishment of my museum shall continue to afford a store of valuable information to the citizen and stranger, and a fund of rational and agreeable amusement to all; whether it shall remain to be numbered amongst the national ornaments or useful improvements which Philadelphia has given to the western world, or whether it shall be driven like an outcast, who has forfeited his birthright, from the place of its nativity, to some more liberal or opulent city, in search of the patronage and support which had been denied to it by its countrymen.[16]

"Address to the Corporation and Citizens of Philadelphia" became the subject of a heated exchange in the newspapers. Some editorialists sided with Peale and implored the council to heed his request to keep the rent at four hundred dollars, and others argued the museum

was making more than enough money to support the rent increase. Camps also grew within the city council. Some argued the museum was a private enterprise, no different than any other, and more than capable of handling the new proposed rent. Others argued that the museum was a city treasure and that Philadelphia should take title to the museum "in perpetuity," with the stipulation that they would "not displace it without providing other suitable apartments for its reception, that the care of it shall continue in the family of Mr. Peale . . . and that out of the receipts from the Museum a certain sum shall be annually appropriated to the increase and embellishment of it." The latter idea was, at its core, what Charles had hoped for: it kept the museum in Philadelphia, ensured an income stream, allowed the museum to remain under Peale family supervision, and though it was not the state or federal museum he had dreamt of, it would at least be a city museum proper.

As with prior efforts with political bodies, all Peale could do at that point was wait. The council waffled for more than a year, and finally decided what, all in all, represented a major setback. It would not grant "to Charles W. Peale and his heirs a right to use . . . the State House for his museum on the terms and conditions" of his appeal. Instead, the museum would need to be insured for $10,000 and pay a yearly rent of $1,200 to the city: four hundred less than originally proposed by the council, but eight hundred dollars more than had been paid to the state.[17]

Peale had made threats to take the museum elsewhere before, but this time he seemed more serious. With Rubens continuing to run the day-to-day operations, Charles explored the options. Elias Boudinot,

former president of the Continental Congress and former director of the United States Mint, had learned of the decision of the city council. He told Peale "he was of the opinion that New York was far . . . more liberal . . . and they would certainly give a good price for the museum." On May 23, 1817, Peale traveled to New York to gauge interest there. He visited the American Academy of Fine Arts, the Literary and Philosophical Society, and the Lyceum of Natural History, where his old colleague, Senator Samuel Latham Mitchill, introduced him as "the father of Natural History in this country." It was, however, Scudder's American Museum that was his main draw in the city.

A descendant of Baker's Museum that Charles had visited in the 1790s and early 1800s, Scudder's American Museum now housed some natural history exhibits that Peale thought respectable enough, though not numerous, alongside wax figures of Sleeping Beauty, which Peale thought "savored too much nudity." All in all, he was more impressed with the museum this round than on his previous visits. "I wonder at his industry to make everything neat and pretty, and, to enrich his museum," Peale wrote. "He seems not to spare expense." He also took note with some degree of jealousy that New York City "had given Mr. Scudder the use of rooms . . . free of rent in a lease of 10 years."

After multiple visits to Scudder's Museum, the American Academy of Fine Arts, the Literary and Philosophical Society, and the Lyceum, Peale determined that the rational entertainment market may have been satiated. Toward the end of his visit, when his friend David Hosack suggested he and Scudder consider merging their museums, Peale told him, "I could not do that or make any advances toward obtaining a change of situation of my museum."

There were other possible locales for a move, with Washington on the list, as it held the additional appeal that the museum might one day be part of a national university that Peale so wanted to see established there. In 1818, he told Jefferson that he was also contemplating "making an offer of the Museum to Congress . . . [because] the collection of Revolutionary characters must have esteemed value with the Government of the United States." In late 1818 and early 1819, during a three-month-long trip he took to Washington, he painted portraits of President Monroe, Vice President Daniel Tomkins, Secretary of State John Quincy Adams, Andrew Jackson, Henry Clay, and John Calhoun. Peale also personally lobbied members of Congress on the idea of moving his museum there. While many respected what he had accomplished, there was not the requisite support to move this idea beyond informal discussions. Peale knew it, writing in his diary, "From what little conversation I have had with a few members, I believe I shall not find the members of Congress disposed to purchase it."[18]

Even with all the machinations with state and city, and Peale's threat to move to a more welcoming venue, income from the Philadelphia Museum remained healthy from 1813 to 1819, ranging from an all-time high of $11,924 in 1813 to a still respectable $6,050 in 1819. But the museum, and how it was presented to the public, were changing. In addition to the gimmicks that Rubens had already added, other changes were afoot. Rubens continued to advertise in newspapers, but far less often than Charles had, and the majority of the ads touted chemistry experiments at the museum, or the museum being illuminated at night, rather than the natural history and art exhibits within. While new samples did continue to flow into the Philadelphia Museum—

including an albatross, a king penguin, three live chameleons from Spain, nine rubies and five sapphires, and a brass god statue from Burma—they did so at a much-reduced rate. The exhibits that Rubens did deem to mention in the newspapers leaned toward the grotesque or sensational. These included a live turtle that weighed four hundred pounds "which can only be seen until the 4th of July after which it will be killed and preserved"; 40 young serpents, "each from eight to nine inches," that had been extracted from their five-foot-long mother that had been killed; a lock of hair from an albino touring Canada; "the hand of an Egyptian mummy"; "a shell thrown into Fort McHenry by the British"; a ticket to the coronation of Napoleon Bonaparte; and a "branch of the siba frandosa tree in Cuba under which Christopher Columbus first invoked Christianity in the New World and under which a lamp has been kept burning for the last two hundred years."

Titian's apprenticeship with Rubens at the Philadelphia Museum had proven to be time well spent for both the young man and the museum. Not only had his artistic talents blossomed, but he had developed both a love and a talent for natural history. Entomologist Thomas Say included half a dozen of Titian's drawings in a prospectus for his soon-to-be-published *American Entomology*, and Reuben Haines, the secretary of the Philadelphia Academy of Natural Sciences, nominated Titian for membership on his 18th birthday. Charles now described Titian as "an indefatigable collector of subjects of natural history, also of preserving animals . . . also excelling in drawing." On Christmas Day 1817, Titian, joined Thomas Say and George Ord and began a four-month expedition of Georgia and Florida, "in pursuit of

objects of natural history." In the evenings, as the team retraced the tracks of Say's great uncle, naturalist William Bartram, Titian was in the moment, and sat by the "cabin fire (though it is not so cold as to need one) reading Bartram's travels." When he returned to the museum, he deposited to the museum's coffers a hatchet and earthenware from an Indian mound at the St. Johns River and various birds and mammals from Georgia and Florida, among other items.

Titian went back to work with Rubens at the museum in Philadelphia. But Charles, sensing not just a naturalist in the making, but another member in what was developing into a small dynasty of Peale museum proprietors, successfully lobbied for Titian to be appointed as assistant naturalist on the Long Expedition. A federally funded natural history, ethnographic, and anthropological exploration led by Stephen Harriman Long, the expedition was to explore the Missouri River and the territories acquired in the Louisiana purchase, with a specific mandate issued by Secretary of War Calhoun to "first explore the Missouri . . . then in succession the Red River, Arkansas [River] and Mississippi [River] . . . the object of the expedition is to acquire as thorough and accurate knowledge as may be practicable . . . you will enter in your journal, everything interesting in relation to soil, face of the country, water courses and productions, animal, vegetable and mineral . . . you will conciliate the Indians . . . and will ascertain . . . the number and characters of the tribes."

For good measure, Calhoun appended the instructions with a copy of the orders that Jefferson had issued to Lewis and Clark.

Titian played many roles on the 1819–1820 Long Expedition, but perhaps the two most important were that of natural history artist and taxidermist. He sketched or painted 122 images of animals, including buffalos, wolves, and gophers, landscapes and scenes of Native American life, many of which were soon on display in the Philadelphia Museum. He also provided to the museum stuffed black wolves, prairie wolves, hawks, otters, and more.[19]

Meanwhile, back in Baltimore, Rembrandt was adding new exhibits to the museum there, including his own allegorical *Court of Death*, a massive 11½- by 23½-foot painting, with its depictions of War crushing the orphan and widow. He added chemical experiments, and magic lanterns displaying "phantasmagoric images," to the evening hours. Some sort of mirror exhibit called "trial by jury" which allowed visitors to view their heads from various perspectives was added. The one-man band, Signor Hellene, with his viola, Turkish cymbals, pan flute, drum and bells, was brought in, and the museum began selling kaleidoscopes to interested parties. Even with all this, along with the gallery of heroes, and the natural history, anthropology, and mineralogy exhibits, financial cracks were appearing. Rembrandt still owed Rubens the money his brother had lent him to seed the Baltimore Museum, and the building costs there had been dramatically underestimated, totaling $14,000 rather than the original estimate of $5,000. On top of that, a flood in 1817 deposited three feet of water on the first floor of the museum. Then a yellow fever epidemic broke out and killed 350 people in the city. By 1819, revenues had plummeted to $2,478, a 40 percent drop from the previous year. Titian went to the Baltimore

Museum to give Rembrandt a hand in 1821. A board of museum trustees was appointed and as a stopgap measure issued $20,000 in shares. The situation was bad enough that when Rembrandt offered Titian part ownership in operations, the younger brother declined. He wrote to their father that accepting would lead to "involving me in his debts and thereby preventing me doing anything for my own benefit." Rembrandt slowly began to retreat, spending more and more of his time painting, and less and less on active management of the museum, eventually contemplating ways of extricating himself from the whole messy matter.[20]

Finances at the Philadelphia Museum were also suffering, even with Rubens's latest additions, which included a stuffed and "celebrated young sea serpent," the rumored offspring of a 100-foot sea serpent that scores of people in Gloucester had sworn swam in the harbor there. The gas lights had helped revenues early on, but their novelty wore off and they were removed in 1820. Revenues in Philadelphia in 1821 dipped below $5,000 for the first time in more than a decade.

As ever, Charles thought that if the museum was granted more space at the State House or perhaps at some other venue he could display even more, and that would boost attendance and revenue. Continued efforts on that front, including another appeal to the City of Philadelphia in March 1820, yielded nothing. He even went so far as to offer to sell Belfield to buy a new building but got no takers. To both guard his investment in the museum and to ensure that his children would inherit that which he had built for the last three decades, on February 21, 1821, the Pennsylvania legislature approved Peale's request to

incorporate the museum as the Philadelphia Museum Company. The corporation and its board of trustees, which included Robert Patterson, who had donated the paddlefish way back when it had all started, issued five hundred shares of stock, valued at two hundred dollars per share. Peale was the sole stockholder, but immediately willed his stock to be divided equally between Rubens, Rembrandt, Raphaelle, Titian, Franklin, and Linnaeus upon his death. The city viewed this as a fiscally responsible move, for when the trustees petitioned to lower the rent to six hundred dollars per year, the request was approved, although their other request, for use of more space in the State House, was again denied.

After incorporation, at Peale's request, the board of trustees created four lectureships, which amounted to professorships, at the museum, as was the wont of contemporary European museums. Thomas Say of the Long Expedition, was appointed lecturer in zoology; Dr. John D. Godman, lecturer in physiology; Gerard Troost, lecturer in mineralogy; and Richard Harlan, lecturer in comparative anatomy. Each represented a step back toward the rational in rational entertainment.[21]

CHAPTER 7

SALUTED BY MANY AN
ACQUAINTANCE

I AM OFTEN SALUTED BY MANY ACQUAINTANCE[S] AS ONE OF
THE GREATEST CURIOSITIES BELONGING TO THE MUSEUM.

— C. W. Peale to Jefferson, January 25, 1824

Incorporating the museum, creating a board of trustees, and endowing
lectureships in early 1821 relieved 80-year-old Peale of some of the anxiety
he had about the short-to medium-term fate of his Philadelphia Museum.
But this was a difficult time in the Peale household. Belfield was a costly
operation to maintain. Repercussions from the Panic of 1819 were still
rippling through the American economy, and the only significant source
of income Peale had was the quarterly $1,000 payments from Rubens. That
steady income was at risk, as revenue at the museum had been steadily
decreasing from its all-time high of $11,924 in 1816 to $4,928 in 1821. At
the same time, museum expenditures were on the rise. Charles was not
fond of borrowing; "Those that go a borrowing go a sorrowing. It has been

truly so with me," he wrote Rubens. Nevertheless, Charles made it known that he would move the museum to Washington, either via Congress, as a national museum, or as part of Washington's first learned society, Edward Cutbush's Columbian Institute for the Promotion of Arts and Sciences. This, despite the fact that chapter 4 of the museum bylaws explicitly directed "the collections of the museum shall forever remain in this city (Philadelphia)." There were no takers at the $100,000 price Peale floated. As a result, his finances were being stretched, and he tried numerous times to sell Belfield, but met with no success.

In the fall of 1821, both Charles and Hannah contracted yellow fever and were ill for much of September. He recovered, but "Hannah became worse," Peale wrote. "The Doctor ordered blisters, the night was a long and tedious one to me, but I hoped from the stillness that they had given her an anodyne to keep her quiet while the blisters [were] drawing. No, the stillness was death—she died without pain." This was all the more tragic because, compared to prior yellow fever outbreaks, the fatality rate in 1821 was very low.[1]

Events at the family museums, in both Philadelphia and Baltimore, as well as interactions with long-time friends, provided some consolation for the yet-again widowed Peale. As ever, there were letters of correspondence with Jefferson. Here Charles could comfortably recount the trials and tribulations of growing old, including a foot injury he had suffered and his remedy which involving deep rubbing, and then comfortably pivot into a general discussion of aging in animals. "I observe that as animals grow old, that their teeth become more solid, the cavities where the nerve or marrow is, it becomes very small," he wrote his colleague at Monticello. "I have not examined the bones of various ages for want of opportunity and leisure,

nor have I read any author on the subject."

Other exchanges between the two octogenarians centered on the Philadelphia Museum, including the growing, but still unofficial, role that Titian and Franklin were playing there. Jefferson savored the updates and provided Peale just the sort of comfort he needed while mourning Hannah. "I do not wonder that visitors to your museum come from afar," his friend of 30-plus years wrote in one letter. "I always learn with pleasure the progress of your museum," he wrote in another. "It will immortalize your name." Both men longed for one last in-person meeting. "A visit from you," Jefferson wrote, "making Monticello your headquarters, would give me great pleasure."[2]

For more than six decades, Charles had been able to lose himself in his art when he needed to escape sorrow. *The Artist in His Museum*, perhaps his most famous painting, provided him that solace after Hannah had left him. Art historians have argued "after Gilbert Stuart's image of Washington, [it is] probably the most well-known American portrait of the nineteenth century." For seven weeks, beginning on July 23, 1822, he worked almost exclusively on *The Artist in His Museum*, which he saw not only as a self-portrait of grand proportion, but a work that would stand the test of time as a legacy, depicting "the rise and progress of the Museum."

To set the backdrop for *The Artist in His Museum*, that spring, Peale and Titian had done some preliminary sketches of the Long Room in the State House, using what Charles called his perspective machine or "painter's quadrant," though in *The Artist in His Museum*, he took some liberties in what he added and omitted from the actual contents of the Long Room at the time. "I have made the design as I have conceived appropriate," Peale said as he described the painting to Jefferson.

"With my right hand I raise a curtain to show the subjects of natural history arranged in the Long Room . . . standing at the east end of the room, the range of birds westward in their classical arrangement, the portraits of the revolutionary characters over them. My pallet [*sic*] and pencils on a table behind me. As the bones of the mammoth first gave the idea of a museum, I have placed a number of them on the floor by the table, and instead of the mineral cases on the north side of the room I have given a faint idea of the skeleton of the mammoth, beyond it quadrupeds . . . at the further end of the room is a figure with folded arms in meditation. Nearer is a gentleman instructing his son, who holds a book, still nearer is a Quaker lady in astonishment, looking at the mammoth skeleton; with up lifted hands."

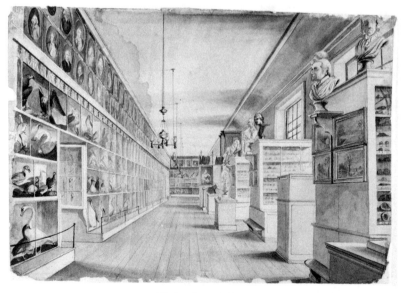

The Long Room, by Charles Willson Peale and Titian Peale, 1822.
Used with permission from the Detroit Institute of Arts.

Peale was especially proud of the lighting effects he created behind and in front of the crimson curtain in *The Artist in His Museum*. As he painted, he used a mirror placed in front of him, which reflected light from behind and created just the effect that he aimed for on his face. As he described it to Rembrandt, "I make a bold attempt—the light behind me, and all my features lit up by a reflected light, beautifully given by the mirror! . . . That you may understand me, place yourself between a looking-glass and the window . . . your features will be well defined by that reflected light, a dark part of a curtain will give an astonishing [illegible word] to the catching lights, and thus the whole figure may be made out with strong shadows . . . catching lights. With this mode I can paint a faithful likeness."

Measuring 104 by 80 inches, *The Artist in His Museum* made its debut in the Long Room on October 4, 1822. "The picture is much approved of," Peale told Rubens. "Mr. Joseph Hopkinson and his lady [saw] it yesterday and seem delighted with its effect, and strength of likeness." Two weeks later he updated Rubens that the piece was garnering much attention "especially by artists." The trustees who had commissioned the portrait were also pleased, though Peale made note of one or two wags in that group who "thought my left arm not quite as it ought to be." Shortly after completing *The Artist in His Museum*, Peale turned his brush to painting a series of six portraits of Maryland's first governors.[3]

A pair of natural history lectures Peale was preparing for presentation at the Philadelphia Museum also allowed him to take his mind off being widowed again. Though not of the scale of the 28 lectures he presented in 1799 nor the 40 lectures in 1800, Peale threw

himself—to the exclusion of almost everything else except for making porcelain false teeth for those in need—into crafting these lectures. Rubens saw the lectures as a way to popularize the museum. Although Peale certainly recognized this as an opportunity for outreach, he also believed, as he wrote Rembrandt in Baltimore, that by emphasizing the educational value of what he still thought of as his Enlightenment temple "It will show the citizens that they possess the foundation of a noble structure."

Peale began composing these lectures in February 1823, and compared with the lectures two decades earlier, his preparations took a different turn. For one thing, he had written the 1799 and 1800 lectures solo, but this time he received some help from both Raphaelle and John Godman, a naturalist and lecturer at the museum. Even more telling, Peale wrote Rubens, Rembrandt, and Angelica letters detailing the many times he practiced these 45-minute lectures before friends. One woman told Charles "she was fully of the opinion that it would be well received by the citizens, and would benefit the institution." Peale also rehearsed them before a small group of Quaker elders: "I find that by reading it frequently that I am getting it by heart," Peale wrote Rembrandt, "and new ideas are creeping in—as the mind dwells on the subject."[4]

Peale's lectures, both of which were heavily advertised in newspapers, were noontime events held at the museum on April 9 and May 17. He opened the first lecture with another plea to make his museum a national one. "A desire to render the museum a lasting benefit to my country has called forth my exertions for a series of years," he told his audience. "I have been animated to continue them by the fond hope it

might finally be made a great national institute." We can only assume that Peale put special emphasis on "finally be made a great national institute," as he underlined those words in his draft notes. "If ever there exists a science which is entitled to our highest consideration and respect," he continued, "it is without contradiction the study of natural history." And if ever there was a place for Philadelphians to learn about natural history, it was his museum. In addition to his numerous deistic nods to a Creator who was all powerful, though no longer active; a section on that greatest of classifiers, Linnaeus; a brief chronicle of natural history museums; and a long diatribe on parental affection in animals, Peale implored his listeners to make use of the treasures he had provided them at the museum. There they could not just see these creatures, but learn about "their attributes, their manners [and] their powers." What's more, "the collection of minerals is acknowledged by all who know their value to be both beautiful and instructive." In case the message escaped anyone in the audience—and it is hard to see how it could have—Peale reminded his audience that "in a moral and civil point of view, such a place . . . is highly valuable." He left it to them "to consider measures to obtain such improvements as will render the museum a more extensive School of Wisdom and virtue and of further importance to the City of Philadelphia."

No contemporary accounts exist of Peale's demeanor or manner as he presented these lectures, but it is not hard to imagine a level of energy and excitement that we might not immediately associate with a man in his 80s. His passion for the study of natural history, his true admiration of and respect for the natural world, surely shone through when he spoke to those seated before him in his museum. "However

vast the disproportion between the whale and the shrimp, the ostrich and humming bird, the mammoth and the mouse!" he proclaimed, "the space between them is filled with living creatures; but, however great the number may appear which come under our observation, they are few compared with those which are so small as to elude our penetration: every shrub, every leaf and tree is filled with living creatures, each as perfect in its internal and external structure as man, and we may presume that they are as tenacious of life, that they have the same affection for their young, and also enjoy as much happiness in their several stations, as any other created beings."

Peale knew these lectures would likely be his last chance to directly reach the general public in any significant way, and so even though it was a bit off point, he felt obliged to touch on the societal role of women. "I know that many of the evils of domesticated life have arisen from that absurd old adage 'that woman is the weaker vessel' . . . the result of the general acceptation of this absurdity is to make them weak by keeping them ignorant," he began. "It is true that the fairer sex [is] weak in animal power, yet let me ask, are they weak in intellectual? I answer no, your experience answers no, and the pages of history in the most decisive manner give this question the same response." He implored the audience to recognize that women "possess . . . brilliancy of genius," and when they are "properly valued and admired, loved and respected, there, and there only, is to be found a transcendence of arts, science, virtue, liberty and true religion."[5]

Despite having polished his performance in front of friends and others, unlike the reaction to his 1799 and 1800 lectures, attendance this time round was disappointing. Peale blamed this on the plethora

of alternatives available to the curious citizen. "My audience were not numerous but respectable," he wrote Rembrandt. "The people of Philadelphia are tired out with lectures, so many on every subject has been given of late in this city . . . The Philadelphians are I believe completely sick of lectures of late." He may have been right. Elsewhere in the city there were lectures on memory, grammar, the art of public speaking, even lectures that advertised that those attending would witness "exhilarating gas" (nitrous oxide) being "respired by several gentlemen." But there were more than just lectures that the curious folks of Philadelphia might attend. There were also theatre shows, music concerts, art exhibits, circuses and the like. There were also lures such as the mechanical museum, run by a former Peale employee, where visitors could be dazzled by "the tumbling automaton," "the Indian automaton sorcerer," "the little magician," and "the mysterious penman."

Though Peale's lectures were an economic failure, with Charles noting that receipts barely covered the costs of advertising in the paper, he thought they might receive a more positive reception at the Baltimore Museum. Advertising in Baltimore's *American and Commercial Daily Advertiser* that he intended "in a few days delivering several discourses or lectures in the Baltimore Museum," Peale gave both lectures there on May 24, and then a second time, in two parts on June 3 and 4. While attendance was better than in Philadelphia, it was still disappointing.

When Peale presented his lectures at the Baltimore Museum, it was no longer being managed by Rembrandt. Instead Rubens was at the helm. This was part of a general shake-up at both the Baltimore and Philadelphia Museums. By the early 1820s, Rubens was growing

weary of his position in Philadelphia. He was technically the director, and he, along with his siblings, were heirs to all stock issued for the Philadelphia Museum Company. However, it was clear to all, including Rubens, that in the mind of the public, and in the mind of his father as well, the museum was and would always be Charles Willson Peale's museum. Rubens wanted more, and an opportunity arose in 1822, when Rembrandt was looking to leave Baltimore.[6]

In January 1822, faltering finances at the Baltimore Museum, where income was barely covering expenses, combined with Rembrandt's desire to move to New York and devote himself full-time to painting, led him to approach his brother with an offer. If Rubens was interested in taking over in Baltimore, the museum was his. "He [Rembrandt] had found his fondness for painting superior to museum keeping, that he had much neglect[ed] one or the other," Rubens recorded in his journal. "He proposed to sell his museum to me, that he saw no prospect of paying the amount he had borrowed from me." At the time, no official contract was drawn up between brothers, and the deal was simple. "I was to give him a little cash to enable him to remove his family to New York," Rubens wrote, "and I was to pay the bills of the building or unsettled accounts. Together with what he owed me, [this] amounted in all to $7,500."

Rembrandt headed off to New York, declining an offer from Jefferson for a professorship in art at the University of Virginia. Rubens moved to Baltimore in the spring of 1822, but not before arranging one more international exchange of natural history objects for the Philadelphia Museum. He had been in contact with Alexandre Ricord, an American who had gone over to Paris to study under Georges Cuvier and was now working at the Muséum National d'Histoire Naturelle. Back in 1818,

Ricord had arranged for 33 South American and African bird species to be sent from Paris to the Philadelphia Museum for a modest charge. Now a new full-fledged exchange with Rubens was in the works. The exact details of the exchange are lost, but we know it involved at the very least "the exchanges of birds," where Ricord would send Rubens two birds "well mounted with their eyes" in exchange "for three skins of yours not mounted."

By July 1822, Rubens was advertising in the newspapers of Baltimore, reusing the Book of Nature emblem that his father had so often used. "To the public: Rubens Peale from Philadelphia, having succeeded his brother in the proprietorship of the museum and gallery of paintings, in Holliday St., Baltimore," the July 8 *American and Commercial Daily Advertiser* proclaimed, "and being determined to make it a place of recreation worthy of the polite and intelligent world, apprises the public that he has begun, and will continue henceforth to devote to it, all his time, attention, and resources."

It was an interesting potpourri of rational entertainment that Rubens had in mind for the museum, his "place of innocent and rational recreation." On the one hand, he hired a band to play at the museum three nights a week and amused visitors by hiring a puppeteer who used Chinese puppets. On the other hand, he initiated an annual art exhibition at the museum, hosted "Philosophical Fireworks," as well as a series of lectures in chemistry and "galvanism, magnetism, and mechanics," all "explained in as familiar and intelligible a manner as possible, so that children themselves may understand them." Rubens even had a menagerie that at one time or another hosted elks, wolves, bears, baboons, eagles, and more.[7]

Peale's letters and diaries reveal no hints of what he thought of Rubens's decision to leave the museum in Philadelphia and take the reins in Baltimore. Instead they show a more matter-of-fact response. Charles wrote to friends, "My son Rubens has purchased from his brother Rembrandt the Baltimore Museum," and then moved quickly to other matters. In his autobiography, he limited his remarks on the matter to "Rubens having purchased Rembrandt's museum in Baltimore, he left a great deal of his business to be settled in Philadelphia."

The board of trustees immediately approached Peale about stepping in and filling the role of manager that Rubens's departure created. Despite the financial problems he was facing, Charles had planned on traveling, perhaps overseas for the first time, but felt obliged to resume a direct leadership role at his museum. The board agreed to pay him a salary equivalent to 25 percent of all revenues coming into the museum and allocated funds for him to employ whatever assistants he deemed necessary. Peale immediately hired Titian and Franklin, now officially on the payroll of the museum, at a salary of six hundred dollars per year. Each had his talent and his assigned role. "Franklin attends to the mineral arrangements and also makes all the apparatus for his lectures, and, he is a very neat and excellent mechanic," Peale wrote to Jefferson. "[He has] a studious turn, and probably will become an excellent lecturer. Titian also arranges the shells and fossils, and bids fair to be learned in natural history. He is fond of classical arrangements and takes care of the subjects to be exchanged for foreign subjects and I have given him the charge of correspondence abroad." For his own part, he told his friend at Monticello, "I have only the survey of the whole and aid them with my advice. Occasionally I paint for the museum."

At first, the brothers feuded about their roles and status at the museum. Charles told Rubens that Titian needed "to harmonize with his brother Franklin, as the museum required the services of both of them." Soon enough, in part perhaps because Titian got married and his wife objected to the squabble, each of the brothers settled into their roles, though on occasion Titian would still gripe to his father about "Franklin stepping into his place."

Franklin quickly took to rearranging the mineral and coin exhibits and organizing evening lectures, which he tried to make both entertaining and educational. "Sometimes the front of the table was removed and the great electrical machine trundled in, and all the electrical experiments of that period shown, including dancing dolls," one observer described many years later. "A cloud [was] made of a couple of oil flasks covered with tin foil suspended to an electric charged trolley wire, drawn by a silk cord over a many-jointed and hinged house, with a lightning rod to its chimney. The clouds would rise . . . then the cloud would descend to send its lightning flash into the ball. The cork would blow out of the gas bottle and with its thunderclap the house would fall to pieces."

Titian spent his time preparing natural history specimens and rearranging the Quadruped Room, which housed the mammals, except for the mammoth, which sat in the former Marine Room. He began by moving some of the animals that were near the windows, "for there they were much injured by a bleaching sun." In part because rambunctious boys were putting their hands all over some of the exhibits far too often, he began "making high railing of wires when the railing is low." The new, higher railings were constructed to create

an oblong in the middle of the room, leaving five feet passage round it, with the "larger animals in pairs on high pedestals in the middle of the square, and the smaller animals on each side below them." The rearrangement also allowed for another large exhibit—a "sea lion . . . a fine subject, handsomely mounted" to be added to the room.[8]

Charles and Titian, though not so much Franklin, were always interested in new techniques for preparing and displaying natural history specimens in the museum. In the summer of 1824, British naturalist and explorer Charles Waterton visited the museum on his way to South America to share a new taxidermy method he had developed. "He came to North America on purpose to see my museum," Peale wrote Jefferson. "Hearing that I had the skeleton of the mammoth . . . he expressed great satisfaction in this museum and was pleased to say that it surpassed most of the museums in Europe." Waterton, Peale continues, "was so fond of the art of preserving animals that he had made it his study and had invented a mode much superior in practice, which Sir Joseph Banks said was superior to any in common practice." Waterton told Charles of his new method, which employed "a stick in the skin . . . [with] strings tied to this stick to support it from the ceiling . . . filling the skin with cut straw, he could put his modeling stick through the straw with ease, and thus model out the skin . . . when perfectly dried, [it] would be so stiff that it would not only support itself but also a considerable weight." Peale was intrigued after seeing a sample—a "cat's head and a bird from South America"—that Waterton had with him. Peale decided to adopt Waterton's method after Waterton accompanied Titian on a collecting mission in New Jersey, and Titian subsequently reported that the new method worked wonderfully.

This technique was put to use immediately, as new items continued to flow into the museum coffers, though not at the brisk pace of earlier years. During the early 1820s, the Philadelphia Museum received many items, including a jaguar, squid, dogfish, chameleon, sea horse, porcupine fish, black wolf, cape pigeon, bananaquit, a large shark jaw, and a rhinoceros horn. Other acquisitions included the head of an Egyptian mummy, stones from the temples at Carthage, a bow from Calcutta, a pair of slippers from Manila, a pair of children's shoes from Amsterdam, a Chinese gong, and minerals and shells aplenty. Many, but by no means all, of the new specimens were displayed in the appropriate space in the museum.[9]

The museum displays and exhibits, both old and new, continued to impress. Charles Gotfried Leland, journalist and author of the humorous *Hans Breitmann Ballads*, recalled the joy of visiting the museum as a child during this period. "There was a very excellent and extensive museum of matters and things in general," Leland wrote in his memoirs, "founded by an ancient artist named Peale, who was the head-central charm and delight of all young Philadelphia in those days, and where, when we had been good all the week, we were allowed to repair on Saturday afternoons . . . I owe so very much myself to the old Peale's museum . . . I often have paused in its dark galleries in awe before the tremendous mammoth." Waterton, the taxidermist who taught Peale his new method, also had only fond recollections of his visit. "When you go to Philadelphia, be sure not to forget to visit the museum. It will afford you a great treat," he wrote in his memoirs. "Mr. Peale has now passed his eightieth year, and appears to possess the vivacity, and, I may almost add, the activity of youth.

To the indefatigable exertions of this gentleman is the western world indebted for the possession of this splendid museum . . . The skeleton of the mammoth is a national treasure . . . It is the most magnificent skeleton in the world."

As impressed as visitors like Leland, Waterton, and others were, there were still not enough of them, and revenue remained disappointingly low in 1823, sinking to an all-time low of $4,476. Peale thought that perhaps a monthly magazine about the museum might bring in visitors and the first issue came out in January 1824. The reception was not what he had hoped, and no subsequent issues were published. At about this time, again to boost revenue, Peale also began selling not just daily and annual passes but passes for three or six months. Then, against his better judgement, for it might "degrade a museum of natural history," he began considering dime museum-like attractions that he had eschewed in the past. He brought in Signor Hellene, who had recently performed in Baltimore for Rubens. And there was an unusual hybrid of natural history, anatomy, and macabre art that was drawing considerable attention. After receiving the bones of a horse that measured 20 hands high, Peale had commissioned Richard Harlan, an anatomist, paleontologist, and physician, to reconstruct the skeleton and also to obtain the skeleton of a man, who was to be placed atop it. "The Philadelphia Museum has lately been furnished with an article which deserves to be particularly made known," read an advertisement. "This deposit consists of a gigantic human skeleton mounted on the skeleton of one of the largest horses that we have yet heard of. The skeleton of the horse is represented as in full action, while his rider is rising to throw his dart, which is poised for this purpose . . . Those

who have not seen, can have very little idea of the awful impression produced on the spectator by this truly poetical arrangement, where all thoughts . . . are lost in the sublime expression of energy."[10]

The fall of 1824 provided Peale the opportunity to reunite with one of his old friends from the Revolutionary War era. In August of that year, the 65-year-old Marquis de Lafayette landed in Staten Island aboard the *Cadmus* to begin a triumphant 13-month tour of all the states. Peale had befriended Lafayette during the war and had painted portraits of the marquis in 1777, and then again when he had returned for a visit in 1784. That 1784 portrait hung in the Long Room 40 years later. Americans were thrilled to welcome back their adopted son who had done so much for the cause all those years earlier, and they hosted endless celebrations, parades, and banquets in his honor.

When Lafayette and his entourage, which included Secretary of State John Quincy Adams, arrived in Philadelphia on September 28, the city was giddy with excitement and spectators described "a reception in this city [that] was grand beyond description." Each of the 150 Revolutionary War veterans present wore a cockade and were drawn in three large carriages trimmed in white and red and lined with benches looking out to the crowd. In gold letters on one side of the first carriage, it read "Defenders of our Country," and on the other side "The Survivors of 1776," while the front bore a sign reading "Washington," and the rear a sign reading "Lafayette." The crowd along the four-mile procession route into the city numbered 20,000, and the excitement was palpable. The entourage was serenaded by a specially commissioned piece—"Lafayette's Grand March"—as it passed under

13 newly constructed arches, emblazoned with "Lafayette" at their apex. "The banners of colored silk waving in the wind," wrote one observer, "the gilded standards, and the emblems of the different mechanical arts, all conspired to give splendor to the scene." As Lafayette neared, 24 young girls, all clad in white and with garlands in their hair, greeted him in verse that began:

> Strike the cymbal, roll the tymbal
> Sound the trumpets, beat the drums
> Loudly ringing, cheerily singing
> Lo, the patriot hero comes . . .

> Pride of Princes, strength of Kings
> To the dust fair freedom brings
> Hail him, hail him, let each exulting band
> Welcome Fayette to Freedom's happy land.

"General," the mayor's opening remarks began, "the citizens of Philadelphia welcome to their homes the patriot who has long been dear to their hearts." Much of the city was illuminated that evening. Transparencies of famous figures from the war, nine of which were made by Peale, lined the streets. And this was all on just the first day of the festivities.

Two days after Lafayette arrived in Philadelphia, Peale sent him an invitation for a private tour of the museum. "Much esteemed friend," Peale wrote his former brother-in-arms, "A few mammoth bones gave rise to the idea of forming a museum . . . this object has had my

unceasing labors for many years, and, is now in high estimation with the lovers of natural history and I doubt not that you will be gratified to see the animals of America, many of which no other museum contains, therefore I ask the favor of you to visit it with . . . no other company to be admitted except such as you invite."

The marquis seems to have been impressed with what he saw in the museum. Peale wrote that Lafayette "expressed great satisfaction . . . but it was immediately after . . . shaking hands with hundreds of citizens, when he was under much fatigue," likely as the result of an earlier reception. Fatigued or not, there is some evidence, though it is not certain, that Charles had his friend sit for another portrait that day.

Shortly after Lafayette's visit to Philadelphia, Titian was recruited for another natural history expedition, this time to study the birds of Florida. Naturalist Charles Lucien Bonaparte, a nephew of Napoleon I, had recently immigrated to the United States, taking up residence in Philadelphia. Bonaparte was updating Alexander Wilson's *American Ornithology*, for which Titian had been making some sketches, when Bonaparte decided he needed to go to Florida to get more information on the birds there. He asked Titian to join him, and Titian jumped at the chance. The expedition ran from October 1824 to April 1825, and though Titian's journals from this period are lost, it appears that his primary role on this particular mission was natural history illustrator rather than collector.[11]

As Lafayette continued his tour of the country, Peale's joy at being reunited with an old friend turned to sorrow when family tragedy

struck yet again. On March 5, 1825, seemingly ever-troubled 51-year-old Raphaelle died of what doctors diagnosed as "an infection of the lungs," a common term used then for consumption or tuberculosis. Raphaelle's last few years were particularly depressing. Though he showed promise early on, Raphaelle's art had never garnered the attention his father had hoped for, nor the sort of prices that allowed for him to support his family. His alcoholism may have begun in part as a means for easing the pain of both the arsenic poisoning he had suffered and his ongoing troubles with gout, but it made supporting a family all the more difficult. Bouts of drinking would often be followed by promises of abstinence, which Charles and other family members and friends would see fall by the wayside. Family tradition has it that shortly before his death, Raphaelle was by necessity forced to write couplets for bakers to insert in their cakes to make ends meet.

Charles was devasted at the loss of his son but took some consolation in Raphaelle's state of mind in the end. "He was nothing but skin and bone before he departed," Peale wrote a friend. "I was with him frequently in his last illness . . . [a] short time before he died, he told me that he loved and respected me, therefore he wished me to know that he was perfectly content to die, that he had never injured any man, and he felt himself easy as to worldly affairs.[12]

A few months after his brother died, Rubens decided he had had his fill of the Baltimore Museum. Despite his best efforts, museum revenues were low and failed to cover current costs. Rather than remain in he what he saw as a quagmire, Rubens decided he would try his hand at opening a brand-new museum in New York City. Before

leaving Baltimore, he offered the directorship to Franklin. "My wish," he wrote his brother, "if you undertake the management of it, is that you should enter into it with zeal and spirit." But Franklin did not possess the zeal and spirit or the interest, and he declined the offer. With no other choice, Rubens retained the role of director of the Baltimore Museum, but appointed a William Wood as operating director. Rubens sold his house on Walnut Street to Charles, who still owned cost-heavy Belfield, but had moved into his son's old house, and allowed Linnaeus to live at Belfield when he wasn't off on some wild, military adventure, as he was prone to be.

Rubens and his family moved to New York, where he purchased the Parthenon Building, 25 feet wide and 100 feet deep, as home to Peale's New York Museum and Gallery of Fine Arts. He stocked his new museum at 252 Broadway, across from city hall, with "subjects of natural history and works of art, Indian dress, war clubs, and spears" from the Philadelphia and Baltimore Museums, along with paintings he purchased from Joseph Delaplaine's Art Gallery. Keen to attract attention from the start, he timed the museum's opening for October 26, 1825, the very day that New York was celebrating the completion of the Erie Canal. "The City of New York was all in motion," Rubens wrote in his memoirs, "crowded with strangers." For maximal effect, he "fired a salute" from a cannon atop the Parthenon, "which had a very good effect and made the museum known and gave me many friends."

Admittance to the New York City Museum was set at 25 cents, with children gaining entry at half price. Annual tickets were sold for five dollars and twice that for an annual family pass. Rubens also made side deals to increase attendance. A Mr. Seaman had a bookstore,

along with a library and reading room, close by, and he and Rubens agreed "subscribers to his reading room . . . should have free access to the museum, and subscribers to the museum should have free access to the library and reading room." Teachers and school children were special targets of Rubens's marketing plan. "I gave the teachers, when they came with their schools, admittance gratis," he wrote Franklin, "and the scholars admitted for 10 cents each—the bills thus distributed are much valued and taken home to their parents. We sent to about 350 schools and delivered about 8,800 bills—it produced a good effect."

Visitors, who included New York luminaries like DeWitt Clinton, David Hosack, and Samuel Latham Mitchill, first entered what Rubens called *his* Long Room. This was filled with "collections in natural history, which consist of numerous quadrupeds, birds, lizards, snakes, fishes; a splendid collection of insects, with corals, shells, minerals, petrifactions, an extensive collection of miscellaneous curiosities; and 63 portraits of eminent men." Shortly after the museum opened, Rubens advertised a remarkable addition to this room, "an Egyptian mummy in a fine state of preservation . . . from the city of Thebes." Up one floor sat "the saloon or Gallery of Paintings . . . constructed with a skylight, by which the pictures are seen to the greatest advantage." These included works from Raphaelle and from his uncle James. That same floor housed a lecture room for "the philosophical and miscellaneous experiments which form a part of the evening amusement." At one point, the lecture room hosted "The Mechanical Turk," Johann Nepomuk Maelzel's chess-playing automaton that decades earlier had matched wits with Benjamin Franklin and Napoleon and was soon was to be the subject of Poe's *Maelzel's Chess Player*. Above the lecture

hall and gallery sat a terrace that commanded "a fine view of the Park, a large extent of Broadway and the surrounding country, forming an agreeable promenade and displaying a prospect equally interesting to the citizen and stranger." For good measure, Rubens also had copies of eight daily newspapers available should a visitor wish to catch up on events while perched above the city.

Many of these exhibits were to his father's liking, and akin to Charles's notion of an Enlightenment temple. Others, such as Romeo "the very learned dog," who barked answers to questions posed to him, not so much so. But, unlike the Baltimore effort, the new museum was doing "tolerably well," Rubens recorded, "receiving from 25 to 30 dollars per day," and yielding a comfortable net income early on. So much so that a few years later Rubens hired his brother Linnaeus to manage a small [short-lived] branch museum upstate in Utica, New York.[13]

Back in Philadelphia, Charles had grown tired of the never-ending haggling with the city over rent and upkeep of the museum at the State House (which was starting to be called Independence Hall). What's more, he needed more space for exhibits and demonstrations, and it was clear that the city was not inclined to provide that space. In 1825, Peale began discussing a move with a group of Philadelphia investors who were working with architect John Haviland on a new commercial building complex called the Philadelphia Arcade. Modeled on the Burlington Arcade in London, this new complex, with its neoclassic motif, would run the length of Chestnut between Sixth and Seventh Streets, not far from the new Chestnut Theatre.

The developers offered Peale the entire top third floor, with five

rooms, lit from skylights above, as a new home to the Philadelphia Museum. On May 3, 1826, the cornerstone for the arcade was laid. The opening date for the arcade with its "four arches springing from the sculptured caps," was set for the summer of 1827. After a bit of negotiating, Peale and the board of trustees of the museum agreed to a rent of $1,500 per year. Charles thought it a bargain, given that the complex would house those hundreds of stores and offices, which would no doubt attract would-be visitors to the museum. With more space looming, Peale quickly went to further expanding the museum collection, purchasing "an extensive and very complete collection of the dresses, arms, implements, pipes and instruments of music . . . of the Sioux, Cheyenne, Aricaree, Mandan, and Osage nation." This collection, read an advertisement "contains all their dresses of war, ceremony and the dance, and is the most complete that has ever been exhibited."[14]

With a new home for the museum secured, Charles turned to two pressing personal matters. Having lived virtually full time in Rubens's old house on Walnut Street since shortly after his son moved to New York, Peale finally dispensed with Belfield. His next-door neighbor, William Logan Fisher, a wealthy industrialist and merchant, was looking to expand his own farm called Wakefield, and Peale sold him Belfield for $11,000. The machinery was sold separately and between the sale of the property and the machinery, Charles was relieved of the pressing debt that been amassing at the farm.

In what would turn out to be his last letter to his friend Jefferson, Peale, writing of the sale of Belfield, expressed hope that freed from his debts, he might have the funds and time to "indulge myself with

a visit to see you." But that visit never took place. Jefferson died not long after receiving the letter, and besides, Peale, who felt "the loss of a female . . . to converse, advise, and to partake with me the enjoyments of life," had already decided to spend his time and energy searching for a new wife. Charles's friend Abraham Ritter recalled a conversation at the time on this very matter. "He told me that as he calculated upon living 27 years longer, which would bring him to 112 years, the proper length of a man's life, as he alleged and attempted to prove by reference to animal creation," Ritter wrote. "He intended getting married again, and was actually on the lookout, laughing heartily at me for remaining so long a widower."

Peale spread the word that he was in search of a mate, and another friend, Simpson Morris, approached him one day. "He had thought on the subject," Peale wrote of this encounter, "and he knew a woman that was exactly such as would suit me. She is a most accomplished woman, sensible, amiable, and would delight in the studies that I enjoyed, she was cheerful and would command respect in all companies, his praise of her was very great . . . she is the youngest daughter of Joseph Stansbury and now is a teacher in the Deaf and Dumb Institution of New York." Despite being her senior by three decades, Charles, who was already planning on going to New York City with some of his grandchildren, decided to call on Mary Stansbury, and had Morris write him a letter of introduction. After sitting in on one of her lectures to the young students at the Deaf and Dumb Institution, and then having tea with Mary, Peale was smitten, and gave her a copy of his *Essay on Domestic Happiness*.

Wasting no time, that very day, he made his intentions of marriage

clear. "I was candid, open, and sincere," he recalls, "and informed that I had expressly come to New York to see her, that I wished to make her happy and myself also." Mary was flattered, but told him she was not well, "that she had spasmatic affections which would soon carry her off . . . that she was sure that she would die soon." Charles told her he would work to nurse her back to health, but then learned there was more to her reluctance. "I entreated her long to consent," he wrote in his journal, "but still her reply was that she had devoted herself to the school . . . and she thought it was doing her duty to help these poor mutes." Mary then told him that though marriage was not an option, she "would be happy to correspond" by mail, but that would not suffice for Peale. He ended his diary entry, "I could not promise that I would, having taken her answer that she could not change her situation."[15]

The late December trip back to Philadelphia was a difficult one. Rather than the more typical single coach ride home, for some reason, this journey involved three legs that commenced with a six-hour boat ride in the freezing cold, rain, and wind from New York to New Brunswick. The ship grounded south of where it should have landed, and "to add to my difficulties," Charles noted his diary, "it was dark and the shore side rough . . . [I had] to lug my trunk about ½ mile, [it] was too severe a labor for me . . . being almost exhausted one of the passengers was obliged to help me." A stagecoach to Trenton was next, and then another ship ride to Philadelphia. Worn out and frazzled from the trip, Peale "had not been in bed more than an hour before I found myself extremely ill, with a violent pain at my heart," the result of pleurisy, an infection of the lungs, that causes severe chest pain. On top of this, Peale wrote of "a stricture on my bowels, my distress was

extreme." The physician, a Dr. James, commenced to numerous rounds of bleeding, "taking all the blood that could be spared," Charles noted, "which reduced me to such extreme weakness, that in attempting to go to the chair I fainted twice."

Within about six weeks, Charles appeared to be on the mend, taking occasional walks in the February cold and writing colleagues about the upcoming museum move to the arcade, and how "the frost will not prevent the masons and bricklayers working." It was a short reprieve. Soon he confided to those close to him that "this spell of sickness has taken from me much of my animal spirits" and he again found himself bedridden for stretches. He mustered the strength to visit family on February 22, and on the walk back, he took ill again. Titian and daughter Sybilla stayed with him the night, comforting him until he died early the next morning.

Obituaries, virtually all of which referred to Peale "as founder of the Philadelphia Museum," and some of which made reference to him being the "father of several sons, ingenious followers and promoters of science," appeared in papers from Philadelphia to New York, Maryland, Connecticut and New Hampshire.

His late morning funeral on February 24, which the American Philosophical Society resolved that all members should attend, took place at St. Peter's Episcopal Church on Third and Pine. He was laid to rest under a tombstone that read:

He participated in the Revolutionary struggle for our Independence

As an artist contributed to the history of the country

Was an energetic citizen and in private life

Beloved by all who knew him[16]

CHAPTER 8

FULL CIRCLE TO
INDEPENDENCE HALL

Six months after Peale was laid to rest in the graveyard at St. Peter's Church, the Philadelphia Museum opened in its new home at the arcade. As a commercial hub, it was just the sort of locale that Rembrandt, writing to the museum board from New York, thought perfect. "Churches and theatres may be placed in any situation where they can be conveniently reached by those who are determined to visit them," he noted, "but a museum is differently circumstanced. A very limited number of persons are disposed to hunt for it." The arcade made such a hunt unnecessary, the more so as soon "Philadelphia Museum" was carved into stone, featured prominently between the balustrades at the top of the entrance.

Tickets for the museum remained at 25 cents, with children admitted for half that amount. The doors were open from sunrise to 10:00 p.m. every day except Sunday. The museum board of trustees appointed Titian curator and Franklin manager, each at a salary of $1,000 a year.

The brothers assured the public, that they would "use every exertion to make the museum more and more worthy of the general patronage; and that they will spare no pains to add to the magnitude and interest of the collection; that in the selection of objects, and in their exhibition, they will be careful to keep in view the dignity of science, and the principles of morality: in a word, they will continually endeavor to follow, in the administration of the affairs of the museum, the course so successfully and so honorably pursued by their venerated father." The board agreed in principle, as did brother and stockholder Rembrandt, but the latter made it clear that in keeping with the role of rational entertainment, financial decisions must be driven by the fact that the museum, "which has grown up as a private enterprise . . . must be considered a money-making institution."[1]

As curator, Titian continued his collecting missions, including short expeditions to Maine and New York and even a few weeks in Colombia, South America, with his friend and colleague William McGuigan, who was working as a taxidermist at the museum. The board even considered funding an expedition to South Africa, but the motion was tabled.

In his 1831 *Circular of the Philadelphia Museum*, Titian provides a detailed description of the museum in its new arcade home. First and foremost, Titian notes that the new location provided the museum what it needed most—space. "By the unremitted exertions of the founder, and the liberal patronage of the public, the collection grew until it became too great, even for the superior accommodation of the State House," Titian wrote in the circular. "Many articles of interest were excluded

for want of room, and a great part of those that were introduced, could not be scientifically arranged, or advantageously exhibited." The arcade remedied the space problem that plagued the museum from its birth: the rooms there were "light, airy, and appropriate to their purpose; and being more than double the size of those in the State House, afford abundant room for the increase in number of the articles, and for their proper arrangement and classification." These articles now included more than 250 mammals, including a rhinoceros; 1,310 birds, "among them specimens from every part of the world"; a collection of reptiles, fish, and crustacea, corals, and shells described as "very numerous"; and thousands upon thousands of insects, including the "most complete collection of the Lepidoptera of the United States."

As ever, there was the fossil that never ceased to amaze—the mammoth—with *Exhumation of the Mastodon* behind it. In addition to the mouse that was always near it, the museum had acquired the remains of a circus elephant named Columbus and a giraffe and placed them aside the giant beast. Some of the rooms were stocked with ethnographic exhibits: "the dresses, implements, arms, etc. of the native tribes of Indians, occupy a large space in the rooms," Titian wrote. "This department is extremely full, and contains everything that can elucidate the manners and customs of these interesting and rapidly disappearing people." Even with all that, there was ample room for a large lecture hall as well, "where experiments are regularly exhibited and explained, in order to illustrate phenomena in nature and effects of art." And placed throughout it all were the portraits, including *The Artist in His Museum* and "men of eminence in Europe and America." Prussian Prince Maximilian, an amateur naturalist himself, was

impressed with it all. "In the museum of Mr. Titian Peale," he wrote after visiting, "I saw many objects which deserve close investigation." Soon the prince was sending the museum new items, like a deer wolf, for its collections.[2]

Circumstances were not nearly as good at the two other Peale museums. From the start, when he had first acquired it from Rembrandt, and then later when he ran it in absentia, Rubens had never been able to make the finances work at the Baltimore Museum. By 1829, creditors were applying pressure, and he had to move the museum into smaller quarters at the corner of Calvert and Baltimore Streets. Its original home soon became the new city hall and then later Male and Female Colored School Number 1. In 1833, the Baltimore Museum suffered a fire that led to $3,000 in damages, and Rubens formed a partnership with a lawyer by the name of Charles de Selding to help pay off the losses. That partnership soon dissolved when Rubens learned that his partner "was a different man from what he always appeared to be." Little is known about the day-to-day operations or finances of the Baltimore Peale Museum after that, except that it was much reduced in scale, and in the early- to mid-1830s was managed by a Mr. Walker. Then sometime in the late 1830s, Rubens handed the museum over to Raphaelle's son, Edmund Peale. In New York, too, finances were poor and though Rubens continued to acquire natural history specimens when he could, including through exchanges with museums overseas, he took to more and more gimmicks at his museum there. He brought in the Native American groups to perform war dances and mock scalpings, and hired Chang and Eng, the Siamese twins, as well as "two fat girls" and a ventriloquist for audiences to gawk at.[3]

In Philadelphia, new samples continued to arrive after the move to the arcade. Between 1827 and 1841 (the last year records were kept), new ethnographic and anthropological items included a Japanese tobacco box, a miniature guitar made from gold, a grass fan from Calcutta, a sugar box made by Indians in Chile, and some bird nests used for soup in China. New natural history specimens included a green macaw, mandrill ("red nosed baboon"), star-nosed mole, black albatross, glossy ibis, soldier crab, cliff swallow, ostrich, horned lizard, and a porpoise. But the total number of natural history contributions was decreasing, and rather dramatically. In 1837, there was a single item, some species of billfish, added to the museum coffers. Excluding that year, between 1827 and 1841, the museum records show between three and 30 new natural history contributions arriving annually (though some contributions contained multiple items). Titian often wrote the board reports like "our donations this quarter have been small and unimportant." At the same time that the absolute number was declining, the proportion of natural history samples that might be classified as freaks was increasing: a cow with three legs, a chicken with four legs, a two-headed calf, a two-headed piglet, a two-headed chicken, a kitten with two snouts, a toad with five legs, and a chicken with five toes, to name a few. And donors knew not only that such items were now welcome at the museum, but that they would be displayed, as the board had recently enacted a policy "that all donations to the Museum, shall be exhibited so as to give evidence of the liberality of the donors, at the same time that they gratify the rational curiosity of visitors."

In addition to the standard natural history, art, and anthropology

items on view, there were special exhibits, such as a replica Italian village and a miniature railroad that Matthias Baldwin of Baldwin Locomotives had donated. Franklin, with his mechanical bend, was especially fond of the locomotive and was forever tinkering with it. Titian brought in a Mr. Weldon, a magician who dazzled with his "Cardbox of Beelzebub," five automatons, including a Chinese juggler, and following their stand at the Peale New York Museum, Cheng and Eng, and the "two fat girls," all to drum up ticket sales.[4]

Manager Franklin never fully possessed Titian's passion for the Philadelphia Museum. Titian was a born natural historian; Franklin was many things, but most of all a mechanic and a builder. When he was offered a position as assistant assayer for the United States Mint, with an assignment to travel to the mints of France and England to study their means of coining, he jumped at the chance. On April 30, 1833, Franklin resigned as museum manager. For the next two years, traveling on a $7,000 budget allocated by the secretary of the treasury, he assayed the mints of Paris and London so that the director of the United States Mint could provide Congress with a detailed state-of-the-art report as the Philadelphia Mint prepared to move to a new facility. Franklin remained at the United States Mint for the next 20 years and soon rose to the role of chief coiner. Along the way, he developed a passion for collecting and studying the pottery and stone tools of native North Americans.

With Franklin gone, the board elected Titian manager and reappointed him curator. While he would have preferred to stay focused on collecting and preparing exhibits, Titian felt obliged to

accept. He was immediately steeped in managerial issues, the primary one of which was the deteriorating state of the arcade building. Almost from the day the building had opened, there were hints of what was to come, with the skylights leaking water into the museum with each new rain. The developers were having trouble keeping the businesses they already had and attracting new ones and took to what Titian saw as unsavory means to remedy that. "I regret being obliged to call your attention to another evil attracting our attention in the Arcade," Titian wrote the board in 1834, "a bawdy wax Venus near our front door."

The museum was bound by a 10-year lease that was only a bit more than halfway through, but with income having dropped 50 percent since the arcade had opened, plans were already in the works for the construction of a new building to occupy when the arcade lease expired in 1838. The board secured a loan of $200,000 from the Bank of the United States for construction of a new building that they envisioned having rooms for exhibits and artwork, and spaces to rent to eight business to supplement ticket sales. Rembrandt, still in New York, shared his thoughts on what such a new establishment might look like. It should include ample space for "a huge, magnificent hall" for exhibits, he wrote the board, with lofty windows, to "pour out the light to attract the spectators . . . [and] create a vortex of elegance . . . [for] beautiful works of art and nature."[5]

In January 1836, a lot on the corner of Ninth and Sansom Streets was purchased for the new building. At about the same time, Nathan Dunn replaced attorney James Broom as museum board president, leading to a radical shift in what would be housed alongside the museum in the new building. Dunn, a Quaker philanthropist, was

back in Philadelphia after spending more than a decade amassing a fortune buying and selling teas and silk in China. He was a collector of the first order, and had procured thousands of items while in China, all of which he shipped back to the United States and temporarily housed at his New Jersey summer home dubbed the "Chinese Cottage." Dunn, along with fellow board member George Escol Sellers, convinced the remainder of the museum board to scrap the idea of using the first floor of the new museum building to house offices for rent, and instead to allocate the space to Dunn's Chinese Museum—to be billed as a collection with "ten thousand Chinese things"—in effect creating a museum complex, all controlled by the board.[6]

Despite the general financial malaise during and after the Panic of 1837, construction of the new building began in that same year. On July 4, 1838, when the doors of the museum opened, light of the very form Rembrandt had hoped for poured through the large second-story windows onto the exhibits. When natural light was lacking, gas lights were employed. The main gallery, the "great salon room," as it came to be called, ran 230 feet long and 70 feet wide with a cavernous 50-foot-tall ceiling. The room was stocked with "all well-preserved animals, birds, reptiles, and fishes," and the mammoth dominated the far end of the salon. The birds drew attention with "the richest tints of the most bright and glowing gems," wrote one visitor. "It was difficult to believe that so much of dazzling brilliance in color and hue could be produced from a feathered surface only." The same visitor wrote of "shells, corallines, minerals, fossils, and insects, of different seas and countries . . . many articles of costume and weapons of war, from the aboriginal

tribes of American Indians, and from the islanders of the South Seas, with antiquities from Mexico and Peru, arms from Persia, Turkey, and other countries of the globe . . . [and] mummies of a family of the Incas of Peru, preserved by embalming." Paintings of "remarkable public men of America and France" hung throughout.

On some afternoons, the Horticultural Society was permitted to display its prize plants, including pumpkins "one of which weighed 196 lbs. and was 7 feet in circumference," in the great salon. Evenings too were busy, with performances on the orchestra stage at one end of the salon by Frank Johnson's African American Brass Ensemble three times a week and a group of Hungarian minstrels on the other nights. In addition to music, evening performances at the museum included a ventriloquist who "maintained a rapid conversation with 6 or 8 persons, supposed to be in different parts of the room and made the voices, all of which were distinct and different, come from the garret, the cellar and all quarters, with surprising exactness." It appears to have been quite the act. "He imitated also the cries of various animals, dogs, poultry, hogs, with wonderful fidelity. The best was the imitation of the hum and buzz of a bee, which was increased and diminished by his attempts to catch it and by distance and which he at last catches and seems to put humming into a bottle."[7]

One thing that visitors would not have encountered at the arcade museum was natural historian and explorer Titian, who just six weeks after the doors to the museum opened, sailed off on one of the ships that made up the United States Exploring Expedition (also called the US Ex-Ex). Titian was one of seven scientists who joined 339 other

men on what to date was the largest expedition in American history, on par with, and in many ways, surpassing James Cook's 1768–1771 expedition of the South Pacific on the *HMS Endeavour*.

The US Ex-Ex had the grandiose mission of mapping the entire Pacific Ocean, not only to establish commerce routes, but to study the entire region, including the Antarctic. The expedition was the brainchild of Jeremiah Reynolds, a newspaper editor, who in a fiery speech to the Congress in April 1836 proposed:

Exploring and surveying new islands, remote seas, and, as yet, unknown territory, [to] collect, preserve, and arrange everything valuable in the whole range of natural history, from the minute madrapore [*sic*] to the huge spermaceti, and accurately describe that which cannot be preserved . . . to secure whatever may be hoped for in natural philosophy, to examine vegetation, from the hundred mosses of the rocks, throughout all the classes of shrub, flower and tree, up to the monarch of the forest; to study man in his physical and mental powers . . . to examine the phenomena of winds and tides, of heat and cold, of light and darkness; to add geological to other surveys, when it can be done in safety . . . there should be science enough to bear upon everything that may present itself for investigation.

President Jackson supported the idea of such an expedition, and his administration approached the American Philosophical Society and other learned societies to suggest a list of scientists for the mission. Titian was not only on the American Philosophical Society committee charged to construct such a list but was sent to Washington to deliver

the list of names, which included his own, to Jackson. From that list of 27 names, Titian was one of seven scientists eventually selected, and, at 39, was the eldest member of the scientific cohort. It would take two years to arrange all the logistics of the US Ex-Ex, which included much political infighting, as Jackson's secretary of the navy, Mahlon Dickerson, was not nearly as enamored with the idea as was the president. When the expedition began on August 18, 1838, Titian was ready to "leave a private corporation for high honors in the service of my country." Rather than resign as curator at the museum, Titian requested a prolonged leave of absence, which the board granted. In his stead, the board promoted Titian's friend and former travel partner, William McGuigan, from taxidermist to temporary curator.

For the next three and a half years, Titian and the crew of the US Ex-Ex, under the command of Charles Wilkes, visited, observed and collected from New Zealand, Australia, South America, and dozens of Pacific Islands, as well as sites along the Pacific Northwest of North America. It was an adventure, but not an easy one. The waters around the Antarctic were treacherous. "The poor ship had her ribs terribly squeezed in the ice," Titian wrote Franklin, "she was embayed and carried stern foremost against an enormous [ice]berg." On one occasion, along the Columbia River, Titian and those on his boat were even shipwrecked for a short stretch. Even when the seas cooperated, the workload could be overwhelming. Titian complained, "I had to do everything myself: shoot, write, draw and explain to the uninitiated."

Over time, a breathtaking amount of material began to flow back to the United States: 50,000 botanical samples, thousands of bird skins, mammals, fish, shells, corals, crustaceans, and more. In addition to

drawing many sketches of the far-off lands they were visiting, Titian sent hundreds of birds and other samples back to the Philadelphia Museum. Franklin, though still working full time at the Philadelphia Mint, came back to the museum on occasion to help with the logistics associated with all these new samples. But US Ex-Ex materials from Titian were only in the Philadelphia Museum for a short while, and never displayed, because the federal government ordered that those samples—indeed all samples that had been sent elsewhere—be shipped to Washington to be exhibited there.

In the same year that the US Ex-Ex had set sail, news arrived that James Smithson had bequeathed a fortune in gold to the United States government to create "an establishment for the increase and diffusion of knowledge among men." Exactly how that money should be used was still a matter of debate, but many thought that it would ultimately be employed to create a national museum (it was) and that the materials from the US Ex-Ex should reside there (they did). In the meantime, the materials from the US Ex-Ex would be exhibited at the new National Institute for the Promotion of Science located in the Patent Office Building in Washington.[8]

With Titian away at sea, the board took a sharp turn toward the entertainment side of rational entertainment. The natural history and anthropology exhibits were not cared for, and though Rembrandt, who had moved back to Philadelphia, would occasionally give a lecture at the museum, new attractions centered on more dime store museum acts like a "Belgian Giant," Native American warriors pantomiming scalpings—similar to what Rubens had done in New York City—

magicians of all sorts, and the like. Perhaps most telling was the display of the Philadelphia Museum's answer to P. T. Barnum's Fiji mermaid at the American Museum in New York. Curator McGuigan had brought his own "mermaid," though to his credit, he made it clear it was no such thing, but rather "a wonderful creation of man's ingenuity . . . joining the two apparent bodies . . . and, as a matter of curiosity, [it] may rival any mermaid ever exhibited in this country." Mermaid or not, ticket sales remained low and the financial situation grew dimmer when an audit of the museum records found the new building had come in $30,000 over budget, that the board had never officially received title to the lot on which the museum sat, and that one of the former treasurers of the board had been paying himself a salary after he resigned. On top of all this, Dunn decided to pull his Chinese Museum from the building and relocate in London, leaving the first floor unoccupied and ending the critical revenue source the board received from the rent that Dunn was paying.

This was the state of affairs when Titian returned from the US Ex-Ex and was reappointed curator on November 1, 1842. Recognizing that they were in deep debt and that their focus on entertainment per se had failed to draw visitors, the board saw Titian's return as their last chance to salvage finances by returning the museum to the Enlightenment temple Titian's father, and to a large extent Titian, had cherished. "Amidst all of this gloom and despondency your Board take unfeigned satisfaction in announcing the reinstatement of Mr. Titian R. Peale as Manager," read a report to the stockholders. "Your Board have full confidence that under his direction the resuscitation of the Institution may confidently be hoped for . . . we fervently trust that

the museum may be placed in its original firm position unaided and unaffected by any entertainment foreign to its objects and the intention of its founder." The board trusted that "such a course judiciously pursued would in a few years cause it to be known and appreciated as it once was, the pride and ornament of our city."[9]

Even with trust of the board, if brother Rubens's experience was any clue, Titian had good reason to fear that it was too late—that the time for Peale museums had come and gone. Convinced that "only energy, tact, and liberality were needed, to give it life and to put it on a profitable footing," P. T. Barnum had acquired the contents of Scudder's Museum in New York City for $12,000, and opened his American Museum on the corner of Broadway and Ann Streets in lower Manhattan, all too close to Rubens. The natural history exhibits and the wax statue gallery, the Fiji mermaid, and General Tom Thumb were attracting visitors galore: 15,000 a day Barnum claimed, though that was clearly a Barnum-esque overcount. Barnum even hired a little girl who pretended she was mesmerized, to both counter and mock the more serious exhibits of mesmerism that Rubens was running in his museum. Rubens simply could not compete and sold the museum in 1842; later that year, Barnum bought its contents.[10]

The financial situation at the Philadelphia Museum was becoming untenable. Income was paltry, exhibits needed repair, and debts, including the United States Bank loan on the building, loomed large. Titian couldn't resuscitate the museum. As the board had hoped, he "judiciously pursued it," but despite his efforts, the museum was not returning to its former glory as Philadelphia's "pride and ornament."

On May 1, 1843, six months to the day after Titian had been reinstated as curator, the board sold the museum building to an Isaac Parker. The proceeds from the sale, however, did not cover debts, as more than $13,000 was still in arrears to the United States Bank. Parker agreed that the museum contents could remain in the building temporarily, but the board would pay him a $10,000 storage fee in exchange. This was more than Titian could bear, and he resigned and left the museum once and for all. He set to writing his memoirs from the US Ex-Ex and soon accepted a job at the Patent Office in Washington. The United States Bank was unhappy with the arrangement too. The bank was set to hold a sheriff's auction to sell the museum contents to the highest bidder and recoup its loan when Edmund Peale, who had been running the Baltimore Museum since the late 1830s, proposed a solution.

Over time, Edmund had learned there was just no money to be made in Baltimore. And so, following Uncle Rubens's lead, in late 1845, he sold the contents of the Baltimore Museum to Barnum, who was slowly building a chain of museums, both by acquiring the competition and scouting the world for new "talent." Edmund and the board agreed that he would use his money from the Baltimore sale to pay down the United States Bank loan and to secure rental space that included more than a dozen rooms and a theatre at the Masonic Hall on Chestnut Street. In return, he was appointed museum manager.

There is scant evidence of what exhibits were in place at the Philadelphia Museum's newest home on Chestnut. The mammoth was there, for sure, as were other natural history and anthropology displays, though exactly which ones we don't know. The theatre, which quickly became the centerpiece of the new museum, was used for many plays

and concerts. Most tellingly, Edmund even "rented" Tom Thumb from Barnum for performances at the museum in early 1848.

None of this was enough, however, and the United States Bank began closing in. They scheduled sheriff's auctions in June and September of 1848, but Edmund and the board somehow staved those off. In September, the bank had waited long enough and took possession of all the artwork in the museum. To generate immediate capital, the museum let it be known that its most treasured possession, the great mammoth, was for sale. Eventually, Johann Jakob Kaup at the natural history museum in Darmstadt, Germany, made an offer— we don't know how much—that the museum accepted. The mastodon resides there to this day.

In the spring of 1849, Barnum opened a branch museum of his own in Philadelphia, in the Swaime Building, just a few blocks from the Philadelphia Museum. There's no evidence that he specifically came to Philadelphia to challenge the Peale museum, but once he was there, he soon wrote Kimball "he'd kill the other shop in no time." And that's what happened. The Philadelphia Museum's last advertisement ran on August 27, 1849, and shortly after that, the United States Bank held a public auction of all the items in the museum. Barnum was there, representing his own interests and those of his former rival and current partner, Moses Kimbell, and bought it all, lock, stock, and barrel. He recorded in his receipt book that it cost him a mere "five or six thousand dollars on joint account of Moses Kimball and myself."

There is no record of precisely what was sold at the auction, but there is a catalog for the auction that the United States Bank planned and then called off a year earlier, and it is reasonable to assume the catalogs

for both were almost identical. From that catalog, it appears that Barnum and Kimball acquired, at the very least, 1,624 birds, hundreds of fish, hundreds of quadrupeds, hundreds of reptiles, hundreds of amphibians, and cases upon cases filled with Native American, Asian, South Pacific, and South American artifacts. Eventually, a portion of Kimball's share of this material made its way to the Peabody Museum of Anthropology and the Museum of Comparative Zoology at Harvard, where much of it can be found today. Exactly where all the items Barnum took ended up is not known, but we do know that many, perhaps most, were sent to his American Museum in New York or down the street to Barnum's Museum in the Swaime Building. Both establishments suffered devastating fires, the Swaime in 1851 and the American Museum in 1865, and it is assumed that much of the Peale material perished in those blazes.

The portraits that had hung in the Philadelphia Museum, and which the United States Bank had taken possession of in 1848, fared better. In 1854, the bank sold 260 of these to the City of Philadelphia, which in turn displayed them in Independence Hall, where they had once hung, albeit one floor up, when the museum resided there between 1802 and 1827. There, at the new National Portrait and Historical Gallery, hung one of Charles Willson Peale's trompe-l'oeil staircase pieces, along with his portraits of the great men of the times: Washington, Franklin, Jefferson, Monroe, Humboldt, Jay, and so many more. Near the founding fathers of the country was a painting of another founder of sorts, Nathaniel Ramsay, who upon seeing those mammoth bones in Charles's home in 1784 suggested that others might pay to see them. And there also hung the pictorial eulogy that Peale had painted for

himself. Grandest of them all, more than eight feet from top to bottom, it captured Charles's every dimension: artist, natural historian, museum proprietor—the quintessential Enlightenment man. With his artist's palette in the foreground, behind it the Long Room with its cases of birds crowned with portraits of the men of the age from his own brush, the father teaching his son of natural history, the Quaker lass in her bonnet staring in awe at the great beast he himself had extracted from the depths of the earth, all there for posterity, as Charles pulls back the crimson curtain to reveal *The Artist in His Museum*.[11]

About the Author

Lee Alan Dugatkin, PhD, is a professor of biology and a College of Arts & Sciences distinguished scholar at the University of Louisville. He is the author of many books, including *Mr. Jefferson and the Giant Moose* (University of Chicago Press, 2009). *The New York Times Book Review* called his 2017 book, *How to Tame a Fox and Build a Dog* (University of Chicago Press), "Sparkling . . . A story that is part science, part Russian fairy tale, and part spy thriller. It may serve—particularly now—as a parable of the lessons that can emerge from unfettered science, if we have the courage to let it unfold."

Acknowledgments and
a Note on Spelling

On occasion, when needed, I have modernized late 18th- and early 19th-century spelling and punctuation to make it more understandable to our modern eyes. I have also replaced British with American spelling in many places.

The support of colleagues, family, and friends during the process of researching and writing this book has been heartwarming.

The archives at the American Philosophical Society and the Historical Society of Pennsylvania are a treasure trove of information on Peale and his museums, especially the Philadelphia Museum. I spent many wonderful days scouring through material at each. I am especially grateful to Valerie-Ann Lutz, Joe DiLullo, and David Gary at the American Philosophical Society and Victoria Russo, Steve Smith, and Cary Huto at the Historical Society of Pennsylvania for all their assistance. The staff at the Library Company of Philadelphia, Columbia University, and the New York Historical Society were also very gracious when I visited. Nancy Proctor at the Peale Center for Baltimore History and Architecture, Adrienne Saint-Pierre at the Barnum Museum, and Barbara Bieck at the New York Society Library also provided advice and assistance.

I am indebted to the Alfred P. Sloan Foundation's Public

Understanding of Science, Technology & Economics program for providing support for this book and to Alan Thomas, Michael Sims, Paul Zak, Carl Bergstrom and two anonymous reviewers for the comments on various parts of the book. My dearest friend, Henry Bloom, took time off from his high-powered job to assist me with research in the American Philosophical Society, creating even more special memories for us to share over the years.

As ever, special thanks to Dana Dugatkin for her advice and for proofreading the manuscripts at numerous stages of development.

Archives and Collections Cited in Notes

APS: American Philosophical Society, Peale-Sellers Family Collection, 1686–1963, Mss. BP31, Philadelphia.

CWP: *The Selected Papers of Charles Willson Peale and His Family*, L. Miller, series editor, five volumes, Yale University Press. Volume 1, 1983; Volume 2, 1988; Volume 3, 1991; Volume 4, 1996; Volume 5, 2000. Unless otherwise noted, all letters to and from Charles Willson Peale are from CWP, except for an occasional Peale-Jefferson correspondence from "The Papers of Thomas Jefferson," https://founders.archives.gov/about/Jefferson. All letters to and from other Peale family members are from CWP.

HSP: Historical Society of Pennsylvania, Peale Family Papers, Collection 0481, Philadelphia.

ENDNOTES

PREFACE

1 "fine Russian sheeting," "should not only make it," and "portrait in the museum," C. W. Peale to Rembrandt Peale, July 23, 1822. The most comprehensive analysis of *The Artist in His Museum*, and the one most heavily relied on here, is: R. Stein, 1981, "Charles Willson Peale's expressive design: *The Artist in His Museum*," *Prospects* 6: 139–185.

2 "I wish it might excite," C. W. Peale to Rembrandt Peale, August 10, 1822. Peale describes the curtain as crimson here: C. W. Peale to Rubens Peale, August 4, 1822.

3 Soon after he was commissioned, Peale, working with his son, Titian, began sketching the long room and its true contents as they appeared in 1822. The product, a 14- by 21-inch watercolor titled *The Long Room*, allows us to see where *The Artist in His Museum* was true to the room and where Peale felt the need to manipulate and embellish for effect. C. W. Peale describes the layout in C. W. Peale to Thomas Jefferson (henceforth Jefferson), October 29, 1822. *The Long Room* is now at the Detroit Institute of Arts. For more on the mastodon, see P. Semonin, 2000, *American Monster: How the Nation's First Prehistoric Creature Became a Symbol of National Identity*, New York University Press.

4 Epithet for Wren, *Qui vixit annos ultra nonaginta non sibi sed bono publico. Lector, si monumentum requiris circumspice.* The comparison to Wren's epitaph was first made by R. Patterson, 1870, "An obituary notice of Franklin Peale," *Proceedings of the American Philosophical Society* 11:587–604.

CHAPTER 1

1 For more on early Peale family history, see Charles Willson Peale's autobiography: CWP 5, Yale University Press (this multi-volume work is hereafter referred to as

CWP). Also see CWP 1:4–31 and C. C. Sellers, 1947, *Charles Willson Peale*, vol. 1, *Early Life: 1741–1790*, American Philosophical Society, 23; "An Essay towards Rendering," *Pennsylvania Gazette*, March 12, 1744.

2 The birth records list him as Charles Wilson Peale; "greatly respected" and "widow to support," CWP 5:4n1. For more on Charles Peale, see Sidney Hart's "Charles Willson Peale and the Theory and Practice of Eighteenth-Century Family," L. Miller, 1996, *The Peale Family: Creation of a Legacy, 1770–1870*, Abbeville Press.

3 "acquired knowledge," CWP 5:6

4 "Hail, rain or snow," CWP 5:9; "hung in curling ringlets," CWP 5:7.

5 "who had considerable influence," CWP 5:9.

6 "how great the joy!," CWP 5:10; "was framed for the design," CWP 5:13n13. The supposed inheritance from his cousin was £2,000.

7 "They were miserably done" and "the idea of," CWP 5:14; "a portrait of Rachel," Peale, Franklin undated, "Notes on Charles Willson Peale," APS, Series 2, Box 2; "possibly might do better by," CWP 5:15.

8 "only knew the names," CWP 5:16; "with very little intermission," CWP 5:16.

9 "so narrow was [my] escape," CWP 5:19.

10 "lonesome disconsolate journey," CWP 5:20; "a great feast," CWP 5:23.

11 "a new scene," CWP 5:29.

12 "something must and shall be done" and "if he was willing," CWP 5:30.

13 "in rough and disagreeable," CWP 5:31. Peale's clothing is described in Sellers, 1947.

14 "all the instruction he," C. W. Peale to John Beale Bordley, March 1767; "poets, painters" and "cultivation is," CWP 5:41.

15 "The Doctor was very friendly," CWP 1:51n2.

16 "was not contented," CWP 5:34–35; "gracing the walls," C. W. Peale, Application to the Governor and Assembly of Maryland, March 31, 1774, CWP 1:131–32. Also see Maryland Assembly Acceptance of Peale's Application, April 18, 1774, CWP 1:131–32.

17 "paying for a glass of milk in the park," Peale's record books, CWP 1:51–70; "prudence and frugality," Charles Carroll to C. W. Peale, October 29, 1767

18 For more on the Cadwalader portraits, see D. Sewell, 1996, "Charles Willson Peale's Portraits of the Cadwalader Family," *Philadelphia Museum of Art Bulletin* 91:25–34 and K. A. Schmiegel, 1977, "Encouragement exceeding expectation,

the Lloyd-Cadwalader patronage of Peale, Charles Willson," *Winterthur Portfolio* 12:87–102; "a happy cheerfulness," John Adams to Abigail Adams, August 21, 1776, Papers of John Adams, https://founders.archives.gov/about/Adams.

19 "the genteelest," J. Bouchier, 1967, *Reminiscences of an American Loyalist, 1738–1789*, Kennikat Press, 65. For more on theatre, see H. Rankin, 1955, *Colonial Theatre: Its History and Operations*, Colonial Williamsburg Foundation Library Research Report Series 0057; "Knights of the Moon" and poet's corner, J. Heintze, 1969, "Music in Colonial Annapolis," (master's thesis, American University); "Ode to Delia," *Maryland Gazette*, February 13, 1772; "the encouragement and patronage," C. W. Peale to Benjamin Franklin, April 21, 1771; "painter's quadrant," C. W. Peale to John Beale Bordley, March 29, 1772.

20 "when you beat my pitch," G. Custis, 1860, *Recollections and Private Memoirs of Washington*, Derby and Jackson, 519.

21 "able to translate French," CWP 5:42; "just now worked myself out of debt," C. W. Peale to Edmund Jennings, August 29, 1775.

22 "great desire to settle there," C. W. Peale to John Cadwalader, September 7, 1770.

23 "a rifle with a telescope," C. W. Peale diary, CWP 1:165. Some of C. W. Peale's diary entries do not have exact dates but fall within a range of dates entered for that particular diary. Other diary entries have specific date entries, and those are provided when available. "springs to prevent the eye," C. W. Peale diary, CWP 1:171; "so that every American," C. W. Peale diary, CWP 1:182.

24 "tender, soft, affectionate," John Adams to Abigail Adams, August 21, 1776, Papers of John Adams, https://founders.archives.gov/about/Adams; "This day the Continental Congress declared," C. W. Peale diary CWP 1:189.

25 "thin, spare, pale-faced man," CWP 5:53.

26 "few cannon shot," CW.P 5:51; "rather the appearance of hell," CWP 5:51; "commissioned by the Supreme Executive Council of Pennsylvania," January 18, 1779, "Resolve of the Supreme Executive Council to Commission a Portrait of Washington," CWP 1:302.

27 "having no employment," CWP 5:67.

28 "houses in general," C. W. Peale diary, CWP 1:276; "the doleful tale of their sufferings," C. W. Peale diary, CWP 1:277; "most disagreeable business," CWP 5:72.

29 "had more attended," C. W. Peale to Edmund Jennings, October 15, 1779.

30 "firmly determined no longer," CWP 5:83. A sketch of Peale's effigy was published in the German *Americanischer Haus und Wirthschafts-Calendar auf das 1781ste Jah Christi*, CWP 1:353, editorial note. Also see *Pennsylvania Packet*, October 3, 1780.

31 "our illustrious CHIEF," *Pennsylvania Packet*, November 1, 1781.

32 "My building has made me miserably poor," C. W. Peale to Benjamin West, December 13, 1782; "a kind of lethargy," CWP 5:111, editorial note.

33 "Exhibition Room," *Pennsylvania Packet*, November 14, 1782; "This collection has cost me," C. W. Peale to Edmund Jennings, December 10, 1783.

34 Philip Freneau, "How things have changed," *Pennsylvania Gazette*, January 1, 1784; "public demonstration of joy," and more on "Pennsylvania Assembly Report Recommending a Triumphal Arch," see CWP 1:398–99.

35 The Ramsay visit was likely in May 1784, CWP 1:445, editorial notes. Also discussed in CWP 5:112–13.

36 "German officer" and "a tremendous storm came and blasted their hopes," CWP 5:112–13; "His Arms like limbs," Edward Taylor, 1705, manuscript in Yale University Library. Also see Anonymous, 1727–1728, "An account of elephants' teeth and bones found underground," *Philosophical Transactions of the Royal Society of London* 35:457–71 and H. Sloane, 1727–1728, "Of fossil teeth and bones of elephants, part the second," *Philosophical Transactions of the Royal Society of London* 35: 497–514.

37 "Stirring debate," *Boston News-Letter*, July 30, 1705; "Mammoth" first came into English usage in the 1690s, Semonin, 2000, 68. Rembrandt Peale wrote "Strahlenberg, in his Historico-Geographical Description, observes that the Russian name is Mammoth which is a corruption from Memoth, a word derived from the Arabic Mehemot, signifying the same as the Behemot of Job. This word is applied to any animal of extraordinary size." R. Peale, 1802, *Account of the Skeleton of the Mammoth: A Non-descript Carnivorous Animal of Immense Size Found in America*, E. Lawrence, 34. The Queen's physician, William Hunter, called the remains of one salt lick specimen the "American incognitum," W. Hunter, 1768, "Observations on the bones, commonly supposed to be elephant bones, which have been found near the Ohio in America," *Philosophical Transactions of the Royal Society* 58:34–45.

38 "given the name Mastodonte to the animal," C. W. Peale to Jefferson, April 3,

1809; also see C. W. Peale to Jefferson, May 5, 1809; "the protuberances on the grinding surface," Jefferson to C. W. Peale, May 5, 1809; G. Cuvier, 1806, "Sur le grand mastodonte," *Annales du Muséum d'Histoire Naturelle*, 270–312.

39　"thought them so interesting," CWP 5:113. For more on the curiosity ethos in early America, see B. Benedict, 2001, *Curiosity: A Cultural History of Early Modern Inquiry*, University of Chicago Press; "the secular world it's point of departure," M. Jacob, 2019, *The Secular Enlightenment*, Princeton University Press.

40　"that while collecting," and "much approved the plan," C. W. Peale "Address to the Corporation and Citizens of Philadelphia," July 18, 1816, CWP 3:411–423; "very obligingly presented," CWP 5:113; "curious nondescript fish," *Columbian Magazine*, November 1786, Plate V.

41　For more on moving pictures, see A. Bermingham, 2016, "Technologies of illusion: De Loutherbourg's eidophusikon in Eighteenth-Century London." *Art History* 39:376–399.

42　"clouds . . . seen gathering in the horizon," *Pennsylvania Packet*, May 19, 1785; "visited by a great deal of company," CWP 5:88.

43　"Mr. Peale, ever desirous," the first advertisement of the museum, *Pennsylvania Packet*, July 7, 1786.

44　"there were few cities," C. W. Peale, undated, *Natural History and the Museum* 7:22, APS, box 2; "the bulk of the exhibited items," M. Cutler 1888, *Life, Journals and Correspondence of Rev. Manasseh Cutler, LL.D.*, Clarke and Co., 259–62.

45　"bring into one view a world," CWP, 5:272; "Franklin, who sent his," CWP 1:464n2; "just deceased golden pheasant," C. W. Peale to George Washington, December 31, 1786; "such subjects are not always," C. W. Peale, "My Design in Forming this Museum," CWP 2:12–19.

46　"about the equivalent of an hour's labor," P. Lindert and J. Williamson, 2012, "American Incomes 1774–1860," National Bureau of Economic Research, Working Paper No. 18396, and P. Lindert and J. Williamson, 2013, "American incomes before and after the Revolution," *Journal of Economic History* 73:725–765; "enlighten the minds of my countrymen," C. W. Peale to Jefferson, January 12, 1802; "render the Institution," CWP 5:207.

CHAPTER 2

1 "You will scarce guess," *The Letters of Horace Walpole*, Claredon Press, 1903–1905, 142; "It is a great pleasure to me," E. Edwards, 1870, *Lives of the Founders of the British Museum, Part I*, Trubner, London, 295. For more see D. S. Wilson, 2002, *The British Museum: A History*, British Museum Press and J. Delbourgo 2017, *Collecting the World: Hans Sloane and the Origins of the British Museum*, Belknap Press.

2 "Last Will and Testament," *The Will of Sir Hans Sloan, deceased*, printed by John Virtuoso, a copy is at the British Library, C.61.b.13.

3 "for the use of learned and studious men," British Library, MS 6179, F.18.

4 For more on the Jardin du Roi, see J. Roger, 1997, *Buffon: A Life in Natural History*, Cornell University Press and S. A. Prince, 2013, "Of Cabbages and Kings: The politics of planting vegetables at the revolutionary Jardin des Plantes," in S. A. Prince ed., 2013, *Of Elephants and Roses: French Natural History, 1790–1830*, American Philosophical Society.

5 the yellow parrot," Roger 1997, 59–60; "undoubtedly the first," C. W. Peale, *Natural History and the Museum*, 11.

6 For more on degeneracy, see L. Dugatkin, 2009, *Mr. Jefferson and the Giant Moose*, University of Chicago Press.

7 "every species" and "instruments and apparatus," *South Carolina Gazette*, March 22, April 5 and 12, 1773. The American Museum reopened later, on numerous occasions, including when it gave its collections to the Literary and Philosophical Society of South Carolina in 1815. For more, see P. Rea, 1915, "A contribution to early museum history in America," *Proceedings of the American Association of Museums 1915*, 53–65.

8 For more on Du Simitière, see P. Sifton, 1987, *Historiographer to the United States: The Revolutionary Letterbook of Pierre Eugene du Simitière*, Vantage Publishing and P. Sifton, 1960, "Pierre Eugen du Simitière (1737–1784): Collector in Revolutionary America," (PhD dissertation, University of Pennsylvania).

9 "This Mr. du Simitiere is a very," John Adams to Abigail Adams, August 14, 1776, Papers of John Adams, https://founders.archives.gov/about/Adams.

10 "very obliging offer to assist," du Simitière to John Sullivan, October 15, 1781, Pierre Eugene du Simitiére Collection, Library Company of Philadelphia; "amus[ing] myself all," E. Burnett, ed., 1921, *Letters of Members of the Continental*

Congress, Carnegie Institute, vol. 1, 209.

11 "he intends his cabinet," *Pennsylvania Packet,* June 1, 1782.

12 "acquainted with Mr. Semitere," C. W. Peale to Rembrandt Peale, October 28, 1812.

13 "fine things," E. Acomb, 1953, "The Journal of Baron Von Closen," *William and Mary Quarterly* 10:207; "a cabinet of natural history," F. Chastellux, 1787, *Travels in North America in the Years 1780, 1781 and 1782,* printed by G. and J. Robinson, vol. 1, 228; "collection, a small one," A. Morrison, ed., 1911, *Johann David Schoepf, Travels in the Confederation (1783-1784),* Bergman Publishers, 85–86.

14 "on the rack," du Simitiére to Gerard ConSeiller, September 12, 1782, Pierre Eugene du Simitiére Collection, Library Company of Philadelphia. Du Simitière died either on October 10 or 22. The Library Company of Philadelphia bought much of the museum material at auction.

15 "almost every Philadelphian," Paine in E. Foner, 1976, *Tom Paine and Revolutionary America,* Oxford University Press, 2005 updated edition, 20.

16 For more on the literary scene in Philadelphia, see R. Remer, 1991, "The Creation of an American Book Trade: Philadelphia Publishing in the New Republic, 1790–1830" (PhD dissertation, UCLA). The distinction between bookshop, printer and publisher was much murkier than it is today.

17 "the most genteel one," John Adams diary, August 29, 1774, Papers of John Adams, https://founders.archives.gov/about/Adams. For more on coffeehouses and pubs, see P. M. Thompson, 1998, *Rum Punch & Revolution: Tavern Going & Public Life in Eighteenth Century Philadelphia,* University of Pennsylvania Press and R. E. Graham, 1953, "The taverns of Colonial Philadelphia," *Transactions of the American Philosophical Society* 43:318–325.

18 For more on Peale and the library, see C. W. Peale to the directors of the Library Company of Philadelphia, October 5, 1795, CWP 2:126–27.

19 "all the rights of fellowship," American Philosophical Society Certificate of Membership to Peale, CWP 1:449.

20 "rational and innocent amusement," Pennsylvania General Assembly, March 2, 1789; for automata see *General Advertiser,* March 3, 1794; for a list of firework shows, see D. R. Brigham, 1992, "A World in Miniature: Charles Willson Peale's Philadelphia Museum and Its Audience, 1786–1827" (PhD dissertation, University of Pennsylvania), appendix I. The appendices in Brigham, 1992

provide a treasure trove of information on alternative entertainment venues in Philadelphia (appendix I), newspaper advertisements about Peale's museum (appendix II), subscribers to Peale's museum (appendix IV), donations of minerals and manufactured items to Peale's museum (appendix VI), donations of Native American and non-western items to Peale's museum (appendix VII); for more on ballooning, see M. Pethers, 2010, "'Balloon Madness:' politics, public entertainment, the transatlantic science of flight, and late Eighteenth-Century America," *History of Science* 48:181–226.

21 "invisible woman," *Philadelphia Gazette*, November 25, 1800; "learned pig," *Porcupine's Gazette*, June 8, 1797.

22 J. Macpherson, 1785, *Macpherson's Directory for the City and Suburbs of Philadelphia*, printed by Frances Bailey and F. White. *Philadelphia Directory* (printed by Young, Stewart, and M'Culloch); stagecoach information, White 1785.

23 210 men and women refers to the number of slaves listed in the city of Philadelphia per se, as in the 1790 census. For the county of Philadelphia, the number of slaves was 334.

24 "the very idea," CWP 2:696. In 1778, before his time on the committee that drafted the Act for the Gradual Abolition of Slavery, Peale had expressed an interest in purchasing a slave, though such a purchase was not made. Peale worked with the Committee to Prevent Distress of Negroes to raise funds to free other slaves, C. W. Peale to Committee to Prevent Distress of Negroes, July 2, 1787, CWP 1:481–82. For more on Moses Williams, see G. D. Shaw, 2005, "Moses Williams, Cutter of Profiles: Silhouettes and African American identity in the early republic," *Proceedings of the American Philosophical Society* 149:22–39.

25 "Here's but one good reason," *Gentleman's Magazine*, vol. 6, July 1736. For more on poverty and crime, see Alexander, J., 1980, *Render them Submissive: Responses to Poverty in Philadelphia, 1760–1800*, University of Massachusetts Press.

26 All Cutler quotes in this note are from Cutler 1888, 259–262; "It is not the practice," CWP 5:309; "their manners and disposition," C. W. Peale broadside, "My Design in Forming this Museum."

27 "favor him with any of" and "Mr. Peale's animals reminded," Cutler, 1888.

28 "Human nature is such that amusements," C. W. Peale, *Natural History and the Museum*, 19; "the importance of diffusing," C. W. Peale to Jefferson, January 12,

1802; "learned in the science of nature," C. W. Peale to Jefferson, June 6, 1802; "To the Citizens," *Dunlap's Daily Advertiser,* January 13, 1792 (*Dunlap's Daily Advertiser* and *Dunlap and Claypoole's Daily Advertiser,* will be hereafter referred to as *Daily Advertiser).*

29 "The farmer ought to know," and the grackle story, C. W. Peale, "On the Use of the Museum," unpublished document, HSP; "to the merchant," C. W. Peale "Introduction to a Course of Lectures on Natural History," CWP 2:265; "a powerful means of every," Commonwealth of Pennsylvania, Twentieth House of Representatives, Legislative Committee Report, March 5, 1810.

30 "particular classes," "Peale Memorial to the State Legislature of Pennsylvania," *Poulson's American Daily Advertiser* (hereafter *Poulson's),* December 18, 1810; "the unwise," C. W. Peale to Philippe Rose Roume, December 25, 1803.

31 "which allow no time for them to," C. W. Peale, *Natural History and the Museum;* "A Dialogue on Mr. Peale's Museum," *General Advertiser,* September 8, 1792. Wissent (wisent) is another name for the European bison, *Bison bonasus;* "speak in a universal language," C. W. Peale, *Natural History and the Museum;* "A lover of Nature," *Pennsylvania Packet,* March 27, 1790. For more on free admission for children, see *Pennsylvania Packet,* February 28, 1787, and February 3, 1790.

32 "a pure source of delight," C. W. Peale, *On the Use of the Museum;* "I wish to be understood," C. W. Peale, "Discourse Introductory to a Course of Lectures on the Science of Nature; with Original Music, Composed for, and Sung on, the Occasion," delivered in the Hall of the University of Pennsylvania, November 8, 1800; "the opponents in politics," C. W. Peale, *Natural History and the Museum.*

33 "I have always declared," C. W. Peale to the American Philosophical Society, March 7, 1797; "ought to become a national concern," C. W. Peale, *Introduction to a Course of Lectures.*

34 "to retain with us many things," C. W. Peale to George Washington, December 31, 1786.

35 "With my early labors," C. W. Peale, *On the Use of the Museum.*

36 "divert [people] from frivolous," C. W. Peale to Jefferson, June 6, 1802; "to whom all things are new," C. W. Peale, *Natural History and the Museum;* "What charming conversations," C. W. Peale, "Discourse Introductory," 14; "Frequent contemplations," C. W. Peale, *Natural History and the Museum;* "folly stopped," C. W. Peale to Jefferson, June 6, 1802.

37 "against whom" and "Herculean and incessant labors," *On the Use of the Museum*; "elevate the mind," CWP 5:152; "insects are capable," *On the Use of the Museum*; "meditated adding on," C. W. Peale to Andrew Elliott, February 28, 1802; "This is the temple of God," *Daily Advertiser*, December 26, 1795.

38 "A list of the portraits which Mr. C. W. Peale has now in his collection of celebrated personages" in the *Freeman's Journal*, October 13, 1784. It is not clear exactly when Peale began hanging the portraits over the natural history exhibits, but it was no later than 1793, as is evidenced in *National Gazette*, September 4, 1793.

39 "public rejoicings," for CWP 5:129. For more on this event, see CWP 1:509–12.

40 "private companies," *Pennsylvania Packet*, July 7, 1786.

41 "if the weather should be warm," C. W. Peale to George Washington, February 27, 1787; "including the gentle" and "only on his solitary efforts," C. W. Peale broadside, "To the Citizens of the United States," February 1, 1790; "The gentlemen and ladies of Maryland," *Maryland Gazette*, November 2, 1786; "Gentlemen, knowing your high," C. W. Peale to Royal Swedish Academy of Science, May 11, 1791.

42 "whether the birds are of this country," C. W. Peale to Christopher Richmond, October 22, 1786. It is not known if Peale purchased this collection.

43 For more on Rachael's death, see CWP 5:134–35.

44 "Mr. Peale finding the task," *Pennsylvania Packet*, July 9, 1790.

45 "to inform the curious observer, C. W. Peale to John Beale Bordley, August 22, 1786.

46 "Regular and uniform subordination," Charles Francis Adams, *The Works of John Adams*, Little and Brown, 1850, 27.

47 "Linnaeus stands before," C. W. Peale, *Natural History and the Museum*.

48 "wonder and admiration," unknown, 1793, description of Peale's museum, CWP 2:66–69; "entertained for two or three hours," H. Wansey, 1796, *The Journal of an Excursion to the United States of North America in the Summer of 1794*, 134–36.

49 Many museum subscribers were affiliated in one way or another with the American Philosophical Society, the University of Pennsylvania, and the Library Company. Subscribers were also more likely than most to own a home and drive a carriage. Museum income in the first decade ranged from to $1,172 to $3,301, S. Hart and D. Ward, 1988, "The Waning of an Enlightenment Ideal: Charles

Willson Peale's Philadelphia Museum, 1790–1820," *Journal of the Early Republic* 8:401. If we subtract $397 for the annual one dollar fee that subscribers paid, that gives us $775 to $2,904 as income generated from single entry tickets per se. At 20 cents per ticket, this translates into an annual attendance ranging from 3,497 to 12,013. These figures represent attendance, not total visitors as some who bought single entry tickets would have come to the museum more than once in a year.

50 "my children to contribute," C. W. Peale, "My Design in Forming this Museum," 19.

51 "in the end it might," C. W. Peale, "My Design in Forming this Museum," 12; "[their] countrymen," "I will at no time," "exercised great patience, economy and diligence," "great national repository of the mineral, animal, and vegetable kingdoms," "wisdom and liberality" and "assistance to raise the superstructure," CWP 5:203–07.

52 "Tabling the request," *Journal of the First Session of the Second House of Representatives of the Commonwealth of Pennsylvania*, March 10, 1792; "the delay will afford," C. W. Peale to Board of Visitors, June 1792.

CHAPTER 3

1 "to be preserved in my" and "always plain and temperate," *Daily Advertiser,* September 5, 1792. The location of the John Strangeways Huttons painting is unknown, C. C. Sellers, 1952, *Portraits and Miniatures of Charles Willson Peale,* American Philosophical Society.

2 "Of the different institutions," J. Hardie, 1794. *The Philadelphia Directory and Register.* Printed by Johnson and Co.

3 "gratify [his] curiosity," *National Gazette,* September 4, 1793; "feed me daily," CWP 5:226.

4 "the moral effect of a museum," *Daily Advertiser,* March 27, 1794; "The exertions of Mr. Peale," *Daily Advertiser,* May 2, 1794.

5 "sixteen and seventeen inches round," H. Wansey, H., 1796. *Journal of an Excursion to the United States,* 134–36; "the French generally appear," *General Advertiser*, April 12, 1794.

6 "lively interest in," Nicholas Collin to C. W. Peale, June 2, 1793; "deems it a duty to inform," *Daily Advertiser,* December 30, 1793.

7 For more on the yellow fever outbreak, see M. Pernick, 1997, "Politics, parties, and pestilence: epidemic yellow fever in Philadelphia and the rise of the first party system," *William and Mary Quarterly* 29:559–86 and J. H. Powell, ed., 1949, *Bring Out Your Dead: The Great Plague of Yellow Fever in Philadelphia in 1793*, University of Pennsylvania Press.

8 "most of the shops," CWP 5:217; "now and then exploded," CWP 5:218.

9 "we should set on foot," Jefferson to Paul Allen, August 18, 1813, Papers of Thomas Jefferson, https://founders.archives.gov/about/Jefferson.

10 "Marie Antoinette," André Michaux to Marie Antoinette as in E. Hamy, 1911, "Voyage d'André Michaux en Syrie et en Perse," *Comptes Rendu des travaux du Congres* 3:351–88 (translated by Savage and Savage, 1986). On July 18, 1785, a royal decree "To the title and position of [Royal] Botanist" was issued.

11 A. Michaux 1801, *Histoire des Chênes de l'Amérique*, Crapelet, Paris; A. Michaux, 1805, *Flora boreali Americana*, Crapelet, Paris; "Does not appear," this is certainly the case from 1787 to 1792, and appears to be true for 1785 to 1786. See C. S. Sargent, 1889, "Portions of the journal of André Michaux, botanist, written during his travels in the United States and Canada, 1785 to 1796," *Proceedings of the American Philosophical Society* 26:7.

12 "the advantages," Michaux journal entry, December 10, 1792, in M. E. Radford, *The Diary of Andre Michaux*, Book 2, trans., Missouri Botanical Garden Archives.

13 "desirous of obtaining for," American Philosophical Society Subscription for Michaux's Expedition, January 22, 1793.

14 For more on the fund-raising committee, see 1884. "Early Proceedings of the American Philosophical Society, 1744-1838," *Proceedings of the American Philosophical Society* 22:215.

15 "The chief objects of your journey," American Philosophical Society's instructions to André Michaux, on or about April 30, 1793; "a considerable portion," Jefferson to Meriwether Lewis, April 27, 1803, Papers of Thomas Jefferson, https://founders.archives.gov/about/Jefferson. For more on Jefferson and extinction, see his *Notes on the State of Virginia*.

16 Genêt originally landed in Charleston in April; "cordial wishes for the success," C. W. Peale to Genêt, May 1793, sometime between May 16–31. On June 1, 1793, Genêt sent a kind note back that he was unable to visit the museum; "were greeted warmly," Genêt to French Minister of Foreign Affairs, May 18, 1793, in F.

Turner, 1904, *Correspondence of the French Ministers to the United States, 1791–1797*. Government Printing Press, 214; "encourage the liberation," and "pave the way," Turner, 201–211; "pursue a conduct friendly," George Washington's Proclamation of Neutrality, April 22, 1793.

17 For more on the Florida plan, see R. Murdoch, 1948, "Citizen Mangourit and the projected attack on East Florida in 1794," *Journal of Southern History* 14:522–540.

18 "I every day meet with," Clark to Michaux, October 15, 1793, in *Annual Report of the American Historical Association for the Year 1896*, Government Printing Press, 1013.

19 "the difficulty, or rather," Michaux to Clark, December 27, 1793, in *Annual Report of the American Historical Association for the Year 1896*, Government Printing Press, 1024; fearing the guillotine on his return to France, Genêt asked for and was granted asylum to remain in the United States.

20 Michaux writes of visiting the museum in his journal entry for December 19, 1793.

21 "so engrossed with his museum," *Daily Advertiser*, April 24, 1794; "the removal of the museum," *Daily Advertiser*, March 27, 1794; "the breadth of Philosophical Hall," *Journal of the Second Session of the Fourth House of Representatives of the Commonwealth of Pennsylvania*, 1794.

22 For more on Philosophical Hall, see W. E. Lingelbach, 1953, "Philosophical Hall: The Home of the American Philosophical Society," *Transactions of the American Philosophical Society* 43:43–69.

23 "advantage of the public," "boys are generally fond," "saved some of the expense," and "all the inhabitants to their doors," CWP 5:224; "the whole city," C. W. Peale to Nathaniel Ramsay, June 9, 1794.

24 "the proprietor will continue," *General Advertiser*, September 19, 1794; "for the sole," American Museum mission statement, June 1, 1791; also see A. Dennett, 1997, *Weird and Wonderful: The Dime Museum in America*, New York University Press, 14–17; "in an out of the way dirty part," and "arranged without method," CWP 2:221–23. For more on "the perfect horn . . . five inches in length," and the "wax figure," see R. McClure and G. McClure, 1958, "Tammany's remarkable Gardiner Baker," *New York Historical Society Quarterly* 42:142–69, 143, 152; "visitor's book," Philadelphia Museum Ledger, HSP; "bowed politely to the painted figures," Rembrandt Peale, "Reminiscences," *The Crayon* 3:100–102.

25 Peale writes of his dream of a "national museum" in C. W. Peale, *General Advertiser*, January 20, 1792; "these little animals," CWP 5:233; "to preserve and collect," C. W. Peale to Edward Trenchard, December 18, 1793; "handsomely lighted" and "to accommodate," *Daily Advertiser*, December 23, 1796.

26 For more on de Beauvois, see E. Merrill, 1936, "Palisot de Beauvois as an overlooked American botanist," *Proceedings of the American Philosophical Society* 76:899–920; "the arduous undertaking," and "appear as patrons," C. W. Peale advertisement in *Daily Advertiser*, November 14, 1795; "troublesome to collect," CWP 5:270; "content[ed] ourselves with giving," C. W. Peale and A. Palisot de Beauvois, 1796, *A Scientific and Descriptive Catalogue of Peale's Museum*, printed by Samuel Smith.

27 C. W. Peale, "Memorial to the Pennsylvania Legislature," *Daily Advertiser*, December 26, 1795; for more on Massachusetts, see C. W. Peale to Representatives of the State of Massachusetts in Congress, December 14, 1795; "if a well organized museum," C. W. Peale to American Philosophical Society, March 7, 1797.

28 "successful rival," CWP 5:207; "particular classes," C. W. Peale to Jefferson, June 6, 1802; "I have received a proposition," Jefferson to C. W. Peale, June 5, 1796; "a small collection of birds," C. W. Peale to Prince of Parma, February 25, 1799.

29 "We are pleased to seize an opportunity," "we send you with pleasure," and "as to great animals," Étienne Geoffroy Saint-Hilaire and Jean-Baptiste Lamarck to C. W. Peale, January 30, 1796; T. Peale, "Drawings of American Insects," unpublished, dated 1796, CWP 2:204; "I will send specimens of every kind of animal," C. W. Peale to Saint-Hilaire, April 30, 1797; "depend on the reciprocation," Saint-Hilaire and Lamarck to C. W. Peale, January 30, 1796; for more on 54 bird specimens, see C. W. Peale to Saint-Hilaire, July 13, 1802.

30 "respectfully informed that Raphaelle," "become more and more worthy," and "illustrious persons," *Federal Gazette and Baltimore Advertiser*, October 25, 1796.

31 "an accident of so extraordinary," "manifest[ing] some degree," "and "withdrew to a private room," *Philadelphia Gazette*, December 6, 1796; "men of every color," H. R. Lamar, ed., *The Readers Encyclopedia of the American West*, Crowell, 1977, 539.

32 "recollections of former scenes of bloodshed," C. W. Peale, "Discourse Introductory," 40; "grand conference" and information on Red Pole and Blue Jacket in *Daily Advertiser*, August 12, 1797; "a dozen Democrats stuffed with

straw," *Porcupine's Gazette,* October 5, 1797.

33 Co-co and Gibbone were discussed in *Aurora General Advertiser* (hereafter *Aurora),* August 16, 1794; "Curious optical," *Aurora,* March 18, 1797; "exhibition of paintings," *Aurora,* January 3, 1798; "the wings," *Aurora,* June 24, 1794; "a carriage," *Aurora,* August 23, 1793. For more, see appendix I of Brigham, 1992.

34 "for farther particulars," *Porcupine's Gazette,* June 6, 1797.

35 "thus departed a youth," CWP 5:259; "His early loss let science mourn," APS, Series, 2, box 1; "on the mind of our citizens," C. W. Peale, 1799, *Introduction to a Course of Lectures.* Peale published this, and when he did, he added an "advertisement" on why. The "on the mind of our citizens," quote comes from that advertisement.

36 "The book of nature" and "It is my wish," *Daily Advertiser,* September 26, 1799; "What more pleasing," "the study of a science," and "the very sinews of government," C. W. Peale, *Introduction to a Course of Lectures.*

37 "the well directed," *Poulson's,* December 17, 1800; "a temple which no thinking," *Poulson's,* December 18, 1800; for notes from one of the attendees, see *Sketch of the First and Second Classes of Zoology, Principally taken from Notes made at the Lectures Delivered by Mr. Peale,* APS, Mss Film 402.

38 "I want public aid," *Aurora,* January 27, 1800. Also see C. W. Peale to Findley, February 18, 1800.

39 "will spare no exertions," *Poulson's,* November 20, 1800; "accompanied with," *Poulson's,* November 5, 1800; "if one hundredth part" "science of nature," "keep out the idle," and "to screen my country," C. W. Peale, "Discourse Introductory."

40 "For more, see Peale's lectures, APS, Mss Film 24, reel 10.

41 "read it with great pleasure," Jefferson to C. W. Peale, February 21, 1801; "remained lit all week," *Poulson's,* March 6, 1801; "afford[ed] me much gratification," and "that occupied all the leisure," C. W. Peale to Jefferson March 8, 1801; "hobby horse." CWP 5:238.

CHAPTER 4

1 "a pair of letters," James Graham to Sylvanus Miller, September 10, 1800; Miller to Samuel Latham Mitchill, September 20, 1800; "men requiring the use of spirits," R. Peale, 1802, *Account of the Skeleton,* 16; "a monster so vastly," *Mercantile Advertiser,* October 14, 1800.

2 "the great probability that," Graham to Mitchill, September 10, 1800; "a spectacle truly astonishing," Miller to Samuel Latham Mitchill, September 20, 1800.

3 "only one large-scale skeleton," CWP 2:311; "immediately proceeded," Rembrandt Peale, 1802, *Account of the Skeleton*, 14. Rembrandt updated and revised *Account of the Skeleton of the Mammoth* in 1803 and renamed it *A Historical Disquisition on the Mammoth: a Great American Incognitum, an Extinct, Immense, Carnivorous Animal, Whose Fossil Remains Have Been Found in North America.*

4 "Bones committee" and "to procure one," 1799, "Circular Letter, Transactions of the American Philosophical Society" 4:xxxvii–xxxix; "heard of the discovery of some large bones" and "to engage some of your friends," Jefferson to Robert Livingston, December 14, 1800, Papers of Thomas Jefferson, https://founders.archives.gov/about/Jefferson.

5 "the folly of nations making war," Peale Diary, C. W. Peale, June 5, 1801, CWP 2:313.

6 "with a sick stomach," C. W. Peale, June 5, 1801, CWP 2:315.

7 "wished to make the experiment" and "regretted that [he] had not made," C. W. Peale, June 19, 1801, CWP 2:321–22.

8 The location of the Masten Farm comes from an application to the US Department of Interior to make the Barber Farm site a National Historic site. The application was filed on September 18, 2009, as "Peale's Barber Farm Mastodon Site"; "many bones were still wanting," CWP 2:330; "everybody in the neighborhood," C. W. Peale to Andrew Ellicot, July 12, 1801; "it would be best to make," CWP 2:330.

9 "Herculean task to explore," C. W. Peale to Jefferson, June 29, 1801; "I told him that completing," CWP 2:332.

10 "flew like wild fire," "everybody seemed rejoiced," and "give me sufficient encouragement," CWP 2:334; "ardor to return," C. W. Peale to Graham, June 30, 1801; "The grandeur of this skeleton when completed," C. W. Peale to Jefferson, June 29, 1801; "zeal enough," Jefferson to C. W. Peale, July 29, 1801.

11 "disagreeable fellow," CWP 2:340; "the rash methods," C. W. Peale to Jefferson, July 24, 1801.

12 "Mr. Peale of Philadelphia," *Kline's Carlisle Weekly Gazette*, July 22, 1801; "the use of tools," CWP 2:351; "had requested from," C. W. Peale to Jefferson, July 24, 1801.

13 "some have suggested," E. Harvey, 2017, "Founding landscape: Charles Willson

Peale's *Exhumation of the Mastodon*," *American Art* 31:40–42; "as in a squirrel cage," C. W. Peale to Jefferson, October 11, 1801; "Every farmer with his wife and children," Rembrandt Peale, *Account of the Skeleton*.

14 "work of necessity," CWP 2:360; "that the difficulty," CWP 2:361; "with quick sands," CWP 2:361; "the woods echoed with repeated huzzas," Rembrandt Peale, *Account of the Skeleton*, 22.

15 "this exhibition of the bones," CWP 2:369; *Exhumation of the Mastodon* is now at the Maryland Historical Society in Baltimore; "the art of painting," Benjamin West to C. W. Peale, September 19, 1809.

16 "faintly Satanic position," L. Rigal, 1989, "An American Manufactory: Political Economy, Collectivity, and the Arts in Philadelphia, 1790-1810," (PhD dissertation, Stanford University), 77–79. For more on *Exhumation*, see B. Zygmont, 2015, "Charles Willson Peale's *The Exhumation of the Mastodon* and the Great Chain of Being: The interaction of religion, science, and art in Early-Federal America," *Text Matters* 5:95–110; L. Miller, 1981, "Charles Willson Peale as history painter: *The Exhumation of the Mastodon*," *American Art Journal* 13:47–68; and A. Davidson, 1969, "Catastrophism and Peale's Mammoth," *American Quarterly* 21:620–29.

17 "filling up the deficiencies," R. Peale, *Account of the Skeleton*, 24; for more, see C. W. Peale to Jefferson, April 19, 1803. The skeleton was 11 feet, 10 inches tall at the shoulder, C. W. Peale to Jefferson, April 19, 1803.

18 "In another century," *Aurora*, January 9, 1802; "mammoth cheese," *Columbia Repository*, January 12, 1802. Also see Jefferson to Thomas Mann Randolph, January 1, 1802, Papers of Thomas Jefferson, https://founders.archives.gov/about/Jefferson, and chapter 8 ("The Mammoth Cheese") in J. Powell, 1969, *General Washington and the Jackass, and Other American Characters in Portrait*, T. Yoseloff.

19 "Skeleton of the Mammoth," museum broadside, 1801–1802, https://diglib.amphilsoc.org/islandora/object/skeleton-mammoth-now-be-seen-museum-separate-room-admittance-which-50-cents-museum; "Feathered dress," CWP 2:379n1.

20 "standing in awe," C. Leland, 1893, *Memoirs*, Appleton, 38; "the human stature," F. Hall, 1818, *Travels in Canada and the United States in 1816 and 1817*, Longman, Hurst, Rees, 278; "a human being shrinks," J. Duncan, 1823, *Travels Through a Part*

of the United States and Canada in 1818 and 1819, vol. 1, 195; "the huge creature," J. Buckingham, 1843, *The Eastern and Western States of America*, vol. 1, 543–44.

21 "I looked on its enormous remains," Deborah Logan to Albanus Logan, January 10, 1802, Logan Family Papers, Library Company of Philadelphia; "perhaps we ought to imagine," W. Blane, 1824, *An Excursion through the United States and Canada During the Years 1822–23 by an English Gentleman*, Baldwin, Cradock and Joy, 98; "they must have been destroyed," R. Peale, 1803, *Account of the Skeleton*, 39.

22 "The laborious, tho' pleasing," "expecting that some grant," and "I wish to know your sentiments on this subject," C. W. Peale to Jefferson, January 12, 1802; "The time is now fully arrived," enclosure in C. W. Peale to Jefferson, January 12, 1802.

23 "No person on earth," Jefferson to C. W. Peale, January 16, 1802; "your communication has satisfied," C. W. Peale to Jefferson, January 21, 1802.

24 "Not solely as the proprietor of the museum," C. W. Peale, "Memorial for Public Assistance to Museum," *Philadelphia Gazette and Daily Advertiser*, February 19, 1802; "place to diffuse universal knowledge," C. W. Peale to Isaac Weaver, February 11, 1802.

25 "Impressed with a sense," Resolution of the Common Council of the City of Philadelphia, February 18, 1802, CWP 2:398; "MUSEUM: GREAT SCHOOL OF NATURE," Peale, C. W. 1804, *A Walk through the Philadelphia Museum*, HSP.

26 "a good and sure correspondence" and "take the portraits of distinguished," C. W. Peale to Jefferson, October 11, 1801; "John Bull or Jack Frog," C. W. Peale to Raphaelle Peale, July 3, 1803; "probably not return," and "all the capital cities," C. W. Peale to Alexander Robinson, April 22, 1802; the Russia trip is discussed in C. W. Peale to Rubens Peale, August 30, 1802.

27 *Aurora*, February 18, 1802, writes the dinner was the prior day. A list of these attending can be found in CWP 2:408n5; "collation WITHIN the BREAST," "the bipedal man," and "Raphael [*sic*] and his Rembrandt round," *Port Folio*, February 20, 1802.

28 "coming to see our pet," Rubens Peale to C. W. Peale, April 2,1802; "extraordinary and enormous bones," *New York Evening Post*, April 3, 1802; "visitors were," Rubens Peale to C. W. Peale, April 7, 1802.

29 "Your love and knowledge of natural history," C. W. Peale to Joseph Banks, June 22, 1802. Rembrandt dedicated his 46-page *Account of the Skeleton* to

Banks; "He wrote a similar letter," C. W. Peale to Benjamin West, March 20, 1802, and C. W. Peale to Saint-Hilaire, July 13, 1802.

30 "the frivolity of the coxcombs," C. W. Peale to Rubens Peale, August 30, 1802; "they revolt at being mixed with pickpockets," Jefferson to C. W. Peale, May 5, 1802.

31 "had the completest," Rubens Peale to Sophonisba Peale Sellers, September 6, 1802. For more, see Rubens Peale to C. W. Peale, September 6, 1802; Rubens Peale to C. W. Peale, September 23, 1802; "most beautiful and majestic looking young lady," Rubens Peale, circa 1856, *Memorandum of Rubens Peale and the Works of his Life*, APS, box 44.

32 "The very extraordinary SKELETON," *Morning Post and Gazetteer*, November 8, 1802; "medical gentlemen whom Rembrandt invited," Rubens Peale to C. W. Peale, October 3, 1802.

33 "I wish we were only in America," Rubens Peale to C. W. Peale, October 15, 1802; "The want of spirits," C. W. Peale to Angelica Peale Robinson, April 13, 1803; "prevent the improvement," C. W. Peale to William Vaughan, June 4, 1803; "the imagination of a fond," C. W. Peale to Rembrandt and Rubens Peale, June 23, 1803; "very few Englishmen love to pay," Rembrandt Peale to C. W. Peale, July 30, 1803; "Everybody of real curiosity," Joseph Banks to C. W. Peale, February 2, 1804.

34 "The best news I can tell you," C. W. Peale quoted Rembrandt Peale in C. W. Peale to Jefferson, June 2, 1803.

35 For a delightful poem about the mammoth exhibit in Reading, England, see Rubens Peale to C. W. Peale, July 30, 1803; "perhaps a dancing Bear," Rembrandt Peale to C. W. Peale, July 30, 1803.

36 "We are happy to hear," *Poulson's*, November 22, 1803; "handsome profit by exhibiting," C. W. Peale to Rubens and Rembrandt Peale, May 31, 1803; "The Great Aborigine of America," *Charleston Times*, March 19, 1804; "Next came Baltimore," *Baltimore Daily Advertiser*, May 26, 1804; "Baltimore Dancing Assembly," CWP 2:678.

CHAPTER 5

1 C. W. Peale, "Guide to the Philadelphia Museum," HSP; "in conjunction with *A Walk*," C. W. Peale, *A Walk through*.

2 "Here, undisturb'd," Peale misattributes this quote to Milton (a favorite of his). Instead it comes from James Thomson's *The Seasons: Summer*, CWP 2:766fn2–3.

3 All quotes and descriptions from C. W. Peale, *A Walk through* and C. W. Peale, "Guide," except for "While ladies are getting their charming faces," *Aurora*, October 18, 1803.

4 "several fine casts," C. W. Peale, "Guide"; "valuable as it is stupendous," C. W. Peale, "Guide"; "Mouse: Gigantic monster," *Federal Gazette and Baltimore Daily Advertiser*, June 16, 1804.

5 "the skull of an unknown animal," and "Chinese laborer," C. W. Peale, "Guide"; "Knowledge is power," "The ends virtue," "These are thy glorious works," and "Nature and Nature's," *Philadelphia Museum Ledger*, March 8–11, 1803, HSP.

6 "The museum must be great," C. W. Peale to Jefferson, February 26, 1804. There is general agreement about Raphaelle's arsenic poisoning, but the question of Charles's intentional neglect with respect to the dangers Raphaelle faced is a matter of heated debate, with Peale historian Lillian Miller taking issue with claims made in W. Honan, 1993, "Suspicions of hatred in a family of artists," *New York Times*, July 5, 1993, and P. Lloyd and G. Bendersky, 1993, "Arsenic, an old case: the chronic heavy metal poisoning of Raphaelle Peale (1774–1825)," *Perspectives in Biology and Medicine* 36:654–65; "classically arranged," C. W. Peale to Rubens Peale, July 6, 1804; " a charming youth," C. W. Peale to Angelica Peale Robinson, September 3, 1804; "does wonders to aid me," C. W. Peale to John DePeyster, October 4, 1804; "very capable of conducting," C. W. Peale to John DePeyster, March 3, 1805.

7 "in one of her exertions," "the largest boy," "It is a dreadful conflict," and "I shall now only live," C. W. Peale to John DePeyster, February 19, 1804.

8 "If we are not guided by our reason," C. W. Peale, 1803, *Epistle to a Friend on the Means of Preserving Health Promoting Happiness and Prolonging the Life of Man*, printed by Robert Aiken, 7.

9 "without exception," C. W. Peale to John DePeyster, June 27, 1804; "writings . . . actions . . ." and "I would love to talk," Humboldt to Jefferson, May 24, 1804, Papers of Thomas Jefferson, https://founders.archive.gov/about/Jefferson. For more on Humboldt, see A. Wulf, 2015, *The Invention of Nature: Alexander von Humboldt's New World*, Knopf, S. Rebok, 2008, "Enlightened correspondents: The transatlantic dialogue of Thomas Jefferson and Alexander von Humboldt,"

Virginia Magazine of History and Biography, 116:328–69, and H. Friis, 1960, "Baron Alexander von Humboldt's visit to Washington, D.C., June 1 through June 13, 1804," *Records of the Columbia Historical Society* 60/62:1–35; "spoke English very well," "how absurd is the conduct" and "bad owing to," CWP 2:683–88.

10 "as a philosopher," CWP 2:690; "We had a very elegant dinner," "All these circumstances," and "the Baron came to my room," CWP 2:693.

11 For more on the portrait of Humboldt, see CWP 2:728.

12 "mild, kind, attentive" and "never beheld a more serene sky," C. W. Peale to Rubens and Sophonisba Peale, July 25, 1805.

13 "Nothing can more deserve," *Poulson's*, December 1, 1807.

14 "paved with cobblestones," *Port Folio*, April 6, 1805; "one of the loveliest cities in the world," D. Franklin, ed., 1952, *Baron Klinckowstrom's America, 1818–1820*, Northwestern University Press, 17.

15 For more, see Brigham, 1992.

16 "what should be," *Museum Ledger*, December 4, 1804; "the want of room," C. W. Peale to Jefferson, November 26, 1806; "a whole square," C. W. Peale to Nathaniel Ramsay, April 3, 1805.

17 "the marmot sleeps," C. W. Peale to Jefferson, January 12, 1806.

18 "Skeleton of two deer," Jefferson to C. W. Peale, October 6, 1805; "everything that comes from Louisiana," C. W. Peale to Jefferson, October 22, 1805; "As you wish to keep," C. W. Peale to Jefferson, January 30, 1806.

19 All quotes from C. W. Peale to Jefferson, January 29, 1808.

20 "the long-clawed grisly [sic] bear," "the skeleton of" and "a striking instance," C. Janson, 1807, *The Stranger in America, 1793–1806*, printed by James Cundy, 191–93; "passed to Peale's," J. Melish, 1818, *Travels in the United States of America in the Years 1806 & 1807 and 1809, 1810 & 1811*, printed by Joseph Smyth, 127.

21 "by the immense collection," Jefferson to C. W. Peale, March 1, 1804; "the biographer of the feathered tribes," Alexander Wilson to William Bartram, August 4, 1809, C. Hunter, editor, 1983, *The Life and Letters of Alexander Wilson*, American Philosophical Society Press; "I don't remember," Rubens Peale, *Memorandum*.

22 "have had many pursuits," Alexander Wilson to Thomas Crichton, June 1, 1803; for more on Wilson, see E. H. Burtt and W. Davis, 2013, *Alexander Wilson: The Scot Who Founded American Ornithology*, Belknap Press.

23 "was indefatigable," C. W. Peale to Saint-Hilaire, April 21, 1808; "knew more of the American," C. W. Peale to David Ramsay, December 6, 1808.

24 "promote the cultivation of the Fine Arts," *Charter of the Pennsylvania Academy of the Fine Arts*, December 26, 1805.

25 "the use of the polygraph," Jefferson to C. W. Peale, January 15, 1809; "such instruments," C. W. Peale to Jefferson, February 26, 1804.

26 For more on a national university, see B. Rush, 1787, "Address to the People of the United States," possibly self-published. For more on Barlow and the national university, see J. Barlow, 1806, *Prospectus of a National University*, reprinted in *National Intelligencer*, November 24, 1806, and A. Castel, 1964, "The Founding Fathers and the Vision of a National University," *History of Education Quarterly* 4:280–302; "the advancement of knowledge," Barlow, 1806; "I have heard," C. W. Peale to Jefferson, August 4, 1806; "It will come as no small," Jefferson to C. W. Peale, December 21, 1806.

27 "I think Mr. Peale has not," Jefferson to Casper Wistar, June 21, 1807, Papers of Thomas Jefferson, https://founders.archives.gov/about/Jefferson; "the discipline of my house" and "his right hand man," C. W. Peale to Jefferson, August 30, 1807; "be solely occupied with his studies," Jefferson to C. W. Peale, August 24, 1808; "The circumstance which has guided us," Jefferson to C. W. Peale, November 15, 1808; "abundance of food for the mind," C. W. Peale to Jefferson, September 1, 1808; "press[ing] him much," Jefferson to C. W. Peale, November 15, 1808.

28 "Mr. Randolph is very attentive," C. W. Peale to Jefferson, December 23, 1808; "I do not discover," C. W. Peale to Jefferson, November 12, 1808; "I have now to thank," Jefferson to C. W. Peale, August 22, 1809; "I begin already," Jefferson to C. W. Peale, February 6, 1809; "felt some bodily weaknesses" and "meets with the approbation," C. W. Peale to James Madison, April 30, 1809.

29 "a fondness for finding," CWP 5:362; "the Museum in the State House," C. W. Peale to Angelica Peale Robinson, June 16, 1808; "left the whole labor," C. W. Peale to Angelica Peale Robinson, October 29, 1805; "I addressed him," C. W. Peale to Jefferson, September 9, 1811.

30 C. W. Peale transfer of museum to Rubens Peale, CWP 2:1245; "to be well managed," C. W. Peale to Jefferson, September 9, 1811.

CHAPTER 6

1 All diary entries from Katherine Fritsch in A. R. Beck, 1912, "Notes of a visit to Philadelphia, made by a Moravian sister in 1810," *Pennsylvania Magazine of History and Biography* 36:346–61.

2 "The museum contains," C. W. Peale to Nicholas Biddle, January 14, 1811; "annual net revenues," "Museum expenditures," HSP.

3 All entries in Rubens Peale, *Memorandum.*

4 "a series of," "introduced fine music," and "in the first year," Rubens Peale, *Memorandum.* Actual income from 1809 was $6,104 and from Rubens's first year, 1810, $8,380; "amusement and instruction," C. W. Peale to James Madison, April 30, 1809; "removed from the sight," *Poulson's,* August 5, 1811.

5 All entries from Rubens Peale, *Memorandum.*

6 "grand military maneuvers" *Aurora,* March 13, 1809; "a Mr. Hippolite," *Aurora,* April 6, 1809; "Zera Colburn," *Aurora,* March 8, 1811.

7 "Come hither," *Cincinnati Chronicle and Literary Gazette,* June 1834. For more on dime store museums, see Dennett, 1997.

8 "20,100 objects," *Poulson's,* April 14, 1810; 100,000 in all, *Aurora,* July 18, 1810; "I have to apologize," Rubens Peale to Joseph Allen Smith, April 22, 1814.

9 "the greatest complacency of mind," C. W. Peale to Rembrandt Peale; "murderous life of a soldier," C. W. Peale to Benjamin Franklin and Titian Peale, November 18, 1813; "I have heard that you have retired," Jefferson to C. W. Peale, August 20, 1811; "[Rubens] has improved the Museum," "I shall get instruction," and "ought to be studied by every man that makes a plow," C. W. Peale to Jefferson, September 9, 1811; "knowing his ignorance," CWP 5:374; "I have an idea of a machine," C. W. Peale to Jefferson, August 19, 1812; "Since my last letter," C. W. Peale to Jefferson, October 3, 1811.

10 "My health not being very good," "laying out the garden, planting trees," and "the walks of the gardens," Rubens Peale, *Memorandum.*

11 "account of the painters," C. W. Peale to Rembrandt Peale, October 28, 1812; "meeting at a friend's house," C. W. Peale to Jefferson, March 2, 1812; "this brings to my mind," C. W. Peale, *An Essay to Promote Domestic Happiness,* February–March 1812, CWP 3:129–46; "it is full of good sense," Jefferson to C. W. Peale, April 17, 1813; "the wonderful variety of animals inhabiting the Earth," CWP 5:380–81; "sentiments, all of a moral tendency" CWP 5:382.

12 "the concerns of the farm," CWP 5:385; "The education it," C. W. Peale to Jefferson, January 1, 1819; "with the progress of time" and "an enlightened policy," Commonwealth of Pennsylvania, Twentieth House of Representatives, Legislative Committee Report, March 5, 1810; "had already done for the museum," C. W. Peale to Simon Snyder, January 5, 1812; "In order to make the utility still" and "a noble exhibition and school of nature," C. W. Peale to Nicholas Biddle, January 14, 1811.

13 "You will do well to weigh," C. W. Peale to Rembrandt Peale, August 6, 1812; "I have said everything," C. W. Peale to Angelica Peale Robinson, October 7, 1812; "touched every string," C. W. Peale to Nathaniel Ramsay, March 13, 1813; for more on Rubens's offer, see C. W. Peale to Angelica Peale Robinson, October 7, 1812; C. W. Peale to Rembrandt Peale, July 27, 1812; "a museum of arts and sciences," Rembrandt Peale to Jefferson, July 13, 1813.

14 "risingest town in America," R. Parkinson, 1805, *A Tour in America in 1798, 1799, and 1800*, vol. 1, J. Harding Publishers, 78; "an elegant rendezvous for taste," *Federal Gazette and Baltimore Daily Advertiser*, August 15, 1814; "an institution devoted," W. Hunter, 1964, *The Story of America's Oldest Museum Building*, Baltimore Peale Museum, 11. For more on the Baltimore museum, see W. T. Alderson, ed., 1992, *Mermaids, Mummies, and Mastodons: The Emergence of the American Museum*, Association of Museums Press, and W. H. Hunter Jr., 1952, "Peale's Baltimore Museum," *College Art Journal* 12:31–36; "naked beauties" and "a cabinet of learned turkeys," Alderson, 1992; "birds, beasts fishes, snakes," and "miscellaneous curiosities," *Federal Gazette and Baltimore Daily Advertiser*, November 29, 1814; "injected preparations," *Federal Gazette and Baltimore Daily Advertiser*, August 15, 1815; "a gentleman not less distinguished," *Federal Gazette and Baltimore Daily Advertiser*, August 15, 1814; "the exertions of the proprietor of the museum," *Federal Gazette and Baltimore Daily Advertiser*, December 29, 1814; "I found it impossible," Rembrandt Peale to Rubens Peale, August 22/23, 1814; "to aid the fund," *Federal Gazette and Baltimore Daily Advertiser*, October 15, 1814.

15 "there is scarcely a difficulty," C. W. Peale to Rembrandt Peale, September 6, 1814; "a valuable collection of preserved" and all other exhibits listed, *Federal Gazette and Baltimore Daily Advertiser*, August 2, 1815.

16 All quotes from C. W. Peale, 1816, "Address to the Corporation and Citizens of

Philadelphia," CWP 3:411–23.

17 "in perpetuity," *Poulson's*, August 5, 1816; "to Charles W. Peale and his heirs," Report of the Councils on the Letter of Charles W. Peale, January 13, 1818, CWP 3:561–564.

18 "he was of the opinion that New York," CWP 3:492; "the father of Natural History," CWP 3:508; "savored too much nudity," CWP 3:493; "I wonder at his industry," CWP 3:504; "I could not do that," CWP 3:511; "making an offer of the Museum to Congress," C. W. Peale to Jefferson, January 15, 1818; "from what little conversation," CWP 3:634.

19 "which can only be seen until the 4th," *Poulson's*, June 17, 1815; "each from eight to nine inches," *Poulson's*, October 24, 1816; "the hand of an Egyptian mummy," *Poulson's*, March 4 1817; "a shell thrown into Fort McHenry by the British," *Poulson's*, June 26, 1817; "branch of the siba," Brigham, 1992, Appendix VI; "an indefatigable collector of subjects," CWP 5:400; "in pursuit of," Thomas Say to John F. Melsheimer, December 12, 1817, W. Fox, 1901, "Letters from Thomas Sax to John Melsheimer, 1816–1825," *Entomological News*, 12; "cabin fire," Thomas Say to Jacob Gilliams, January 30, 1818, as in T. Bennett, "The 1817 Expedition of the Academy of Natural Sciences," *Proceedings of the Academy of Natural Sciences of Philadelphia*, 152:1–21; "first explore the Missouri," as in H. Evans, 1997, *The Natural History of the Long Expedition to the Rocky Mountains (1819–1820)*, Oxford University Press. Also see K. Haltman, 2008, *Looking Close and Seeing Far: Samuel Seymour, Titian Ramsay Peale and the Art of The Long Expedition*, Pennsylvania State University Press.

20 "involving me in his debts," Titian Peale to C. W. Peale, June 2, 1821.

21 For more on the sea serpent, see C. Brown, 1990, "A Natural History of the Gloucester Sea Serpent: Knowledge, Power, and the Culture of Science in Antebellum America," *American Quarterly* 42:402–36.

CHAPTER 7

1 "Those that go a borrowing," C. W. Peale to Rubens Peale, May 9, 1822; "the collections of the museum," Museum Bylaws, 1827, APS series 7, box 53; "Hannah became worse," CWP 5:434. Hannah died at Belfield on October 21, 1821.

2 "I observe that as animals grow old," C. W. Peale to Jefferson, January 4, 1821; "I do not wonder that visitors to your museum," Jefferson to C. W. Peale, July 18,

1824; "I always learn with pleasure," Jefferson to C. W. Peale, February 15, 1824; "A visit from you," Jefferson to C. W. Peale, September 15, 1825.

3 "after Gilbert Stuart's," D. C. Ward, 1993, "Celebration of self: the portraiture of Charles Willson Peale and Rembrandt Peale, 1822–27," *American Art* 7:12; "the rise and progress of the Museum," C. W. Peale to Rembrandt Peale, July 23, 1822; "I have made the design," C. W. Peale to Jefferson, October 29, 1822; "I make a bold attempt," C. W. Peale to Rembrandt Peale, August 2, 1822; "The picture is much," C. W. Peale to Rubens Peale, October 4, 1822; "thought my left," C. W. Peale to Rubens Peale, October 17, 1822.

4 "It will show the citizens," C. W. Peale to Rembrandt Peale, March 10, 1823; "she was fully," C. W. Peale to Rubens Peale, February 26, 1823; "I find that," C. W. Peale to Rembrandt Peale, March 10, 1823.

5 All from C. W. Peale, *Natural History and the Museum.*

6 "My audience were not numerous" and "by visitors who paid," C. W. Peale to Rembrandt Peale, May 18, 1823; "mechanical museum," *Poulson's*, March 31, 1819, and December 30, 1819; "intends in a few days," *American and Commercial Daily Advertisement*, May 23, 1823.

7 "He [Rembrandt] had found" and "I was to give him," Rubens Peale, *Memorandum*; "the exchanges of birds," Alexandre Ricord to Rubens Peale, February 10, 1822; Rubens Peale advertisement, *American and Commercial Daily Advertiser*, July 8, 1822; "Philosophical Fireworks," Alderson, 1992, 61. For more on the menagerie, see J. Orosz, ed., 1990, *Curators and Culture: The Museum Movement in America, 1740–1870*, University of Alabama Press.

8 "My son Rubens," C. W. Peale to Miss Butler, May 3, 1822; "Rubens having purchased," CWP 5:436; "Franklin attends to," C. W. Peale to Jefferson, February 8, 1823; "to harmonize with his brother Franklin," C. W. Peale to Rubens Peale, September 10, 1822; "Franklin stepping into his place," C. W. Peale to Rubens Peale, May 5, 1822; "Sometimes the front of the table," G. E. Sellers to H. Sellers, May 2, 1895, as in C. C. Sellers, 1980, *Mr. Peale's Museum*, W. W. Norton; "for there they were much," "making high railings," and "sea lion," C. W. Peale to Rubens Peale, January 1, 1823.

9 "He came to North America," "a stick in the skin" and "cat's head," C. W. Peale to Jefferson, July 2, 1824. All items listed are from the *Museum Ledger.*

10 "There was a very excellent," Leland, 37–38; "When you go to Philadelphia," C.

Waterton, 1879, *Wanderings in South America*, MacMillan; "degrade a museum of natural history," C. W. Peale to Rembrandt Peale, April 6, 1823; "The Philadelphia Museum has lately been furnished," *American and Commercial Daily Advertiser*, June 5, 1821.

11 "A reception in this city," "The banners of colored silk waving," and "*Strike the cymbal, roll the tymbal*," J. Foster, 1824, *A Sketch of the Tour of General Lafayette, on His Late Visit to the United States, 1824*, printed by A. W. Thayer, 178; "General, the citizens of Philadelphia," Foster, 1824, 180; "Much esteemed friend," C. W. Peale to Lafayette, September 30, 1824; "expressed great satisfaction," CWP 5:481; "there is some evidence that Peale painted," CWP 4:428, editorial notes. The location of the Peale portrait of Lafayette, if indeed there was one, is unknown.

12 "he was nothing," C. W. Peale to William Patterson, February 8, 1826. For more on the relationship of C. W. and Raphaelle Peale, see L. B. Miller, 1993, "Father and son: the relationship of Charles Willson Peale and Raphaelle Peale," *American Art Journal* 25:5–61.

13 "My wish," Rubens Peale to Franklin Peale, April 25, 1826; "subjects of natural history," "the City of New York was all in motion," "which had a very good effect," and "subscribers to his reading room," Rubens Peale, *Memorandum*; "I gave the teachers," Rubens Peale to Franklin Peale, March 5, 1829; "collections in natural history," "the philosophical and miscellaneous," and "command[ed] a fine view," *Peale's New York Museum and Gallery of Fine Art Catalogue*, 1825, Library Company of Philadelphia, record number 000309158; "an Egyptian mummy in a fine state," T. Longworth, 1826, *Longworth's American Almanac, New-York Register and City Directory*, printed by T. Longworth; Romeo "the very learned dog," G. Odell, 1928, *Annals of the New York Stage*, Columbia University Press, 3:367; "tolerably well," Rubens Peale to Franklin Peale, May 9, 1826.

14 "four arches springing from the sculptured caps," Anonymous, 1917, "Notes and Queries," *Pennsylvania Magazine of History and Biography*, 41:378–79; "an extensive and very complete collection" and "contains all their dresses," *Poulson's*, June 9, 1826.

15 "indulge myself with a visit to see you," C. W. Peale to Jefferson, February 1, 1826; "the loss of a female," CWP 4:561; "He told me that," A. Ritter, *Death's Doings, or Memorabilia of Such as Were*, unpublished manuscript; "he had thought on the subject," "I said I was candid," "that she had spasmatic affections," "I entreated her

long to consent," "she would be happy to correspond," and "I could not promise," CWP 4:561–65.

16 "to add to my difficulties," CWP 4:567; "had not been in bed, " C. W. Peale to Angelica Peale Robinson, February 8, 1827; "a stricture on my bowels," and "taking all the blood," C. W. Peale to Rubens Peale, February 2, 1827; "the frost will not " and "this spell of sickness," C. W. Peale to John Godman, February 13, 1827; some of the obituaries for Peale can be found in *Poulson's*, February 24, 1827, *New-Hampshire Gazette*, February 20, 1827, *Republican Star*, March 6, 1827, *New Hampshire Patriot and State Gazette*, March 5, 1827, and *Connecticut Courant*, March 5, 1827.

CHAPTER 8

1 "churches and theatres," Rembrandt Peale to Museum Trustees, May 5, 1836, APS series 7, box 1; "the public," T. R. Peale, 1831, "Circular of the Philadelphia Museum: Containing Directions for the Preparation and Preservation of Objects of Natural History," printed by James Kay, Jun. & Co.; "which has grown up," Rembrandt Peale to Rubens Haines, October 22, 1828.

2 "By the unremitted exertions of the founder," "Many articles of interest," "light, airy," "among them specimens from every part of the world," "most complete collection of the Lepidoptera," "the dresses, implements, arms," "where experiments are regularly exhibited," and "men of eminence in Europe and America," T. R. Peale, 1831, "Circular of the Philadelphia Museum"; "in the museum," Prince Maximilian of Wied, "Prince of Wied's Travels in the Interior of North America, 1832–1834" in R. Gold Thwaites, 1906, *Early Western Travels 1748–1846*, Arthur H. Clark Company, 504.

3 "was a different man from," Rubens Peale to Charles Mayer, November 2, 1836; "Chang and Eng, the Siamese twins," Rubens Peale to Franklin Peale, September 27, 1836; "two fat girls" and the ventriloquist, Alderson, 1992.

4 All items listed are from *Museum Ledger*; "Our donations this quarter," Titian Peale, Report to the Museum Board of Trustees, March 20, 1834, HSP; "that all donations to the museum," Titian Peale, 1831, "Circular of the Philadelphia Museum."

5 "I regret being obliged," Titian Peale, Report to the Museum Board of Trustees, April 17, 1834, HSP; "a huge, magnificent hall" and "pour out the light to attract the spectators," Rembrandt Peale, Report to the Museum Board of Trustees,

May 5, 1836, HSP.

6 "Ten Thousand Things Chinese," N. Dunn, 1839, *Ten Thousand Things Chinese: A Descriptive Catalogue of the Chinese Collection*, private printing. For more on Dunn and his Chinese Museum, see APS, Nathan Dunn's Chinese Museum archive, Mss.069.C17n.

7 "all well-preserved animals," "the richest tints," "shells, corallines," "remarkable public men" and "mummies of a family," Buckingham, 1843; "pumpkins, one of which weighed 196," N. Wainwright, ed., 1967, *A Philadelphia Perspective: The Diary of Sidney George Fisher*, Historical Society of Pennsylvania, 65–66; "maintained a rapid conversation with 6 or 8 persons," Buckingham, 1843.

8 "exploring and surveying new islands," Reynolds's speech to Congress was reprinted in the January 1837 edition of *The Southern Literary Messenger*; "leave a private corporation," T. Peale, 1874, "The South Sea Surveying and Exploring Expedition," *American Historical Record*, 3:250; "The poor ship had her ribs," Titian Peale to Franklin Peale, April 5, 1840; "I had to do everything myself," Titian Peale to R. M. Patterson, November 13, 1838.

9 "a wonderful creation of man's ingenuity," as in C. C. Sellers, 1980, 299; "Amidst all of this gloom," Report to the Stockholders of the Philadelphia Museum, January 1, 1843, HSP.

10 "only energy," P. T. Barnum, 1856, *The Life and Adventures of P. T. Barnum, Clerk, Merchant, Editor, and Showman*, 7th ed., Ward and Lock, London, 82.

11 "he'd kill the other shop," Barnum to Moses Kimball, April 10, 1849 P. T.; "five or six thousand dollars," Barnum receipt book, May 21, 1849, to August 7, 1851. For more on the Museum of Comparative Zoology, see W. Faxon, 1915, "Relics of Peale's Museum," *Bulletin of the Museum of Comparative Zoology* LICX:117–148. For more on the portraits, see 1854, *Catalogue of the National Portrait and Historical Gallery Illustrative of American History: Formerly Belonging to Peale's Museum, Philadelphia, Now Exhibiting at Independence Hall, in Fourth Street*, printed by the Gazette Company, Cincinnati. The paintings were sold to the city for $12,000, John McAllister to B. J. Lossing, October 7, 1854, APS, Series 1, Box 14. Over time, the paintings have been dispersed to many museums and institutions around the world. Many can be found in the portrait gallery of the Second Bank of the United States in Philadelphia.